American Kaleidoscope Themes and Perspectives in Recent Art

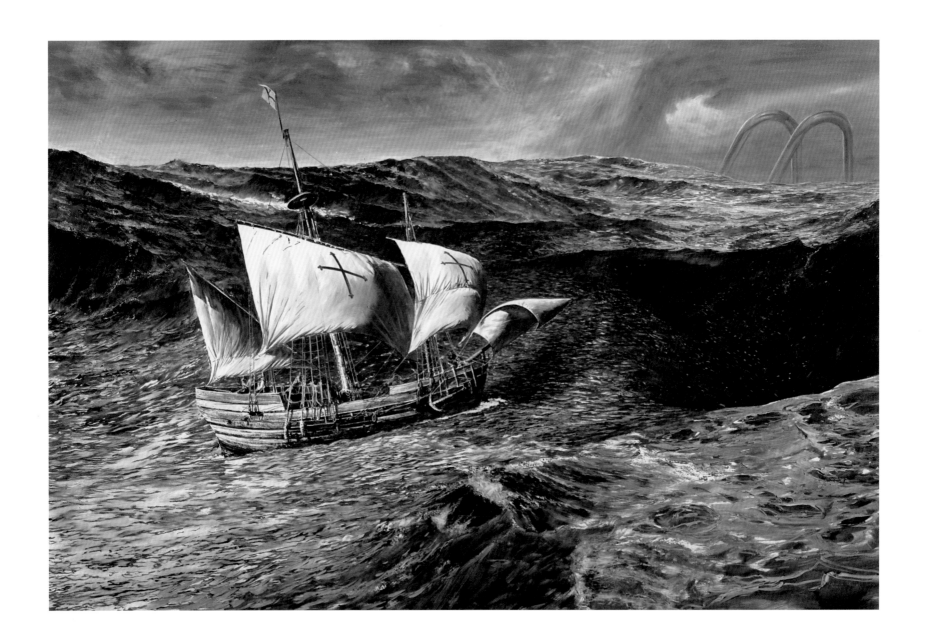

Jacquelyn Days Serwer

with contributions by
Jonathan P. Binstock
Andrew Connors
Gwendolyn H. Everett
Lynda Roscoe Hartigan

American Kaleidoscope

Themes and Perspectives in Recent Art

National Museum of American Art
Smithsonian Institution

Distributed by
D.A.P./Distributed Art Publishers,
New York

Published on the occasion of the exhibition *American Kaleidoscope: Themes and Perspectives in Recent Art,* organized by the National Museum of American Art, Smithsonian Institution, and presented from October 4, 1996, to February 2, 1997. The exhibition and accompanying catalogue are made possible by a generous grant from The Rockefeller Foundation and gifts from Anne and Ronald Abramson and the Pearson Art Foundation–Gerald L. and Beverly Pearson.

Curator: Jacquelyn Days Serwer
Project Assistant: Jonathan P. Binstock

Front cover: Jaune Quick-to-See Smith, *Genesis,* 1993, oil, collage, mixed media on canvas. High Museum of Art, Atlanta

Frontispiece: Mark Tansey, *Columbus Discovers Spain,* 1995, oil on canvas. Private collection, Houston. Courtesy Curt Marcus Gallery, New York

Project Editor: Janet Wilson
Editor: Lee Fleming
Designer: Polly Franchine
Printed by Hull Printing, Meriden, Connecticut

The National Museum of American Art, Smithsonian Institution, is dedicated to the preservation, exhibition, and study of the visual arts in America. The museum, whose publications program also includes the scholarly journal *American Art,* has extensive research resources: the database of the Inventories of American Painting and Sculpture, several image archives, and a variety of fellowships for scholars. The Renwick Gallery, one of the nation's premier craft museums, is part of NMAA. For more information or a catalogue of publications, write: Office of Publications, National Museum of American Art, MRC-230, Smithsonian Institution, Washington, D.C. 20560. NMAA also maintains a gopher site at **nmaa.ryder.si.edu** and a World Wide Web site at **http://nmaa.si.edu.** For further information, send e-mail to NMAA.**NMAAInfo@ic.si.edu.**

Library of Congress Cataloging-in-Publication Data
American kaleidoscope: themes and perspectives in recent art/Jacquelyn Days Serwer; with contributions by Jonathan P. Binstock . . . [et al].
 p. cm.
Exhibition catalog.
ISBN 0-937311-13-8 (pbk.)
1/ Art, American–Themes, motives–Exhibitions. 2. Art, Modern–20th century–United States–Themes, motives–Exhibitions. 3. Art and society–United States–History–20th century–Exhibitions. 1. Serwer, Jacquelyn Days
N6512.A6153 1996
709'.73'074753–dc20 96-25199
 CIP

Contents

Foreword
Elizabeth Broun 7

Acknowledgments 9

American Kaleidoscope
Themes and Perspectives in
Recent Art
Jacquelyn Days Serwer 11

Spiritual Expressions

Gronk
Jacquelyn Days Serwer 28

Sharon Kopriva
Jacquelyn Days Serwer 36

Jaune Quick-to-See Smith
Jonathan P. Binstock 44

Renée Stout
Lynda Roscoe Hartigan 52

Shared Concerns

Terry Allen
Jacquelyn Days Serwer 62

Kim Dingle
Jacquelyn Days Serwer 70

Pepón Osorio
Andrew Connors 76

Frank Romero
Jacquelyn Days Serwer 84

Roger Shimomura
Jacquelyn Days Serwer 92

Historical Perspectives

David Bates
Lynda Roscoe Hartigan 104

Frederick Brown
Gwendolyn H. Everett 112

Hung Liu
Jonathan P. Binstock 120

Deborah Oropallo
Gwendolyn H. Everett 132

Mark Tansey
Jonathan P. Binstock 140

Artists' Biographies 148

Exhibition Checklist 158

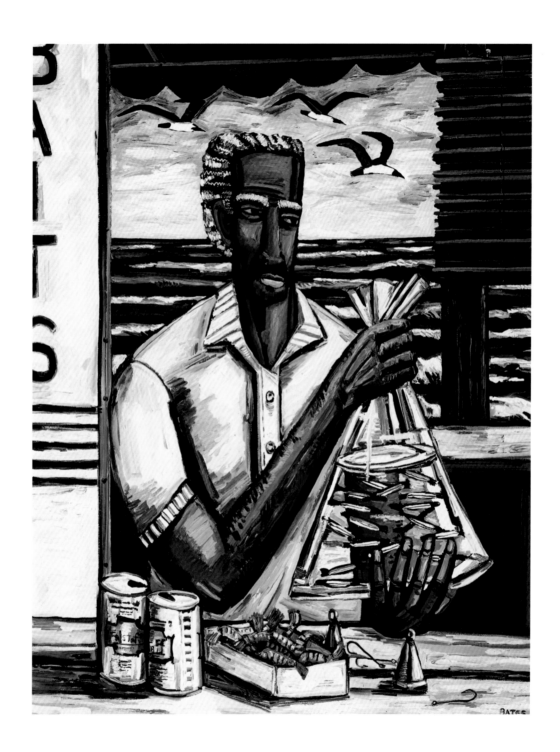

David Bates, *Baits,* 1990,
oil on canvas, 213.4
x 162.6 cm (84 x 64 in.).
National Museum of
American Art, Museum
purchase

Foreword

Sampling American art at the close of a turbulent century is an irresistible but risky undertaking. A decade from now, will the fourteen artists chosen for "American Kaleidoscope" still seem relevant as guides to our concerns at the end of this period that early optimists called the "American Century"? How could any selection of artists adequately mirror this restlessly mobile, constantly splintering society in the midst of radical change?

It's hard even to identify the significant forces at work, much less those artists who most eloquently summarize their effect on our age. Is it globalization of the economy that is reshaping modern America, or demographic shifts in ethnic, racial, and regional groups that we see reflected in politics, advertising, and popular culture? Is it the telecommunications revolution propelling us into a future of promise and anxiety, or familiar forces like the threat of nuclear war that still shape the universe toward which we guide our children? How can artists relate to such pervasive but indefinable concerns?

At mid-century, many artists responded to genocide and nuclear war in the only language that seemed capable of utterance about unspeakable things. But their heroic abstraction, more difficult and private than earlier nature-inspired abstract styles, ruptured the relationship between artist and audience. If traditional figurative narration threatened to trivialize such profound experience, a proud and silent abstraction often seemed remote, claiming meanings that no one could securely locate.

Formalism in the 1960s and 1970s was in part a search for the elements of a new vocabulary, but its academic, intellectual aspect further distanced the already-small art public. During the same period, museum curators and art historians proliferated to fill the widening gap between the artwork that "speaks for itself" and the public that didn't understand and, increasingly, didn't care. As skepticism took root on all sides, the fundamental contract between artist and audience, inherent in the expressive purpose of the artwork, eroded. The relationship idealized as a stimulating conversation between viewer and artist is now often two soliloquies: the public stands in line for blockbuster exhibitions celebrating masters of the past, while a handful of critics anoint contemporary "art stars" who dominate international fairs without penetrating public consciousness.

Before we get discouraged about this situation, however, it's useful to remember that there has long been a serious disconnection between artists and the public in America. John Singleton Copley complained that his fellow colonials considered artists no better than cobblers. More than a century later, Thomas Eakins wrote, "My honours are misunderstanding, persecution, and neglect, enhanced because unsought." Yet both Copley and Eakins are championed today for their way of filtering experience through a complex social mesh, leaving a visual record of their times that engages and teaches us about the past.

Looking to artworks for insight into social, political, and economic interests beyond aesthetics is one way we gauge the passing of pure formalism. The death of critic Clement Greenberg, whose commanding intellect and brilliant writing defined the formalist precept, marked a symbolic passing. The resurgence of overt social themes in art in recent years has revived narration and inspired reverence for survivors of the wilderness. Artists such as social satirist Paul Cadmus and political critic Leon Golub figure in a new lineage of ancestor figures, honored for their insistence on confronting reality in the vernacular.

The very different artists in "American Kaleidoscope" make art that provokes and attracts an audience rather than bearing silent witness. Although diverse in style, they all embrace robust physicality in subjects and materials: large canvases, oversize figures, assertive gestures, vibrant color, bold compositions, impastoed paint, active brushwork, collaged objects, and much more. There's forceful initial impact, but also a strong return on the investment of long looking, with multiple visual access points, shifting perspectives, and seductive appeal to the senses.

Many of these artists use narrative elements to prolong our engagement with their work. They rarely tell an entire story, but they supply the details needed for long "takes," allowing the viewer to follow unfolding ideas. They also relate subject to style (Hung Liu's dripped "veils" of translucent paint evoking memory), or link personal

experience to larger social themes (Fred Brown's part-Indian grand-mother), and otherwise lay out an elaborated fabric of interwoven ideas, with multiple threads to be followed. Reclaiming a narrative tradition and reasserting physicality are recognized as conservative strategies by the avant-garde, but they reach out to people as a way of reestablishing trust.

Exhibition curator Jacquelyn Days Serwer chose from a rich field of exciting artists working in all corners of the country. Her selection is personal, signaling the multiple possibilities available to those eager for visual evidence of our common experience in this chaotic time. The three themes highlighted here are loose groups with permeable boundaries; each artist could easily fit in different categories of de-scription.

The themes of community, history, and spirituality emphasize personal experience and the democratization of our common culture. Though all significant art directly or indirectly mirrors aspects of social organization, the artists included here are especially adept at holding in balance the conflicting forces of fragmentation and assimilation in our nation today.

American artistic culture was profoundly shaped by European standards and institutions, but the legacy of royal academies and state-sponsored museums is inadequate to the realization of a cultural expression befitting the pluralistic society now maturing in the United States. Frank Romero, Roger Shimomura, Deborah Oropallo, and others explore the clash of immigrant or slave experiences from the varying perspectives of new arrivals or their descendants. Jaune Quick-to-See Smith evokes the equally disjunctive experience of the "first American." Mark Tansey unearths and deconstructs the edifice of Western civilization, just as Hung Liu mines the cultures of the Eastern world—both points of the compass converging in the new America. Terry Allen provides a personal running chronicle of events current in our time. Each artist reminds us that their individual stories are not dry history in America. And for each of the artists included here, a dozen others are similarly stitching our multiple fragmented pasts into a larger social narrative.

In the mid-1970s—in response to the civil rights movement and in anticipation of the Bicentennial—historians reviewed the original archival documents of colonization, revolution, establishment of national institutions, and expansion across the continent. As a result, the entire history of the United States has been rewritten to expunge old legends in favor of more nuanced and equivocal accounts. The artists in "American Kaleidoscope" parallel these histo-rians' reinterpretations through their insights and expressions.

Spirituality and materialism have long been linked in America; our artists have often relied on private patronage from merchants, industrialists, and corporations. Thomas Cole's dependence on mer-chant-grocer Luman Reed did not dampen his enthusiasm for spiritual meanings in his art, linked to Transcendentalism, dissenting religious traditions, and cyclical theories in history. Artists of the American Renaissance were supported by Gilded Age industrialists like Charles Lang Freer, who found a kind of redemption from materialism in his subordination to the artists he revered. Although few of the artists featured here could be described as religious in the traditional sense, many bring an enduring spirit to their work, which reinforces the beliefs and strivings of so many Americans. Indeed, the very commit-ment to being an artist in America at the end of the twentieth century can be seen as a belief in the spirit. This part of their work is hardest to define, but impossible to ignore.

Similarly, few if any of these artists would describe their art as centering on nationality. Yet taken together, they offer the image of a society seeking the fullest expression, revealing the various personal, social, and spiritual impulses current today. Their achievements are convincing evidence that the democratic experiment begun more than two centuries ago offers unparalleled opportunities for understanding ourselves in relation to the society we are creating.

Elizabeth Broun
Director
National Museum of American Art

Acknowledgments

Preliminary preparations for "American Kaleidoscope" began in the spring of 1993. Inevitably, a project of this length has built upon the efforts of many individuals, some within our institution and others associated with organizations outside. At the National Museum of American Art, I must first express my gratitude to our director, Elizabeth Broun, who from the very beginning demonstrated nothing but enthusiasm and confidence in what has been our most ambitious project to date in the area of contemporary art. Our chief curator through most of the preparation period, Virginia Mecklenburg, was extremely supportive as well, devising strategies at crucial points in the planning that assured the project's viability.

Museum curators Andrew Connors, Gwendolyn Everett, and Lynda Roscoe Hartigan, who generously authored individual artists' entries despite the pressures of other urgent commitments, made an invaluable contribution to this endeavor. Jonathan Binstock, my research assistant for the last two years, has shown enormous dedication to his tasks, which have included both the routine responsibilities involved in the exhibition and publication, as well as the challenging assignment of writing three of the artists' entries.

Several museum interns contributed to the research for the exhibition and book. Their efforts provided the foundation on which to build the project. Ann Kenny was the first, followed by Megan Duffy, Amy Sweigert, Karen Glickman, Anne Samuel, and Angela Chang. As the text for the book began to take shape, Samuel and Chang provided invaluable support by tracking down references and making editorial suggestions. Staff secretaries Christine Donnelly-Moan and Sara Spees were extremely helpful during the proposal-writing stages of the project.

During the final stages of shaping the manuscript, outside readers Trinkett Clark, Steven Nash, and Nancy Grove went far beyond the call of duty in giving their very thoughtful and constructive advice. Their suggestions were invaluable in making the publication a worthy reflection of the art and artists featured in "American Kaleidoscope."

The support staff of NMAA have demonstrated their usual dedication. Our registrar, Melissa Kroning, and others in her department, including Patti Hager and Michael Smallwood, have been enormously helpful in arranging the loans, transportation, and insurance for the works of art. Val Lewton, former chief of design and production, offered early, invaluable advice on the installation, while designer Linda McNamara envisioned and carried out the complicated and imaginative realization under the supervision of our new chief of design and production, John Zelenik.

With the most heartfelt gratitude, I wish to thank Dr. Tomás Ybarra Frausto and the Rockefeller Foundation for their faith and financial sponsorship of this exhibition and book. I also wish to express my deep gratitude to Anne and Ronald Abramson, and the Pearson Art Foundation—Gerald L. and Beverly Pearson—for their generous support of "American Kaleidoscope."

I am especially grateful to the lenders who have willingly sacrificed their private enjoyment of these treasures so that they could be shared with others. I want to thank the artists as well for their patience and cooperation, and for the wonderful works they have created.

Finally, I wish to thank my husband, Daniel, and sons Jared and Adam. They remained unfailingly supportive of my efforts, never showing the slightest doubt in the ultimate success of this three-year endeavor.

Jacquelyn Days Serwer
Acting Chief Curator
National Museum of American Art

American Kaleidoscope: Themes and Identities

In planning for a contemporary exhibition with national scope, I looked for artists whose work seemed to offer both visual impact and a message that communicated something compelling and universal about being an artist in America towards the end of the century. Concerned about the emphasis being placed upon the conflict of cultures in America and the deterioration of America's sense of national community, I felt it worthwhile to focus on artists who reflect and were formed by all kinds of cross-currents in American culture—spiritual, regional, ethnic, political—but whose work, in the end, would tell us more about an America we recognize and share than about any of the separate groups a particular artist might seem to represent.[1]

The metaphor of a kaleidoscope, an instrument in which the patterns of colored glass fragments shift and change, altering the perspectives of the viewer with each transformation, seems an apt way to describe this particular group of artists who display an array of vibrant, distinctive modes of expression. Undoubtedly, many other artists might have been included. In the end, the artists in the exhibition were selected from a crowded field of lively candidates not only for the clarity of their vision, but also for their ability to communicate directly and forcefully to a general audience.

The works in "American Kaleidoscope" function on a variety

Roger Shimomura, *Beacon Hill Boy* (detail), 1994, acrylic on canvas

of levels. Deliberately engaging in their craftsmanship and use of imagery and metaphor, they are also repositories for content that is more deeply embedded and subject to many possible interpretations. At times, the public may be surprised at my reading of a given artist's work; another curator would surely have taken a different approach. But part of the appeal of these artists derives from a richness that allows for a range of meanings. And while the artists were selected for their individual qualities, they converge in many ways, highlighting especially three aspects of contemporary art that reveal some of our deepest concerns today: the search for spirituality, the nature of personal identity and social responsibility in our pluralistic society, and the "truth" of history.

Spiritual Expressions

As the century closes, many people have found the need for spiritual outlets beyond conventional religious practices. Rooted in a deeply secular culture, they nevertheless seek value, meaning, and inspiration in the context of their everyday lives. Four of the artists chosen for "American Kaleidoscope" have achieved this goal and, in so doing, provide insight into important aspects of their identity and self-image, as well as ours.

Renée Stout grew up in a modest African-American family in Pittsburgh that was a "very secure and nourishing place physically and spiritually."[2] That spiritual grounding provides the basis for all her

work. Appalled by the empty materialism so common in our society, she has sought to retrieve, rethink, and reinvest the ordinary with significance and spiritual resonance. One of Stout's vehicles for demonstrating her preference for otherworldly functions over those of the more material realm is her alter ego, the healer and fortune-teller Madam Ching (fig. 41). This mysterious presence employs an array of texts, charms, roots, oils, and fortune-telling equipment, adapted from found materials or crafted by Stout to look like found materials, that serve as instruments of sacred transformation.

Stout began her artistic career as a Photorealist painter (fig. 1). The illusion of reality soon gave way to a more allusive reality. In embracing the more tangible presence of three-dimensional form over painting, she also discovered that certain kinds of objects—whether African-American, Native American, Christian, or "pagan"—possess the power to affect the lives of human beings. After leaving her parents' home in Pittsburgh, she returned periodically, gradually piecing together elements of her family's folk traditions, including the discovery of funerary artifacts associated with old African practices. She also revisited the galleries at the Carnegie Institute where, as a child, she had been fascinated by the *minkisi* figures from Africa, as well as objects from ancient Egyptian and South American tribal cultures. Stout has also drawn from the strong tradition of craftsmanship in her family—her grandfather had worked in a steel mill, her father was a mechanic, and her uncle was a self-taught painter. Following in their footsteps, she approaches work and creative production not as ends in themselves, but as spiritual exercises derived from a wide mix of cul-

tures that endow her productions with an aura of sacred significance recognizable across the boundaries of traditional belief systems. Her giant *nkisi* figure created for an installation at the Corcoran Gallery of Art evoked a variety of associations, from African cult objects to South Pacific totems to giant Buddhas and Madonnas.[3]

Just as Stout uses Madam Ching as an alter ego, Gronk, steeped in an American mix of Catholicism, Latino folklore, and Hollywood movies, communicates his view of the world through the persona of La Tormenta, who appears in one of her guises in *St. Rose of Lima* (fig. 25). For Stout, Madam Ching is a medium through whom she can both express her philosophy of human existence and create the works of art that reflect that philosophy. Gronk's La Tormenta functions in a similar way. The ambiguity of La Tormenta's identity, emphasized by the fact that she is never shown from the front but only from the back, allows Gronk great latitude in using her for symbolic purposes.

Like Stout, Gronk often combines Christian concepts with less conventional religious ideas. La Tormenta is always depicted with strong vertical and horizontal elements defining the figure. The main part of the body is vertical, and the outstretched arms form a clear horizontal. Despite Gronk's assertion that his subject's physical character derives primarily from his preference for elemental form, the result is unmistakably reminiscent of a Roman cross with its connotations of crucifixion, death, and resurrection. At the same time, La Tormenta can be interpreted in a less orthodox vein as a theatrical protagonist, an actress or operatic diva, whose ability to change roles and identities constitutes an allegory for humankind's capacity—through faith either in oneself or in a higher being—for renewal and transformation.

The importance of transformation and its liberating effect are central to Sharon Kopriva's belief system as well. All of her work demands that we deal with the reality of the human condition, recognizing that death is the corollary to life. The loving way in which Kopriva gives a new existence to discarded animal bones, teeth, and worn cloth by fashioning these organic elements into her mummy-like figures demonstrates her faith in transcendence, in the ability of humankind to find meaning and continuity in death as in life. While Stout's and Gronk's spiritual outlook is more conventionally life-affirming, Kopriva challenges us to look beyond the physical appearance of life to an afterlife that may well offer its own comforts and consolations. Kopriva suggests that a conscious acceptance of our

mortality gives deeper meaning to our everyday lives.

Jaune Quick-to-See Smith's monumental paintings and assemblages, such as *Trade (gifts for trading land with white people)* (fig. 36) and *Genesis* (fig. 37), offer a more pessimistic interpretation of the human condition. Smith is always conscious in her work and in her life of the need to reinforce the authentic culture and beliefs of Native Americans that are so often vulgarized by others. "My art, my life experience, and my tribal ties are totally enmeshed," says the artist.[4] Such a synthesis is apparent in a complex creation like *Trade,* in which she uses an amalgam of visual and textual elements to chronicle both the historical Native American saga and the superficial mockery of it to be found in American popular culture.

Along with references to the tragedies and injustices, signs of survival are also evident in Smith's passionate and beautifully rendered imagery. The canoe unifying the three panels of the painted composition symbolizes perseverance and the preservation of traditional beliefs that have sustained Native Americans throughout their history. Although not a happy tale, the message of triumph over adversity through faith in the spiritual power of the natural world has a positive resonance for Americans of all backgrounds. Moreover, it serves as a metaphor for Smith's own life, in which she struggled to keep her creative spirit intact despite deprivations in her personal life and in the life of her Native American community.

Shared Concerns

Throughout the ages, artists as diverse as William Hogarth, Honoré Daumier, Käthe Kollwitz, and the Mexican muralists have drawn from their own experience to create works that deal with issues of importance to the larger community. In the nineteenth century, Spanish artist Francisco de Goya executed some of the most effective visual statements depicting the horrors of war, including his series of etchings titled "The Disasters of War" (fig. 2). In the twentieth century, Pablo Picasso achieved a similar result with his painting *Guernica* (fig. 3), one of the most powerful anti-war statements of any epoch. During this century in America, artists ranging from Ben Shahn to Miriam Schapiro and Glenn Ligon have chosen to focus on problems and injustices of broad interest to American society. In a similar vein, several artists in "American Kaleidoscope" have given us an opportu-

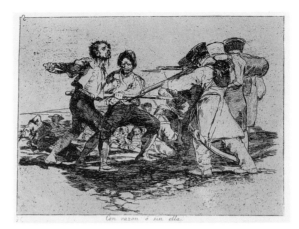

Fig. 2. Francisco de Goya, *Con razon o sin ella (Rightly or Wrongly)*, published 1863, etching, lavis, drypoint, burin, and burnisher. Rosenwald Collection, ©1996 Board of Trustees, National Gallery of Art, Washington

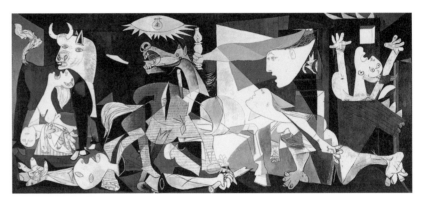

Fig. 3. Pablo Picasso, *Guernica*, 1937. ©ARS, NY. Centro de Arte Reina Sofia, Madrid, Spain

nity to consider or reconsider certain topics that have helped to shape the current social landscape.

Like Goya, Picasso, and many others, Terry Allen has focused on the tragedy and social costs of war in his series "Youth in Asia" (figs. 48, 50–53). These works explore the theme of exploitation and betrayal suffered by many of the young American soldiers who went to Vietnam, a large percentage of whom came from minority backgrounds. Allen's disorienting parallels between Southeast Asia and the American Southwest, along with his evocative assemblages and dramatic narratives, provide new insights into the human tragedy of the Vietnam War and the socially debilitating effects of war in general. Jarring juxtapositions of Disney characters, taxidermic specimens, collage elements, poetry, and music direct our attention anew to the

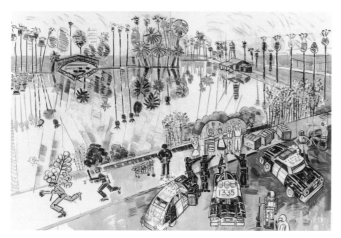

Fig. 5. Frank Romero, *The Arrest of the Paleteros* (in progress), charcoal on canvas, diptych, overall dimensions: 243.8 x 365.8 cm (96 x 144 in.). ©1996 Frank Romero

suffering and divisiveness that transformed the Vietnam War into a national trauma that continues even today to shape our outlook and identity as Americans.

Frank Romero's trilogy dramatizing key events in the Chicano civil rights struggle is closely related to Allen's subject. Opposition to the Vietnam War was one of the issues that helped galvanize Mexican-American activists in the Los Angeles area during the late 1960s and early 1970s. The organizers of the Chicano movement felt, as does Allen, that minority groups like their own made too great a contribution in numbers of draftees, and correspondingly paid too high a price in casualties. Resentment over those sacrifices in the face of what they saw as the denial of their social concerns and full civil rights brought their activism in the East Los Angeles area to its climax. *The Closing of Whittier Boulevard* (fig. 64), *The Death of Ruben Salazar* (fig. 66), and *The Arrest of the Paleteros* (ice cream vendors) (figs. 5, 67) emphasize the confrontational nature of the struggle at its height. With these emblematic episodes, Romero situates this movement squarely within an American tradition that urges its citizens to insist on equal justice for all.

Pepón Osorio has chosen a different kind of social crisis for the focus of his installation. It is one that particularly affects disadvantaged urban communities all over America: the absent father. The piece, called *Badge of Honor* (figs. 62, 63), was conceived and executed for a storefront site in a Latino neighborhood in Newark, New Jersey (fig. 6), before being moved to the Newark Museum.

Although the piece is situationally specific, the difficulty of communication between generations and between parent and child, as well as the poignancy of parental anguish in the face of a child's disappointed expectations, constitutes familiar territory for most of us, regardless of our home neighborhood. Osorio's experiences as a social worker in New York City gave him many opportunities to observe the negative effects on families of crime, incarceration, and absentee fatherhood. The real-life experiences incorporated into the work endow the presentation with an extraordinary emotional power. The riveting father-son dialogue cuts across social boundaries, making this drama an especially compelling American experience.

Both Kim Dingle and Roger Shimomura deal with another social issue: race relations and cultural interface. In contrast to other artists in this section, they employ humor to render a serious subject less

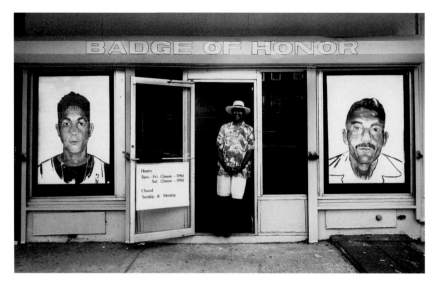

Fig. 6. Pepón Osorio outside the storefront site of *Badge of Honor*, 33 Broadway, Newark, New Jersey, 1995

satisfy the requirements essential to attain full "American" status. In these paintings, Shimomura's comic juxtapositions place all the players, whether of European, Asian, or other origin, in the funhouse, where we can laugh together at our prejudices and pretensions.

Historical Perspectives

Judging by the popular colloquial expression "It's history," the past has become for many a dusty irrelevancy. For the artists in the exhibition's section on "Historical Perspectives," however, the past is a source of myths, beliefs, and memories that help to illuminate our present outlook and circumstances. David Bates is the only artist in this group who consistently chooses subjects of humble origin. In his paintings of the nineties, generic individuals belonging to the rural or coastal environs of the southern United States embody our nostalgia for the life of an earlier, less complicated America. Iconic in their visual presence, his images remind us that the old values of loyalty, dependability, pride in one's work, and respect for nature retain an enduring appeal. Since Bates has included African-American males in many of his works, viewers often make the assumption that he is African American as well. He is not, but he does share many of the rural experiences and environmental influences that have shaped the orientation of southerners, both black and white. Bates, like artists Red Grooms and Terry Allen, has been deeply affected by a regional culture that has determined many of his attitudes and preferences. Here, as is so often the case in America, cultural influences resist the artificial boundaries and designations we tend to superimpose.

Bates's current concentration on sculpture has produced works directly related to earlier paintings, such as *Male Bust # 5* (fig. 80), as well as others, such as *Female Head #1* (fig. 83) and *Male Head #4* (fig. 84), that have "moved farthest into that realm of universality . . . simultaneously abstract and representational, personal in subject matter but increasingly generalized."[5] Rather than giving us specific reference points, as he does in his paintings, these sculptures seem to fuse elements of twentieth-century Cubism and African art with American and Hispanic folk-art traditions. His retrieval and reincorporation of discarded scraps of wood and metal, some of which have identifiable origins—the junkyard farm machinery fragments—and others that function like archaeological specimens, remind us that another story

threatening. They also make sure that the jokes highlight foibles on both sides of the fence, creating a safe space for all of us to take a fresh look at an old problem. Dingle's "Priss" installations featuring terrible toddlers, almost indistinguishable except for their hair and skin color—they even have identical eyeglass prescriptions—make it impossible for us to attach stereotypes to one color or the other (figs. 55, 58, 59). All the "Priss" babies behave outrageously, despite their fluffy white party dresses, suggesting that a civilized demeanor comes naturally to none of us and that we are all equally capable of indulging in amoral behavior, should we lack the socializing effects of proper nurture.

Shimomura's "Great American Neighbors" series (figs. 70, 72–75) presents hilarious vignettes mixing Hollywood icons and traditional Japanese stock characters, including geishas and samurai, to illustrate the cultural overlays and disjunctions that define everyday American life. Kentucky Fried Chicken and sushi, cocktails and rice cookers, Superman capes and kimonos dramatize the double consciousness many "hyphenated" Americans feel when society so often dwells on their otherness rather than their identity as Americans even after several generations in the United States. While ancestral links of Euro-Americans pose few identity dilemmas, Americans with Asian backgrounds are sometimes made to feel that they do not entirely

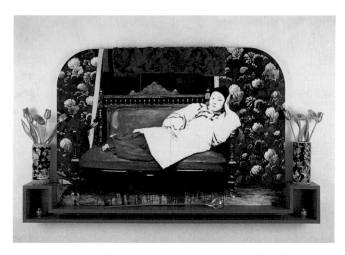

Fig. 7. Hung Liu, *Odalisque*, 1992, oil on canvas, lacquered wood and antique architectural inserts, 133.4 x 241.3 x 20.3 cm (52½ x 95 x 8 in.). Collection of Barbara and Eric Dobkin. Courtesy Steinbaum Krauss Gallery, New York

precedes ours. The old, discarded character of these materials links the objects to earlier times and previous incarnations.

Hung Liu, an artist born and educated in China, uses archival photographs or her own photographs of historic subjects as sources for her depictions. "Bad photographs," she says, "can make great paintings."[6] Like Bates, she concentrates on the figure without using live models. As an art student and painting professor in China, she was forced to paint the model in the socialist realist style. Since then, her resistance to such an approach has only increased. Liu's paintings whether about America or China concern "personal and cultural loss." While she thinks that "it's impossible to abandon your past," no matter how painful, she wants "to turn the negative into something positive . . . to put it out there, to share with other people."[7]

Although many of the individuals who appear in Liu's paintings have been ignored by history, such people often allow us to make a more personal connection to the past.[8] A painting from Liu's "Baltimore Series," *Children of a Lesser God* (fig. 93), shows immigrant child laborers in an early twentieth-century canning factory. Liu's attitude, which is in keeping with what historian Lawrence W. Weiner has described as the more "inclusive notion of where the historian's quarry lies," rescues these footnotes of history and elevates them to a new level of respect and significance.[9] Like the youthful Chinese prostitutes

(fig. 7) who appear in another series of Liu's paintings, these young victims of greed and prejudice become visible players in the pageant of the past. Sensitized to the issue of exploitation of the powerless from her knowledge of Chinese history, Liu is able to offer a new perspective on comparable episodes in American history.

Customs (fig. 8), a painting belonging to the same series, provides another example of Liu drawing on her bicultural background to arrive at a fresh interpretation of an old American subject. An immigrant herself, Liu recaptures for a contemporary audience the physical and psychological indignities suffered by nameless earlier newcomers to America. She transforms anonymous documentary snapshots into sensuously rendered, personalized images imbued with a poignancy not to be found in the original pictures. By choosing both a Chinese boy and a European woman undergoing inspection by immigration authorities, she reminds us that the immigrant experience was shared by future Americans of many different origins.

Liu's Chinese subjects, such as those associated with the last Chinese dynasty, often have a dual significance that reflects her American orientation as well as her Chinese roots. *Five Eunuchs* (fig. 98) is a meditation on the excesses of power. Both highly influential and corrupt, the court eunuchs sought status and position in a quest that became an end in itself. The appearance, if not the reality, of late twentieth-century America as a society of many subject to the selfish manipulations of the few gives the history of the imperial eunuchs, a powerful bureaucratic minority, a contemporary relevance. In addition to providing us with entree into the complexities of another civilization, Liu's valuable juxtapositions of cultural ideas and historical subjects suggest further reflections on our own past.

Like Liu, Frederick Brown celebrates both the ordinary individual and famous figures from history. In several paintings belonging to his "Magic Man" series, Brown pays homage to Native Americans. Three of the paintings turn likenesses of tribal leaders into iconic images of dignity and pride. In the fourth picture, Brown, of African-American, European, and Native American heritage, depicts a person who is not specifically identified in the title. This painting, called *She Knows How* (fig. 92), turns out to be a symbolic portrayal of Brown's part-Seminole grandmother. His mixture of the public and the private demonstrates an important link between history and heritage. Considering himself an embodiment of the rainbow of colors and

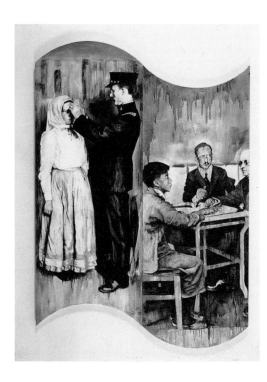

Fig. 8. Hung Liu, *Customs*, 1995, oil on canvas, diptych, 198.1 x 152.4 cm (78 x 60 in.). Courtesy Steinbaum Krauss Gallery, New York

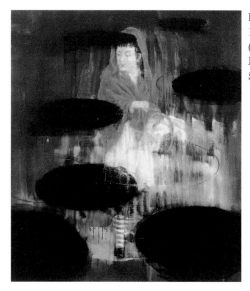

Fig. 9. Deborah Oropallo, *The Forest*, 1992, oil on canvas, 127 x 111.7 cm (50 x 44 in.). Collection of Buck A. Mickel. Courtesy Stephen Wirtz Gallery, San Francisco

cultures that characterizes America, Brown pays tribute to the Native American segment of that rainbow. He reminds us that unless this part is acknowledged, his story and that of America would be incomplete.

In contrast to Liu and Brown, Mark Tansey and Deborah Oropallo are more concerned with the human condition as it relates to our past than to the role of specific groups or individuals. They deal with allegories rather than with straightforward historical situations, creating works that function almost as parables, subtly offering us lessons with which we can interpret the past as well as the present. Literary associations often underlie and enhance their visual conceptions.

Oropallo embarked on her "Little Red Riding Hood" series (figs. 9, 100, 104) after she became intrigued with a Victorian greeting card. Her fairy-tale paintings stem in part from her fascination with old children's books and the images of childhood and Americana they contain. The subjects of the paintings included in "American Kaleidoscope" relate to familiar children's stories. In the guise of make-believe, they offer lessons in transformation, renewal, and redemp-

tion. In these classic tales, evil lurks everywhere, and any triumph over circumstances is likely to require a good deal of fortitude. The message, however, is essentially optimistic. We are reassured that *Pinocchio* (fig. 105) can repent and be redeemed, *Snow White* (fig. 103) can survive the poisonous apples, and that Little Red Riding Hood may be safer than the wolf (fig. 100). Our world is similarly perilous and unpredictable. The hope-filled paradigmatic plots provide positive constructs to interpret and analyze the real moral dilemmas of history and of our own time.

Tansey's parables are more enigmatic and more grandiose in scope, linking them to the tradition of Western history painting. Nevertheless, the paintings' superficial resemblance to book illustration and their deliberate ambiguity—one explanation can be as valid as another—account for their broad appeal. This is especially true of works such as *Landscape* (fig. 107) and *Columbus Discovers Spain* (frontispiece), in which the roles and accomplishments of major personalities are revisited in a new context. All the Tansey paintings seem to share the notion that truth is a matter of interpretation, and that the individual has the responsibility to determine his or her own version.

Committed to the "coexistence of contradictions,"[10] Tansey presents a view of the world that is complex, with conflicting realities operating simultaneously. *Continental Divide* (fig. 112) offers a compelling example of Tansey's brand of ambiguity, juxtaposing two equally convincing but irreconcilable points of view in one picture. In *Columbus Discovers Spain,* confusion is fostered by the inconsistency between the title and what seems to be depicted. *Landscape* disturbs our assumptions in another way: it overturns conventional reverence for the male icons of history by relegating their vandalized effigies to a monumental trash heap.

The reversals, contradictions, and inconsistencies in his paintings suggest that the conventions of history are to be periodically reevaluated rather than routinely accepted on faith. Stimulated by Tansey's challenges and enigmas, we are obliged to reexamine the process of memory and the records of the past in a way that helps us to rethink and perhaps reconcile the incongruities of the present. With that effort under way, we can look to an interpretation of the past that establishes a more useful foundation for the future.

American Kaleidoscope: Sources and Vocabulary

In addition to the way in which the "American Kaleidoscope" artists illuminate the three major themes of the exhibition, there are other similarities, parallels, and connections that contribute to a deeper understanding of the exhibition. All of the artists represented have benefited from the more tolerant attitude in the art-critical world that now recognizes a spectrum of styles, materials, and media. After a succession of hegemonic movements that characterized the postwar 1950s and 1960s—Abstract Expressionism, Pop, Op, Minimalism, Color Field, and Conceptualism—came the 1980s when artists could finally choose a variety of valid approaches, from geometric abstraction to Photorealism, from Neo-Expressionism to the new figuration and performance art. This art-world pluralism has fostered the kind of richness and cross-fertilization of cultural sources and vocabulary characteristic of the artists in "American Kaleidoscope." In fact, many of them have drawn on the same indigenous cultural resources that are so much a part of our American civilization, including blues music, folk art, visual metaphors, and language. These resources serve as vehicles for arriving at the larger statements that reflect the exhibi-

tion's broader themes of spirituality, social concerns, and history.

Bates and Tansey were both at the Whitney Museum of American Art during the mid-1970s. Bates had been selected for one of the artist internships and Tansey was supporting his graduate studies by working as an art handler. Bates, from Texas, and Tansey, from California, used the experience in very different ways. Bates had the opportunity to glimpse the big-city art world with its complicated mechanisms and glitzy personalities, ultimately seeing them as no match for the more nature-oriented environment he had left behind. Tansey was able to gather, firsthand, the kind of background he would need for the multilayered pictorial analyses of recent art and criticism characteristic of his later work. Later, in 1989, Bates and Tansey appeared together in "10 + 10: Contemporary Soviet and American Painters" at the Corcoran Gallery of Art.

Many of the artists share the experience of having pursued their careers with a greater concern for substance and connectedness derived from the real world rather than for the trends and fashions of the art world. Bates, at a moment in his painting career when he could hardly produce enough canvases to satisfy his dealers and collectors, chose to set aside painting for a period of time in order to concentrate on what he saw as the more elemental medium of sculpture. Stout's rejection of her early Photorealist painting style in favor of working in three dimensions involved a similar revelation. Frederick Brown's decision in the late 1980s to do a series of paintings commemorating some of the great blues musicians, like the choices made by Bates and Stout, came out of "that ineffable artmaking crossroads where history and society interact with the individual psyche."[11] An interest in blues music that had begun during his childhood in Chicago coincided with a new passion for celebrating such unsung heroes of American culture. In the end, Brown's interest in the blues not only resulted in monumental portraits of blues greats like *Howling Wolf* (fig. 10) and *Robert Johnson* (fig. 11), he also based one of his most important compositions on a blues song. Entitled *Stagger Lee* (fig. 12), it depicts the urban outlaw of the same name, along with a cast of popular American icons: a Pilgrim, Squanto, and a steelworker.

In addition to Brown, other artists in "American Kaleidoscope" have been strongly affected by the blues. It represents one of the real-world influences shaping themes and modes of expression. Allen has long divided his time between visual art and music, developing both a

vocal and an instrumental sound that derives its inspiration from the blues musicians who performed in the West Texas town of Lubbock where he grew up. In 1987, when the Washington Project for the Arts in the District of Columbia featured Allen's work, the presentation consisted of an exhibition of individual pieces, an installation, and a performance of his own music. Often Allen weaves existing blues standards, like the music of John Lee Hooker, with his own original music to create background sound tracks for his multimedia installations.

Hooker's music has long been a favorite of Bates as well, going hand in hand with the solid, rural folk who people much of his art. Bates's work was included in another Washington Project for the Arts exhibition in 1989 entitled "The Blues Aesthetic: Black Culture and Modernism."[12] Stout devoted a 1995 solo exhibition to Robert Johnson, a Mississippi Delta blues musician, whose legend endured long after the end of his short life playing in local night spots across the Deep South.[13] Moved by the brilliance of his music and the tragedy of his life—he died young and relatively unknown—Stout created a moving installation of evocative objects and declarations of love that accords him the aura and adulation his accomplishments deserve.

Even Shimomura, a third-generation Japanese American, has incorporated the blues into a performance work. He described a sequence that "will feature a female blues vocalist. The vocalist will wear a geisha wig over her blonde hair, a sorority tee-shirt, skirt w/heels and a gaudy kimono on top. Periodically . . . she will make her way through the crowd singing 1940s . . . tunes, while passing out samples of sushi and sandwiches, sake and white wine, and origami cranes made out of rice paper and Disney wrapping paper."[14]

Liu was drawn to the blues when she delved into the history of Baltimore in preparation for an exhibition there and became fascinated by the career of singer Billie Holiday. The resulting portrait (fig. 13) joined Liu's pantheon of icons drawn from American as well as Chinese cultures.

The pervasiveness of the blues as a strong influence in the sphere of American culture has led to a lively controversy. In 1995 an article in the *New York Times* examined the now highly charged question of cultural ownership: is it just black musicians who can claim the tradition as their cultural heritage, or can American musicians of whatever origin share in this home-grown American expression?[15]

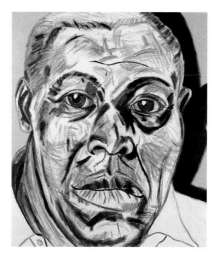
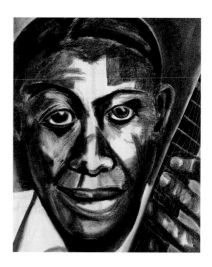

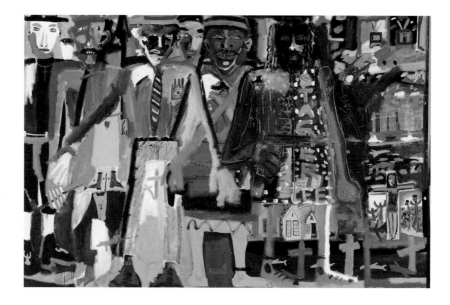

Fig. 10. Frederick Brown, *Howling Wolf*, 1989, oil on linen, 152.4 x 127 cm (60 x 50 in.). Private collection. Courtesy Marlborough Gallery, New York (top left)

Fig. 11. Frederick Brown, *Robert Johnson*, 1989, oil on linen, 91.4 x 76.2 cm (36 x 30 in.). Collection of Sebastienne Brown (top right)

Fig. 12. Frederick Brown, *Stagger Lee*, 1983, oil on canvas, 228.6 x 355.6 cm (90 x 140 in.). National Museum of American Art, Smithsonian Institution, Museum purchase (above)

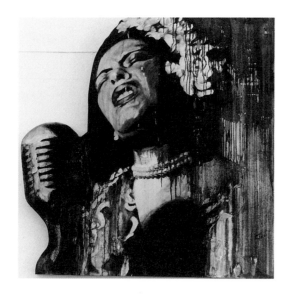

Fig. 13. Hung Liu, *Billie*, 1995, oil on canvas, 144.9 x 142.2 cm (57 x 56 in.). Courtesy Steinbaum Krauss Gallery, New York

Fig. 14. Tobias Anaya, *Horse and Rider*, date unknown, wood, wire, and aluminum, 66 x 15.2 x 59.7 cm (26 x 6 x 23 1/2 in.). Collection of David Bates

Fig. 15. Kim Dingle, *Lincoln's Cow (map of the Confederacy)*, 1990, oil on canvas, 152.4 x 182.9 cm (60 x 72 in.). Collection of Stuart Katz, Laguna Beach, California. Courtesy Blum & Poe, Santa Monica

Resolving such a dilemma is part of the ongoing search for elements that contribute to the cultural identity of all Americans.

Like the blues, American folk art has been an important source of ideas and inspiration for a number of the artists in "American Kaleidoscope." The artists are drawn to it because it offers a similar sort of connection to an authentic, relatively uncorrupted form of creative expression. The assemblage character of many of the constructions in Allen's "Youth in Asia" series and of Stout's ensembles owes a great deal to the artists' knowledge and admiration of self-taught artists. Romero, a Los Angeles artist attracted to Mexican-American popular culture, has found folk art to be a central influence on his style and subject matter as well. Speaking of Romero in the 1980s, a critic pronounced folk art "the abiding inspiration for Romero's past decade of work."[16] And for New York artist Osorio, the decorative folk traditions that still thrive in the Puerto Rican community are an essential resource for his ornate installations and furnishings encrusted with plastic flowers and pearls, religious images, and small tokens of familial endearment.

Bates also cites folk art as an important stimulus for his earthy images, especially his recent sculpture. For many years, he has had a small equestrian figure in his studio carved by Tobias Anaya, a self-taught artist from Galisteo, New Mexico (fig. 14). The work's visual richness and rustic appeal continue to fascinate him.

In Houston, Kopriva has found the local folk art to be an inspiration as well. Kopriva has spoken enthusiastically of the Houston artists' determination to preserve *The Orange Show,* "a maze-like monument to the orange" created by a former postal worker.[17] She also cites as another inspiration the folk-art shrine known as the "Beer-can House," a home transformed by the application of thousands of beer-can bottoms. The unorthodox character of these creations has reinforced her independent vision.

While many of the artists have been attracted to music and folk art for their intuitive, emotional qualities, a number are also intrigued by more intellectual approaches to enlightenment that include maps, charts, and diagrams. Used extensively by Conceptual artists such as Robert Smithson and Dennis Oppenheim in the 1970s, several

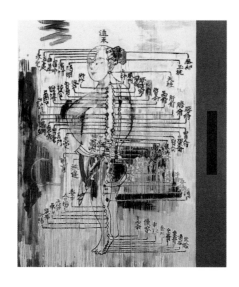

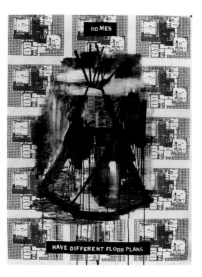

Fig. 16. Deborah Oropallo, *Bandage*, 1991, oil on canvas, 91.4 x 91.4 cm (36 x 36 in.). Collection of Tecoah and Tom Bruce, Berkeley, California. Courtesy Stephen Wirtz Gallery, San Francisco

Fig. 17. Hung Liu, *Red Bladder*, 1995, oil on canvas, 243.8 x 208.2 cm (96 x 82 in.). Courtesy Steinbaum Krauss Gallery, New York

Fig. 18. Jaune Quick-to-See Smith, *Homes Have Different Floorplans*, 1995, mixed media on paper, 127 x 96.5 cm (50 x 38 in.). Collection of St. Paul Companies, Minnesota. Courtesy Steinbaum Krauss Gallery, New York

"Kaleidoscope" artists have chosen to use these vehicles not to document but to communicate information that might go unnoticed in other forms. Dingle's maps of the United States (fig. 15) are useless as guides, but they do offer an unconventional configuration that provides us with new insights into the details that have traditionally been left out of our conception of the American landscape. Oropallo did a series of "How-To" (fig. 16), or instructional paintings that suggest, like Dingle's maps, that we have not taken the time to look carefully at information we are expected to take at face value. A close reading is required to decipher Oropallo's subjects, which include instructions on violin assembly, laying brick foundations for buildings, and human anatomy.

Oropallo's instructional paintings have their counterpart in the series of paintings based on acupuncture diagrams executed by Hung Liu in 1995 (fig. 17).[18] They, too, insist that we must look carefully at the visual clues available to us if we are to unravel the mysteries that reside within ourselves. The diagrams of land and property (fig. 18) included in some of Smith's paintings are intended to make a similar

point. Despite the abundance of this coded information handed down by older cultures, whether Chinese or Native American, the larger society has had little exposure to them and thus has largely failed to grasp the meaning of their accumulated wisdom. Understanding requires access and openness to unfamiliar ideas.

Like the maps, charts, and diagrams, the artists also have used visual metaphor to present information in a more intriguing form. The various symbolic uses of boat imagery demonstrate the versatility of this approach. Kopriva's *Rite of Passage* (fig. 30), consisting of a vessel with an oarsman and three trusting passengers, is perhaps her most enduring expression of the intimate relationship between life and the hereafter. The dignified, ceremonial passage from one realm to another has a timeless and reassuring quality that speaks to the continuity of the human cycle.

For Smith, in *Trade (gifts for trading land with white people)* (fig. 36), the boat (a canoe) becomes both a symbol of cultural vulnerability and survival. The Native American presence remains strong despite the stereotyping and commercialization of the culture by those out-

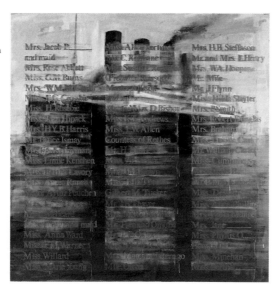

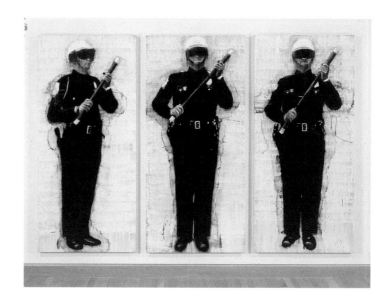

Fig. 19. Deborah Oropallo *Partial List of the Saved*, 1988, oil on canvas, 166.4 x 166.4 cm (65½ x 65½ in.). Private collection, Courtesy Stephen Wirtz Gallery, San Francisco

Fig. 20. Deborah Oropallo, *Three Man Patrol*, 1993, oil on canvas, 194.3 x 292.1 cm (76½ x 115 in.). Collection of Harry W. and Mary Margaret Anderson, Atherton, California. Courtesy Stephen Wirtz Gallery, San Francisco

side it. Smith has likened her mission to the freedom symbolized by the canoe. "If I could be the artist that I would really like to be," she said, "my greatest wish would be . . . to somehow build canoes so that people would be able to travel with that canoe, fish with that canoe, and would be able to bring back culture to their place."[19] Smith also used the idea of the canoe as a positive symbol in another context when she compared the successful realization of a painting to "a canoe catching the movement of the stream and gliding with the current."[20]

Tansey's version of one of Columbus's ships in *Columbus Discovers Spain* (frontispiece) simultaneously signifies illusion and disillusion. Although in his historical time Columbus was perhaps convinced that he was approaching the climax of his adventure as he neared the water's end, here he is still figuratively adrift and unaware of the ramifications of the event. The disorienting effect of this monochromatic, highly detailed but superficially inexplicable image may also reflect recent, more equivocal interpretations of the Columbus episode.

Oropallo shares with Gronk an interest in a particular boat—the *Titanic*. Both have used it as the focus of major works. Part of a series of paintings inspired by past and current disasters, Oropallo's *Partial List of the Saved* (fig. 19) makes a belated but effective epitaph for the victims of a tragedy that, decades later, still exerts an extraordinary fascination. Gronk's 1985 exhibition entitled "The Titanic and Other Tragedies at Sea" used the subject to explore a favorite Gronk theme: the ephemeral and unpredictable nature of life. Even the *Titanic,* a symbol of invulnerability, yielded to the dictates of fate.

Oropallo's major painting, *Three Man Patrol* (fig. 20), demonstrates another of her preoccupations, one that she shares with Romero: the effect of police misconduct on the normal functioning of an urban community. Oropallo's image, inspired by newspaper reports of the 1992 Los Angeles riots, features three rigid, uniformed, and heavily armed riot police who constitute a frightening tableau of law enforcement as a threat to democratic society rather than its defender. Romero's triptych commemorating events during the Chicano struggles of the early 1970s presents a similar, but more explicit, statement about the excessive use of authority and its corrosive power.

Brown and Smith have both devoted important paintings to Chief Seattle, the famous leader of the Duwamish people near Puget

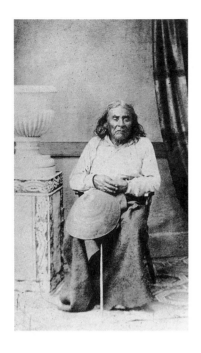

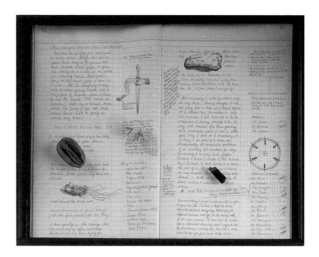

Fig. 21. *Chief Seattle*. Courtesy Special Collections Division, University of Washington Libraries, Negative No.: NA#1511

Fig. 22. Roger Shimomura, *Memories of Childhood #1*, 1993, acrylic on paper, 38.1 x 53.3 cm (15 x 21 in.). Collection of Barbara and Eric Dobkin. Courtesy Steinbaum Krauss Gallery, New York

Fig. 23. Renée Stout, *Madam Ching's Diary*, from *Madam's Desk*, 1995, ink on paper, ledger, overall dimensions: 143.8 x 96.5 x 71.1 cm (56⅝ x 38 x 28 in.). Courtesy the artist and David Adamson Gallery, Washington, D.C.

Sound (fig. 21). Both revere him for his commitment to the inviolability of the land by resisting the careless encroachments of settlers and other actions upsetting the balance of the natural environment. In his own way, Chief Seattle came to terms with the culture of the newcomers, converting to their Christian religion as he probably converted some of them to the ways of nature in the Northwest paradise that is now Washington State. "To harm the earth," he preached, "is to heap contempt upon its creator."[21] Smith's homage to this Native American visionary is metaphorical. In her symbolic landscapes consisting of canvases that have been lavishly painted and collaged, she alludes to the grandeur and sanctity of nature—beliefs that were central to Chief Seattle's religious perspective. Brown focuses instead on the man, endowing his stylized portrait (fig. 91) with the moral authority of a great philosopher and prophet.

Several of the artists produced series of works on paper about their early lives for an exhibition called "Memories of Childhood."[22] Liu shared the significance of her first name—it means rainbow in Chinese—and the sadness of growing up without her father, who was a political prisoner for more than forty years. Shimomura gave an

account of his family's internment during World War II (fig. 22), and Smith provided a glimpse of the hardships she endured, both emotional and economic, growing up in the West as a Native American during the 1940s and 1950s. The poignancy of the stories and the dispassionate rendering of the emotionally charged images demonstrate the way in which early experiences affected the artists' interests and outlook later in life.

As is true for so many contemporary artists, several of those in "American Kaleidoscope" use language in clever and provocative ways. Since Picasso's and Braque's early Cubist collages, words in pictures have functioned in both a formal and a symbolic way. From Jasper Johns's paintings and prints of the 1960s to artists of the 1980s such as Joseph Kosuth and Jenny Holzer, language has played a central role. The artists in "American Kaleidoscope" have been affected by the more visual tradition of Picasso and Johns, as well as by the Conceptualists, employing language in ways that reinforce structure as well as meaning.

Bates often has incorporated words, phrases, or simulated newspaper fragments for purposes of punning and double entendre. Words

also play both a structural and a decorative role in highly organized compositions such as *Baits* (p. 6). Stout's use of language is decorative as well. But it is also the repository of mystery and magic. The markings she uses in *The Old Fortune Teller's Board* (fig. 47) appear to be a kind of calligraphic automatic writing that is not readily decipherable, while the text and diagrams used in the diary on *Madam's Desk* (fig. 23) can be read with relative ease. Fragments and excerpts as well as long passages of text embellish the instruments belonging to Madam Ching, Stout's conjuring alter ego. Stout subscribes to the idea that written text is not just a means of communication; it can have "protective power."[23]

The words that enliven the surfaces of Smith's paintings also exert an effect beyond their superficial meanings. Mundane signs, labels, or expressions are given a new prominence and a new context that often endow the words with a novel significance. Just one of the little punning phrases in *Genesis* (fig. 37), "To air is human," becomes an effective mechanism to focus our attention on the environment and humankind's troubled relationship to it.

In a series of paintings from 1990, Tansey used words for a dual purpose. He screened them onto the canvas to add an additional layer of texture as well as a deeper level of meaning. In *Derrida Queries de Man* (fig. 24), the two post-structuralist philosophers Jacques Derrida and Paul de Man struggle at the edge of a precipice fashioned from passages of text written by de Man. The conceit allows Tansey to communicate a two-part hypothesis simultaneously: the source of de Man's vulnerability derives both from what he has written and from where he stands.[24]

Oropallo uses words in a similarly ironic way. They add texture and optical interest to the surface of a work such as *Pinocchio* (fig. 105), while providing a narrative counterpoint to the imagery. In ovals that graduate in size as they descend across the canvas, excerpts of text lifted from this classic children's tale bring us to a climactic stage in the story: the moment when Pinocchio's wooden nose is returned to normal. The contrast between the happy outcome communicated by the words and the menacing depiction of logs piled high, as if for a bonfire or funeral pyre, establishes a compelling psychological tension.

For Allen, language—both as sound and text—is inextricably

Fig. 24. Mark Tansey, *Derrida Queries de Man*, 1990, oil on canvas, 212.7 x 139.7 cm (83½ x 55 in.). Collection of Michael and Judy Ovitz, Los Angeles. Courtesy Curt Marcus Gallery, New York

combined in his mixed-media productions. Puns, wordplays, words with multiple meanings, poetry, and narrative excerpts ensure the multilayered experience characteristic of his constructions, installations, and performance works.[25] The storytelling tradition of the South where Allen grew up has affected every aspect of his creative life.

Osorio has edited hours of recorded words for his "American Kaleidoscope" installation, *Badge of Honor* (figs. 62, 63), to arrive at a coherent dialogue between a father and son for whom a face-to-face exchange is impossible. It represents the oral complement to the visual contrasts established by juxtaposing the two parts of the installation space: the father's austere jail cell and the son's lavishly appointed bedroom.

American Kaleidoscope: Reflections

The process of organizing "American Kaleidoscope: Themes and Perspectives in Recent Art" has occasioned some important realizations. This particular coming together of artists and ideas would have been an anomaly in an earlier decade. Until the 1970s and 1980s, women artists and artists identified with so-called minority groups

were rarely represented in major museums. Their presence in exhibitions as equal participants with "mainstream" artists was even rarer. In the postwar decades of the fifties and sixties, it was unusual to see a major show that did not represent some specific stylistic trend, whether Abstract Expressionist, Pop, Color Field, Minimalist, or Neo-Expressionist. There is at last a thriving alternative to the closed art world epitomized by Arne Glimcher's Pace Gallery superstars featured on the cover of the *New York Times Magazine* in 1993.[26] The art community now sustains both a variety of expressions and a more inclusive group of artists whose backgrounds reflect the cultural richness of the United States.

The nature of an American identity, or even its existence, has inspired endless discussions and analyses. The emphasis since the 1970s on separate group identities has further complicated this issue. The breadth of backgrounds, regional associations, styles, and media represented by the artists in "American Kaleidoscope" is intended to contribute to an understanding of what an American identity means in the final years of the twentieth century. The work produced by each of the selected artists has been shaped by personal histories. American identity evolved from a peculiar mix that speaks simultaneously of their distinctiveness and of their profound connectedness to America.

After almost two centuries of ignoring or denying the importance of cultural expression outside the Euro-American mainstream, the various social movements of the last thirty years, demanding an expanded role for minorities and women, have cleared the way for recognition and appreciation of the art and culture of a wider spectrum of American society. At last, the various group identities that have emerged over the last two decades can be situated within the broader spectrum of contributors to American culture. In this larger context, these group identities become part of a shared American experience. The ongoing process that brings us together as a nation requires an expanding definition of American identity based on the accumulation of cultural elements from many different origins. "American Kaleidoscope" explores that expanded definition through the work of the fourteen artists featured in the exhibition.

Jacquelyn Days Serwer

Notes

1. See Arthur M. Schlesinger, Jr., *The Disuniting of America* (New York and London: W. W. Norton, 1992) and Robert Hughes, "The Fraying of America," *Time,* 3 February 1992, 44–49.
2. Marla C. Berns, "Dear Robert, I'll See you at the Crossroads," A Project by Renée Stout (Santa Barbara: University Art Museum, 1995), 16.
3. Installation, "Luxor v1.0," Corcoran Gallery of Art, Washington, D.C., 1994.
4. Gloria Russell, "Smith College Museum features compelling exhibits," *Sunday Republican,* 2 May 1993, F-6.
5. Steven Nash, *David Bates: Sculpture* (New York: Charles Cowles Gallery, 1995), 9.
6. Conversation with the author, 11 December 1995.
7. Teresa Annas, "Translating Loss," *Virginian-Pilot,* 8 November 1995, E3.
8. The U.S. Holocaust Memorial Museum in Washington, D.C., has used this idea very effectively. All visitors are given the passport and vital statistics of a Holocaust victim close to the visitor's age, whose history can be followed as the visitor views the sequence of permanent exhibits documenting the course of events.
9. Lawrence W. Weiner, "Clio, Canons, and Culture," *Journal of American History* (December 1993): 850.
10. Jörg-Uwe Albig, "Ein Denker malt Kritik," *Art: Das Kunstmagazin* 4 (April 1988): 36–54; translation by unnamed author provided by Curt Marcus Gallery, New York.
11. John Howell, "Brown's Blues," *The Blues by Frederick Brown* (New York: Marlborough Gallery, 1989), 2.
12. See *The Blues Aesthetic: Black Culture and Modernism* (Washington, D.C.: Washington Project for the Arts, 1989).
13. See Berns, "Dear Robert, I'll See you at the Crossroads."
14. Letter to the author, 28 August 1995.
15. See Phil Patton, "Who Owns the Blues?" *New York Times,* 26 November 1995, 2:1, 35.
16. Heather Sealy Lineberry, "Frank Romero," *Art in California,* (September 1990): 24; see also article on his contribution to an urban folk-art exhibition: Meg Sullivan, "Latino Folk Art Thriving in L.A.," *Daily News,* 9 September 1991, 13.
17. Rebecca Knapp, "On the Road," *Art and Auction* (November 1995): 63.
18. At Steinbaum Krauss Gallery, 14 October to 18 November 1995.
19. Jaune Quick-to-See Smith, unpublished interview with Trinkett Clark, 9 October 1992.
20. Artist's statement in exhibition brochure: "Parameters #9: Jaune Quick-to-See Smith" (Norfolk, Va.: Chrysler Museum, 1993).
21. Chief Seattle, quoted in Robert Hould, "Sovereignty over Subjectivity," C 30 (Summer 1991): 33. Some scholars have challenged the authenticity of the statements attributed to Chief Seattle. See Eli Gifford and R. Michael Cook, eds., *How Can One Sell the Air: Chief Seattle's Vision* (Summertown, Tenn.: Book Publishing Company, 1992), 25.
22. Bernice Steinbaum, Judith Rovenger, and Roslyn Bernstein, *Memories of Childhood* (New York: Steinbaum Krauss Gallery, 1994).
23. Berns, "Dear Robert, I'll See you at the Crossroads," 14.
24. See Judi Freeman, *Mark Tansey* (Los Angeles: Los Angeles County Museum of Art, 1993), 42, for a discussion of painting and the controversy over de Man's life and philosophy after his death in 1983.
25. In an early performance piece called "The Ring," "ring" referred to a wedding ring and also to a boxing ring.
26. *New York Times Magazine,* 3 October 1993, cover.

Spiritual Expressions

Gronk

Sharon Kopriva

Jaune Quick-to-See Smith

Renée Stout

Renée Stout, MADAM'S DESK
(detail), 1995, found and
handmade objects

Gronk

EVERYDAY OBJECTS CAN BE VERY SPIRITUAL. . . .

I SEEK THE DIVINE IN THE DAILY.[1]

Gronk (Glugio Gronk Nicandro),[2] like so many artists in "American Kaleidoscope," works in a variety of modes and media. Having begun his career as a performance artist, he subsequently became a painter, printmaker, set designer, and musical collaborator, conveying in all his endeavors the psychological power of good drama. He haunts, intrigues, and engages us with symbols and characters that derive not so much from life, but from the theater of the mind. And, as the theater of ancient times was closely related to early religion, Gronk's dramas that unfold on walls, panels, canvas, or scrim have the spiritual effect of revelations. Gronk's sphere of activity, whether painting or performing, lies in the limbo area of the psychic landscape. There, demons of anguish and despair confront the guardian figures of hope and faith in a struggle that appeals to jaded, contemporary souls seeking answers to the spiritual emptiness of everyday life. Despite the gravity of this undertaking, Gronk never fails to enliven his productions with his own brand of ironic, self-deprecating humor.

The influences and inspirations for Gronk's body of work are an amalgam only imaginable in America. Growing up in East Los Angeles in the 1950s and 1960s, Gronk's experience of the Mexican-American mix of Latino culture as it developed into a self-conscious Chicano identity was very much a part of his formative years. The Southern California fascination with film and the pop culture of television and comics also represent important sources for Gronk's ideas.[3] But the novels of Albert Camus, the work of the French playwright Alfred Jarry, and the medieval Italian poet Dante, as well as the antics of the Dadaists, images of the American Magic Realists, and the rich tradition of Catholicism, have also contributed to his creative process.

Gronk's dynamic and very physical approach to executing a painting, along with his use of thick outlines and passages of flat, saturated, color, certainly places him in the tradition of Expressionist painting established by the Belgian artist James Ensor and the German Expressionists of the early twentieth century. Most likely, Gronk's preference for working big and bold comes out of the example set by the Abstract Expressionists—a kind of "melding of the[ir] heroic gestures" with "the ephemerality of dance and performance art."[4]

Fig. 25. Gronk
St. Rose of Lima
1991, acrylic on canvas, 289.6 x 330.2 cm (114 x 130 in.). Museum of Contemporary Art, Los Angeles, Gift of Nestle USA, Inc.

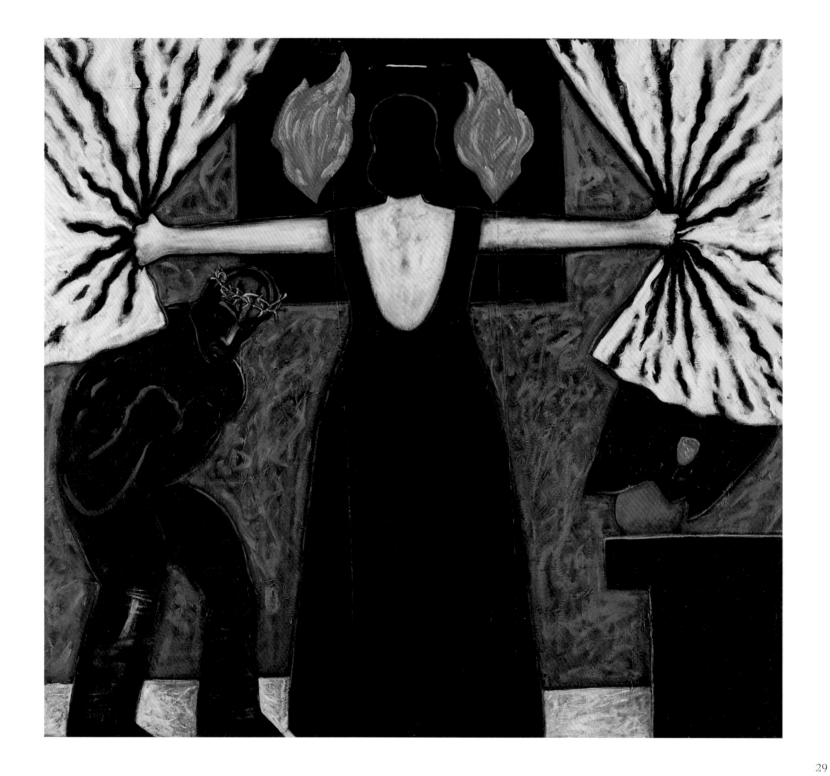

Gronk has said that he knew he was an artist as early as age five. Perhaps it was this predisposition that made it difficult for him to adjust to a regular academic routine. Instead of concentrating on his classes, Gronk did a great deal of studying on his own. He was "the library kid, the one who wanted to read every single thing."[5] As soon as he could, he dropped out of high school.

In 1971, together with three collaborators, he founded the performance group ASCO ("nausea" in Spanish). While many Chicano artists sought inspiration and identity in the past, ASCO members "didn't want to go back, we wanted to stay in the present and find our imagery as urban artists."[6] Driven by the prejudice and stereotyping of Latino artists that characterized the attitude of mainstream institutions and critics, and by opposition to the Vietnam War, ASCO set out to challenge the prevailing cultural authority.[7]

Gronk continued his youthful soul-searching in street performances, instant murals, walking murals, "no-movies," and "defacements" such as ASCO's graffiti spray-painting of the artists' names on the entrances and exits of the Los Angeles County Museum in 1972.[8] For some disaffected people in their community, ASCO members became anti-establishment heroes. Harry Gamboa, an original member of ASCO, described Gronk as being "a 'personality' even back then. He was a myth."[9] Gronk's early performances with ASCO included "Stations of the Cross" and "Cockroaches Have No Friends." An enigmatic female character in "Cockroaches" called Cyclona can be seen as the precursor to the recurrent female presence named La Tormenta who would later appear in many of Gronk's paintings.

Later in the 1970s, ASCO artists were included in art exhibitions in alternative spaces such

Fig. 26. Gronk
Conquest from "Grand Hotel" series
1988, acrylic on canvas, 156.2 x 186.1 cm (61½ x 73¼ in.).
Private collection. Courtesy Daniel Saxon Gallery, Los Angeles

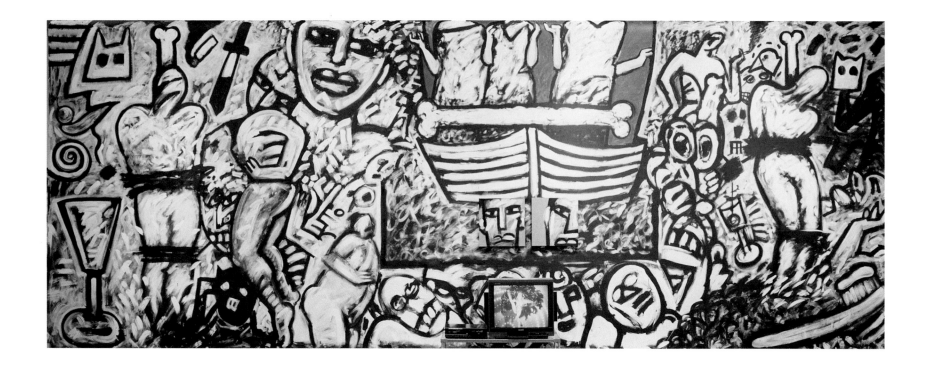

as LACE (Los Angeles Contemporary Exhibitions), as well as commercial galleries and even the Los Angeles County Museum of Art. ASCO continued some of its activities into the 1980s, with many additional members participating in live performances, film and video projects.

With Willie Herron, a founding member of ASCO, Gronk executed a number of murals on the graffiti-covered walls in Latino neighborhoods. The traces of writing and images on these deteriorated surfaces, sometimes barely legible, served as an important stimulus to Gronk's imagination. He has spoken of himself as a kind of urban "archeologist," who excavates mysterious messages buried beneath the surface of his urban environment. These messages have an otherworldly quality that Gronk feels compelled to interpret and communicate in his art. The dilapidated hotel sign across the street from his downtown L.A. studio, the traces of an advertisement on an abandoned building in which he deciphered the words "fascinating slippers" are modern-day cultural artifacts that have launched Gronk on lively visual odysseys.

Much of Gronk's most important work of the last ten years has been done either in series or as temporary, mural-scale, site-specific paintings. The "Titanic" paintings, the "Grand Hotel" (fig. 26), "Hotel Senator," and, more recently, the "Fascinating Slippers" series, as well as the temporary painting installations (fig. 27), all deal in some way with what one critic has described as "a succinct meditation on life in perpetual passage."[10] In all these creations, Gronk dwells on the impermanence, vulnerability, and frightening transitions that shape human existence and

Fig. 27. Gronk
Bone of Contention
1987, acrylic on drywall, 426.7 x 914.4 cm (168 x 360 in.). Courtesy Daniel Saxon Gallery, Los Angeles

test the limits of our spiritual resources.

Gronk's two paintings for "Kaleidoscope," *St. Rose of Lima* (fig. 25) and his improvisational wall painting executed during the opening week of the exhibition, call to our attention two major characteristics of Gronk's career to date: his repetition of potent images and symbols, such as the female figure La Tormenta, and the interactive process between the artist and his audience that for Gronk is the energizing force behind the site-specific projects.

Images of bottles, coffee cups, wide-tooth grimaces, wine glasses, flames, and severed limbs abound in Gronk's expansive, broadly painted, expressionistic visions. Some of the images are unusual; others, such as the coffee cups, couldn't be more ordinary. The effect of the repeated symbols is cumulative: it establishes a past whose echoes resonate and enrich each subsequent appearance. This is especially true of La Tormenta, always clothed in a long black gown and seen only from behind (fig. 28). Her enigmatic posture never fails to arouse the viewer's imagination. Gronk has referred to these images as "letters in an alphabet" that determine both his form and content.[11] As form, Gronk gravitates towards simple geometric shapes. To depict La Tormenta, the circle, triangle, and square form the main building blocks of the dominant figure. Gronk's distinct zones of color, the black, white, and red of the lady, her dress, and the background create a configuration of iconic grandeur.

According to Gronk, La Tormenta's meaning changes with each appearance, depending upon the chronological moment in Gronk's career and the particular visual context, although certain fundamental associations remain central to her significance for the artist. Most basically, she makes Gronk's point that "the back can reveal almost as much as the front."[12] What he does *not* say is that much of the mystery stems from the fact that the back reveals very little. Gronk purposely keeps the meaning ambiguous. He maintains that meaning is not always self-evident; some of it must come to the viewer from within. He also cites biography as one reason he remains attached to the image. Gronk's upbringing in a single-parent home by an independent-minded mother with strong religious beliefs left him with a real-life model for his favorite female personage.

La Tormenta is also Gronk's version of the Hollywood diva—above all, Ingrid Bergman in *Notorious*.[13] He also talks about the fact that the word means "storm" in Spanish, and he leaps to an association with another favorite movie, Alfred Hitchcock's *The Man Who Knew Too Much*, with Doris Day and Jimmy Stewart, in which the climax comes in a concert hall as Bernard Hermann conducts "Storm Cantata."

Gronk has always been attracted to live theater and the opera—other locales where such an exaggerated presence would be right at home. He has been commissioned to design sets for the Los Angeles Opera, and that experience has reinforced his feeling for his character's theatrical persona. In a performance at the University of California, Los Angeles, in 1995, Gronk collaborated with the composer Joseph Julian Gonzalez, the Kronos Quartet, and an opera singer dressed as La Tormenta to produce an improvisational painting on stage. Gronk's actual onstage execution of the painting was accompanied by music that incorporated sounds made by

Fig. 28. Gronk
La Tormenta
1985, acrylic on canvas, 228.6 x 152.4 cm (90 x 60 in.).
Private collection. Courtesy Daniel Saxon Gallery, Los
Angeles

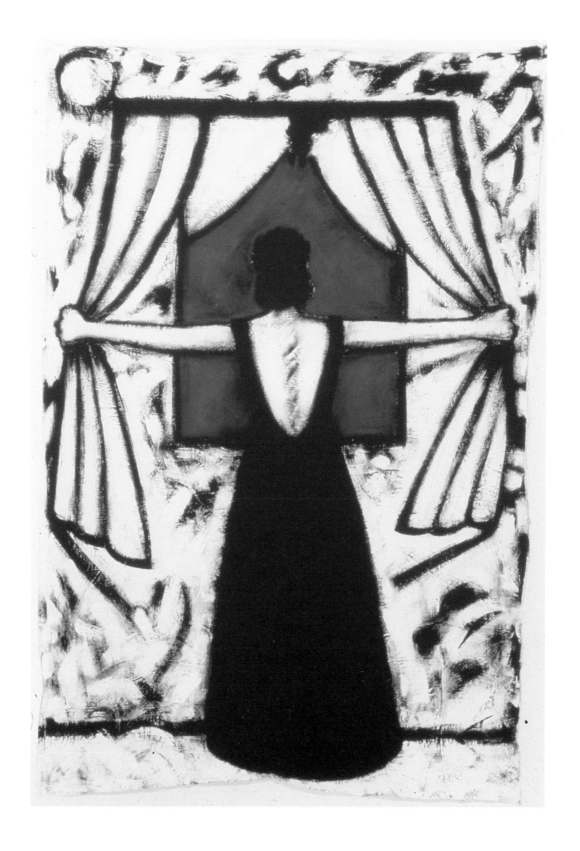

Fig. 29. Gronk at work before a group of schoolchildren, September 1994. Courtesy Elvehjem Museum of Art, University of Wisconsin-Madison

the artist—the amplification of his brush stroking the canvas—as part of the score. The mystery lady appeared both in the flesh and as a figurative element in the composition.

As is evident from the title of the painting in "Kaleidoscope," *St. Rose of Lima,* Gronk's La Tormenta has a religious identity as well. *St. Rose of Lima* refers to the first Latin-American saint. According to Gronk's version of the legend, the sixteenth-century St. Rose was a very beautiful and devout woman, half European and half Native American, who lived an ascetic existence, supporting herself modestly as a milliner.[14] In order not to be distracted from her simple ways by the attention of admirers, she scarred her face, using the thorns of long-stemmed roses. As a result, she never voluntarily showed her face in public, thus living out her saintly life in anonymity. Some observers have suggested that La Tormenta/St. Rose can be seen as a kind of alter ego for Gronk—an artistic individual (a hatmaker) who manifested her presence in the world primarily through her creations.

Unlike St. Rose, however, Gronk is a public figure who thrives on social interactions, especially those that derive from his site-specific projects. One of Gronk's original motives in doing such mammoth, improvisational paintings was to create major work that would represent a different kind of purity and integrity because it exists solely for a museum audience and for only a limited period of time. These works have almost no commercial value, but Gronk continues to receive museum requests to produce ephemeral pieces on a grand scale. Since 1994, he has done several major site-specific painting installations in museums around the country. Rather than being daunted by the task of filling so much space in a matter of days with the public looking on, Gronk is exhilarated by the challenge. He enjoys the role of creator, and audiences are captivated by being able to observe art in the making (fig. 29). While the aura of the artist persists, Gronk's ability to interact with the audience during these public encounters establishes a relationship with visitors that gives them a personal basis for appreciating contemporary art.

Like the "Hotel" paintings, these site-specific projects explore the theme of life's ephemeral nature in ways that do not diminish life's value and importance, but rather teach us to experience each moment with intensity and reverence. Gronk's spiritual interpretation of human existence will soon find a new, more permanent site-specific venue: he has been commissioned to paint large interior and exterior murals in a Catholic Church in East Los Angeles dedicated to St. Gertrude.

Jacquelyn Days Serwer

Notes

1. Radio interview with Bridget Forsmark, KGNU, Boulder, Colorado, 7 October 1994.
2. Gronk uses only his middle name, a Brazilian Indian word that means "to fly." See Lee Ann Clifton, "Gronk at SJMA," *Artweek,* 9 April 1992, 21.
3. Gronk cites specifically an old movie called *Devil Girls From Mars. Artweek,* 25 July 1987, 7.
4. Max F. Schultz, *the mythic present of chagoya, valdez, and gronk* (Los Angeles: Fisher Gallery, University of Southern California, 1995), 9.
5. Steven Durland and Linda Burnham, "Art with a Chicano Accent," *High Performance* 35 (1986): 57.
6. Ibid., 57.
7. Gronk clarified what he meant by stereotyping in the following comment: "If [well-known white artist] Jon Borofsky makes a wall painting, it's called an installation. If I do one, it's called a mural, because I'm supposed to be making murals in an economically deprived neighborhood." Quoted in Lucy Lippard, *Mixed Blessings* (New York: Pantheon Books, 1990), 29.
8. The "no-movies" were described by ASCO member Gamboa this way: "We would create a scene to give almost a cinematic feel, as if it were a frame from the rest of the movie. You could take it out and that image...could create a whole concept." Steven Durland and Linda Burnham, "Interview with Harry Gamboa, Jr., and ASCO," *High Performance* 35 (1986): 52.
9. Durland and Burnham, "Art with a Chicano Accent," 51.
10. Max Benavidez, "Hotel Senator: 13 Portals to the Underworld," *Gronk: Hotel Senator* (Los Angeles: Daniel Saxon Gallery, 1990).
11. Interview with the author, 18 August 1995.
12. Radio interview, KGNU, 7 October 1994.
13. According to a 1995 interview, Gronk identifies the visual inspiration for La Tormenta as coming "specifically from Ingrid Bergman's appearance in a V-backed dress in Alfred Hitchcock's 1946 film, *Notorious.* See Schultz, *the mythic present,* 7.
14. Reference sources provide slightly different details of the saint's life. See *Butler's Lives of the Saints,* ed. Michael Walsh (San Francisco: Harper & Row, 1985), 260–61; and David Hughes Framer, *The Oxford Dictionary of Saints* (Oxford: Oxford University Press, 1982), 349.

Sharon Kopriva

I AM AFRAID OF DEATH, BUT ALSO FASCINATED BY IT.
DEATH IS NOT AN END, BUT PART OF A CYCLE—THERE IS
CONTINUATION, REBIRTH.[1]

Sharon Kopriva has dedicated herself to making sense out of death and trying to inspire her audience to reexamine this taboo subject with her. She feels a special affinity to the many artists, including Mathias Grünewald, Francisco de Goya, Edvard Munch, James Ensor, and the Día de los Muertos (Day of the Dead) wood carvers, who have dealt with the troubling reality of humankind's mortality.

At first, her work—primarily sculptures crafted to look like mummified human beings—makes people uneasy. But given time with her creations, uneasiness usually changes to a combination of recognition and awe. She forces us to acknowlege and come to terms with death, an inevitability most people spend their lives denying. For Kopriva, death does not mean an end; it is life's corollary and, together, the two define human existence. As she has said about her work, "It is not intended to be a negative statement about death but an exploration of it as a form of change or transformation."[2]

Sources for Kopriva's work derive from many different cultures and traditions: her own Catholic upbringing, her experience of Latino and African-American culture in Houston, a fascination with ancient Egyptian rites, and the religious practices of Peruvian indigenous peoples.[3] Kopriva distills and refines all these elements in the process of arriving at her own metaphysical brew.

Kopriva, of Italian-American heritage, has lived all her life in the Heights area of Houston. Her current studio, a converted laundry, is across the street from the high school that she and her husband attended. After college, she taught art in secondary schools in Houston's inner-city neighborhoods. M.F.A. studies at the University of Houston brought her into contact with such mentors as John Alexander, James Surls, and, most importantly, Edward and Nancy Kienholz. But the pivotal experience for Kopriva's artistic evolution appears to have been her 1982 trip to Peru. "I left the plundered Nazca burial grounds with a different attitude toward life," she says.[4] The mummies she saw, naturally desiccated by the desert climate, were a revelation. Rather

Fig. 30. Sharon Kopriva
Rite of Passage
1991, papier-mâché, cloth, bone, wood, mixed media, 152.4 x 335.3 x 182.9 cm (60 x 132 x 72 in.). Collection of Nancy Reddin Kienholz

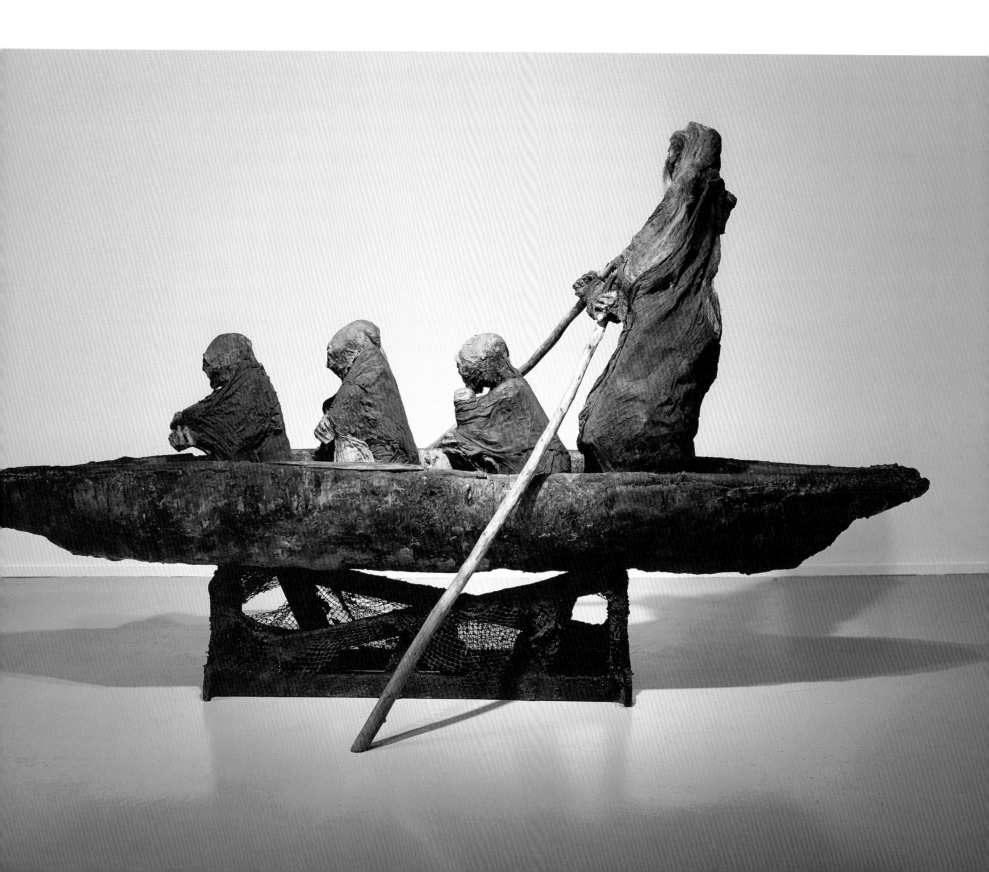

than being struck by their lifelessness, she responded to their humanity. These long-dead bodies still had the power to communicate the significance of life across the barriers of time.

Kopriva was still a painter in 1982, and she did not shift her focus to sculpture until after the mid-1980s. Her signature piece in the Houston Museum's ground-breaking survey of local art in 1985, "The Bad, Ugly, Proud, and Disconcerned" (fig. 31), was a kind of painted frieze with mixed media on canvas. It represents a transition toward a completely three-dimensional medium. But Kopriva's major theme was already clearly in place. A critic commented that "for all its macabre qualities, Kopriva's painting seems to make of death an extension of life."[5] Another posited that her "obsession with the physical decay of the flesh leads to the contemplation of such spiritual concerns as resurrection, transmigration, and rebirth."[6]

During the late 1980s Kopriva perfected her sculptural technique. Combining animal bones, worn fabric, clay, wood, teeth, and papier-mâché with armatures of wood and metal, she creates the illusion of mummified human beings. These figures have such presence that they personify the actuality rather than the evanescence of death.

In the late 1980s and early 1990s, Kopriva completed a series of figures named after Christian martyrs, including a riveting *Sebastian* (1986), whose body made of animal bones, sticks, and papier-mâché is meant to hang on the wall. Not long after the sculpture came into the possession of a young collector, he lost it in a most dramatic manner. While he was away from home, a flood caused by a broken aquarium forced the landlord, with the help of police, to break into the apartment. Confronted by the tortured figure on the wall, the police felt obliged to remove the "corpse" to the city morgue as a suspected homicide. Simple tests revealed the "body" to be mostly animal bones and papier-mâché, but the incident merited a front-page story in the *Houston Post*.[7] It also provided a demonstration of the convincing effect of Kopriva's painstaking creations.

Perhaps the most impressive sculpture in the "Saints" series is the freestanding depiction of *Joan of Arc* (fig. 32) being burned at the stake. Here we cannot mistake the release from life as a peaceful transaction; the struggle and the agony are all too painfully apparent. Yet while the body seems trapped within the crisscross structure of charred wood, there is no trapping of the nonphysical component of this transcendent being.

In addition to the series of saints, Kopriva has taken up other Catholic themes. *The Confessional* (fig. 33) contains an elaborate ensemble with three seated figures. Looking as though they were just recently exhumed, the figures are united physically in a warmly illuminated, tripartite confessional. A somewhat mysterious atmosphere, made more dramatic by the light shimmering behind the veil drawn across the front, reveals the priest listening to the transgressions of one fragile, kneeling supplicant, while the other patiently awaits her turn. Despite the somber look of the shriveled figures and the animal skulls above the openings, Kopriva's subtle use of lighting bathes the piece in an appealing, enchanted glow. Reality, remembrance, and imagination converge to challenge our fixed notions of the "here" in contrast to the hereafter.

Fig. 31. Sharon Kopriva
The Bad, Ugly, Proud, and Disconcerned
1984, oil and mixed media on canvas, 182.9 x 304.8 cm (72 x 120 in.). Collection of Allan Stone, New York
(opposite)

Fig. 32. Sharon Kopriva
Joan of Arc
1989, papier-mâché, bone, wood, cloth, mixed media, 160 x 76.2 x 35.6 cm (63 x 30 x 14 in.). The Menil Collection, Houston
(below)

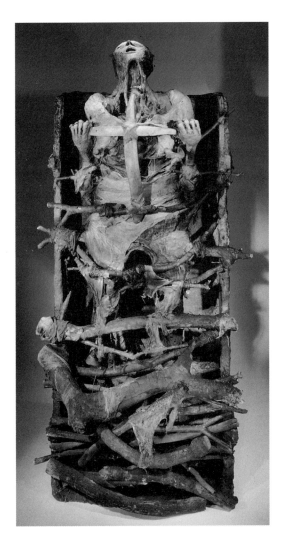

Fig. 33. Sharon Kopriva
The Confessional
1992, wood, papier-
mâché, fiberglass, paint,
cloth, bone, mixed
media, 213.4 x 243.8
x 91.4 cm (84 x 96
x 36 in.). Edmund
Pillsbury Collection,
Fort Worth
(right)

Fig. 34. Sharon Kopriva
In Excelsis Deo
1994, piano, papier-
mâché, cloth, paint,
bone, mixed media,
147.3 x 152.4
x 154.9 cm (58 x 60
x 61 in.). Courtesy
the artist
(opposite)

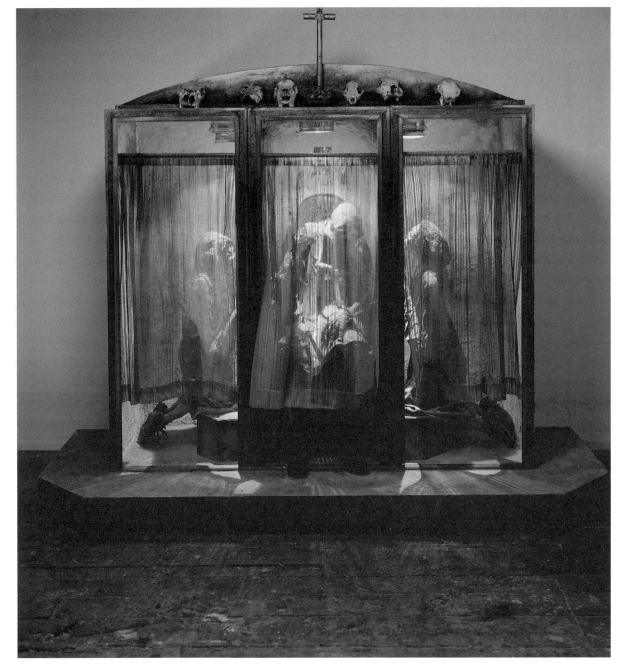

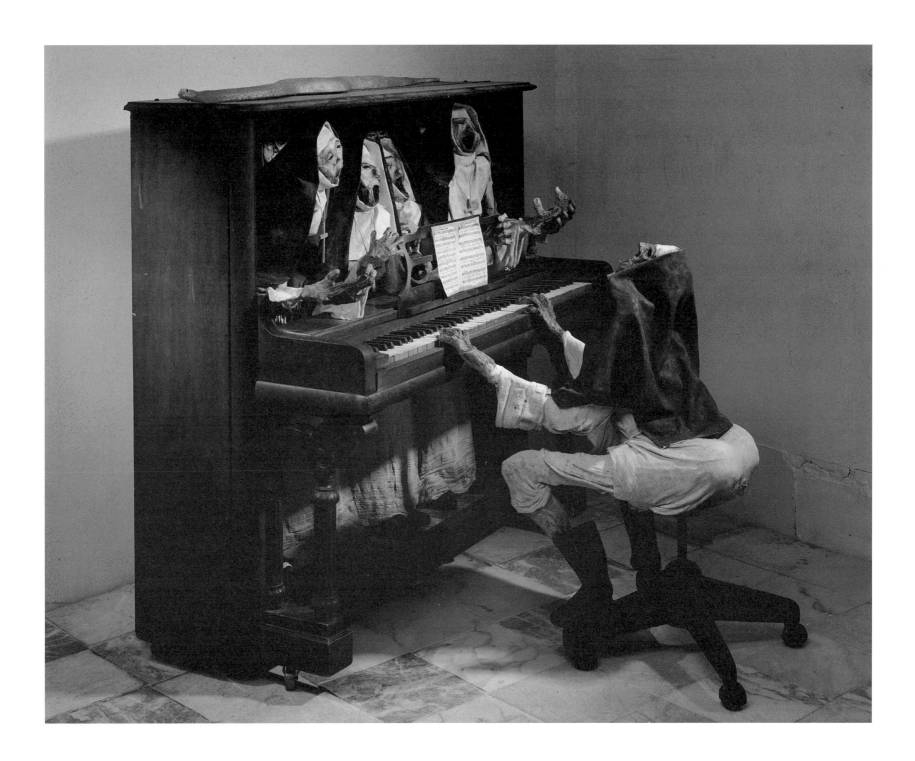

Still drawing from her Catholic girlhood, Kopriva has found humor as well as seriousness in her religious experiences. The warmth, affection, and nostalgia evoked by the poignant *Bench of Nuns* (1991), cuddly *Sister Solitaire* (1993), and the nuns in *In Excelsis Deo* (fig. 34) who serenade us from inside the piano—all mummies and all on the petite side of the human scale, elaborately outfitted in traditional habits that are rarely seen these days—charm and disarm us by their matter-of-fact accommodation with the inevitability of their mortality and physical decay.

Although Catholicism is never far from Kopriva's consciousness, much of her work derives from her knowledge of and fascination with other religious traditions. But her work is not so much informed by that knowlege as validated by it. The effect of sculptures such as *Buck* (1989), *Primogenitur* (1992), and *Horned Ceremony* (fig. 35) depends upon a collective "memory" of a prehistoric time and rituals that marked the close identification of human life with other living forms.

In "Kaleidoscope," Kopriva is represented by her masterpiece in this genre, titled *Rite of Passage* (fig. 30). A standing oarsman cloaked in gauzelike drapery steers a long, narrow vessel, aged by time and the elements. His three passengers calmly await their destination in purposeful resignation. Although the boat seems heavy with the gravity of its voyage, it is fabricated in wood of an almost ethereal lightness. Held aloft by an airy base embellished with fishnet material, it seems to glide along weightlessly. Most suggestive perhaps of the Greek and Roman mythology that describes an aqueous passage from life to the underworld of death, it is also indebted in its inspiration to elements of Egyptian theology and the religious philosophy of the ancient native cultures of Peru. It undoubtedly also resonates with similar metaphors to be found in religious traditions of many other peoples.[8]

According to the Roman poet Virgil, the path to

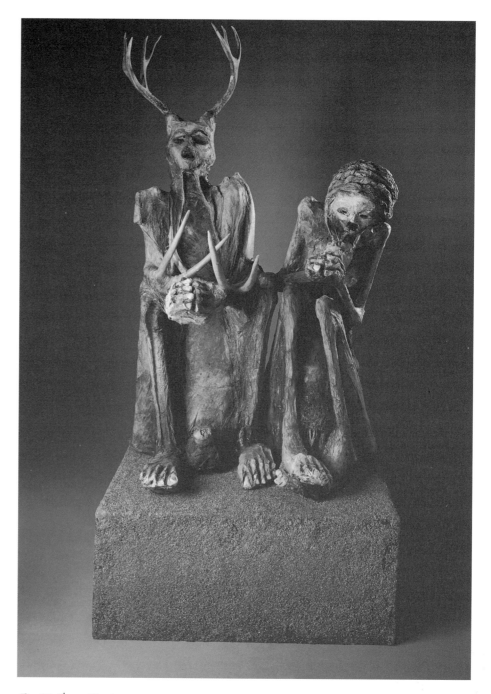

Fig. 35. Sharon Kopriva
Horned Ceremony
1994, papier-mâché, bone, mixed media, 127 x 76.2 x 91.4 cm (50 x 30 x 36 in.). Courtesy the artist

the underworld "leads to where Acheron, the river of woe, pours into Cocytus, the river of lamentation. An aged boatman named Charon ferries the souls of the dead across the water to the farther bank, where stands the adamantine gate to Tartarus [the lower division of the underworld]."[9] In the modern European tradition, Dante's voyage across the Stygian Marsh in *The Divine Comedy* and Richard Wagner's dramatization of a Nordic legend in his opera *The Flying Dutchman* offer other paradigmatic narratives of death and deliverance in which the transitional state is symbolized by a water passage.

In the Egyptian context, Kopriva may have thought of the boat made of papyrus reed used by the goddess Isis to travel through Egypt in search of the scattered body parts of her husband, Osiris.[10] Osiris is ultimately resurrected and, for thousands of years, worshipers believed he would bring them eternal life, not so much in a physical form but in a spiritual one.[11] Osiris's murderer, his brother Seth, is transformed into the boat that carries the resurrected Osiris along the Nile.[12] In later Egyptian times, worship of Osiris was largely replaced by worship of Amen-Ra, who sailed the sky in a boat. Moreover, according to the lore surrounding the death and salvation of the Pharaoh, the transformation involved a boat trip conducted by a ferryman "who had the power of a judge." His passage was assured only if he could answer the ferryman's ritual questions correctly.[13]

The figures in *Rite of Passage*, however, derive not from Egyptian mummies, but from human remains found in the ancient burial grounds of Peru, near Cuzco. Speaking of the natural, unwrapped mummies, Kopriva says, "[They] were beautiful. They weren't frightening. But they make you think of your own mortality."[14] In our time, when youth means everything and rock stars plan to freeze their bodies for revival at a time of more advanced medical knowledge, it is reassuring to contemplate our fate in more poetic and metaphysical terms. *Rite of Passage* makes a universal statement grounded in our feelings and instincts for the rituals of the past. We are invited to see our physical and spiritual selves as part of the cycle of human history and to trust to the imagination—or to our own religious faith—the rite of passage that will link us to the larger cycle of nature.

Jacquelyn Days Serwer

Notes

1. Sharon Kopriva, quoted in Betty Ann Brown and Arlene Raven, *Exposures: Women & Their Art* (Pasadena: New Sage Press, 1990), 70.
2. Artist's statement in Susie Kalil and Barbara Rose, *Fresh Paint: The Houston School* (Houston: Museum of Fine Arts, Houston, 1985), 144.
3. See Kopriva's statement in Kalil and Rose, *Fresh Paint*, 144, where she describes her Catholic orientation: "A firm Catholic background during my early youth had specific influences on my life. During my mandatory service in the church youth choir, our group buried enough people that I am able to this day to recite most of the Latin requiem mass from memory."
4. Ibid., 144.
5. David Bell, "Empowering Painting at the Santa Fe Museum of Fine Arts," *Art in America* (January 1987): 145.
6. Donna Tenant, "Reviews: Sharon Kopriva at Graham Gallery, Houston," *Artspace* (Fall 1986): 45.
7. Felix Sanchez, "'Mummy' Unwinds at Morgue," *Houston Post*, 15 March 1990, 1.
8. See Mircea Eliade, *A History of Religious Ideas* (Chicago: University of Chicago Press, 1978), vol. I, 79, for a description of the Mesopotamian hero Gilgamesh and his boat trip across the Waters of Death.
9. Edith Hamilton, *Mythology: Timeless Tales of Gods and Heroes* (New York: New American Library, 1942), 39.
10. See W. A. Wallis Budge, *Egyptian Religion* (London and New York: Arkana, 1987), 52.
11. Ibid., p. 79.
12. Eliade, *A History of Religious Ideas*, 97.
13. Ibid., 95–96.
14. Patricia Covo Johnson, "The Art of Being Contemporary, *Texas*, 13 November 1994, 9.

Jaune Quick-to-See Smith

ONCE MY PAINTINGS GET STARTED AND THEY START ROLLING THEY TAKE ON A LIFE OF THEIR OWN, AND OFTEN THAT'S THE WAY THINGS TAKE PLACE. THEY COME FROM SOME MYSTERIOUS PLACE WITHIN.[1]

Statements like the one above are relatively uncommon in the large and ever-increasing body of literature on Jaune Quick-to-See Smith. Much has been written by critics and art historians about the artist and her work, but, in the main, Smith prefers not to say much herself. A talented and sought-after public speaker, she prefers to devote her presentations and more informal discussions to political activism, broader historical concerns, and the art of her Native American colleagues.

Over the course of her career Smith has founded two artists' groups, the Coup Marks Coop and Grey Canyon Artists, and curated numerous exhibitions, including "Our Land/Ourselves" (1991) and "We the Human Beings" (1992–93), organized respectively by the University Art Gallery, State University of New York, Albany, and the College of Wooster Art Museum in Wooster, Ohio. She has acted as spokesperson and historian for Indian artists she believes are underrecognized and often marginalized. She also educates and politically activates communities by lecturing about art and organizing related events at the grass-roots level, in schools, universities, and museums throughout the country. Motivating and unifying most of her efforts is an overriding concern for the deterioration of the environment and the preservation of Native American cultures. Smith has been a longtime activist against industrial-ecological abuse, as well as commercial disregard for, and historical and contemporary misrepresentations of, Native American identities.

However, it is Smith's artistic effort that promises to be most enduring and efficacious. It appeals to audiences from the Flathead Reservation in Montana, where she is a registered member, to museums and art galleries in metropolitan centers across the United States. Through her prints, drawings, mixed-media collages, and paintings, Smith parlays her need to speak out against basic injustice into aesthetic experiences that raise the consciousness of others.

Fig. 36. Jaune Quick-to-See Smith
Trade (gifts for trading land with white people)
1992, oil, collage, mixed media on canvas with objects, triptych, 152.4 x 431.8 cm (60 x 170 in.). The Chrysler Museum, Norfolk, Virginia, Museum purchase

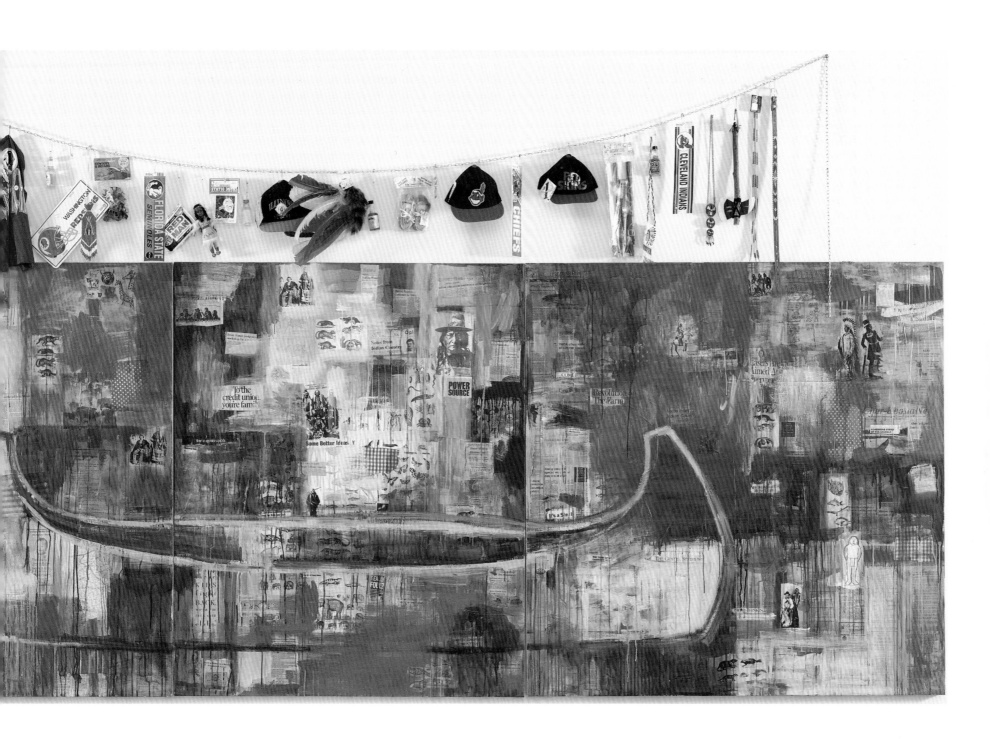

According to curator Trinkett Clark, Smith is "a harbinger, a mediator and a bridge builder."[2] In a 1992 interview with Clark, the artist stated, "I go from one community with messages to the other and I try to teach and enlighten people. My paintings and drawings are part of the conduit. They are my voice."[3] In a contemporary art world rife with petty squabbles, economic and political misgivings, Smith is a healing presence. Even though her work has been steadily acquired by private collectors and public institutions since the early 1970s, and even though much of her earnings is given to social causes, educational projects, and Indian reservations, she staunchly opposes steep increases in her art prices. Her tempered interest in economic advancement and the shrewd dealings of the art world, however, are the most basic and easily measured of her virtues. By confronting head-on violence against the natural world, the government's oppression of its Native American cultures, and the pervasive myths that shape notions of American cultural identity as a whole, Smith deals in facts that cut across race, gender, class, and geographical differences. Her bold messages are always pressing, always prescient—and she never fails to convey them in a uniquely expressive manner that consistently is reinvented for the specific task at hand.

Smith was originally trained in the late 1950s as an Abstract Expressionist, a style often extolled for its unwavering pursuit of the existential self. Since that time, she has been cultivating more apposite means for articulating the fullness of her life's experiences, without sacrificing the needs of the world and the people who have made them so richly rewarding. The irony of having transformed an ostensibly self-centered style of painting into one that emphatically transcends the illusion of the artist as autonomous and isolated should not be underemphasized. Smith has the rare ability to see the big picture, to conceive of herself and her place within the world's various social, political, and environmental matrixes, holistically.

"We are a part of the earth and it is a part of us."[4]

This quotation is from an 1854 speech by Chief Seattle, the Duwamish tribe leader who was forced to negotiate the Port Elliott Treaty of 1855 that sold to the U.S. government native claims to northwestern ancestral territory. In his speech, which has been a perennial source of inspiration for Smith, Seattle warned Native Americans and Westerners alike against Euro-American belief systems that ignore the plenitude and inherent value of undisturbed nature.[5] Smith's 1990 "Chief Seattle" series, with each work signed "CS 1854," is a homage to the man who, in return for the notorious sale, was promised protection for his tribal people on reservations.

One work from the series, *Cornfield*, condemns commercial disregard for nature by means of an aesthetic that prompts viewers to envision spiritual strength beyond the deplorable physical abuse (fig. 39). The image of a cornfield, rich with greens and yellows, and the hingeless door on which it is painted together invoke a conceptual dissonance. The tension caused by the juxtaposition of the mass-produced architectural element and the romanticized, painterly vision offers viewers the possibility of transport beyond the basics of a door and a cornfield. For Smith,

Fig. 37. Jaune Quick-to-See Smith
Genesis
1993, oil, collage, mixed media on canvas, diptych, 152.4 x 254 cm (60 x 100 in.). High Museum of Art, Atlanta, Georgia, Purchase through funds provided by AT&T NEW ART/NEW VISIONS with funds from Alfred Austell Thornton in memory of Leila Austell Thornton and Albert Edward Thornton, Sr., and Sarah Miller Venable and William Hoyt Venable, 1995.54. Courtesy Steinbaum Krauss Gallery, New York

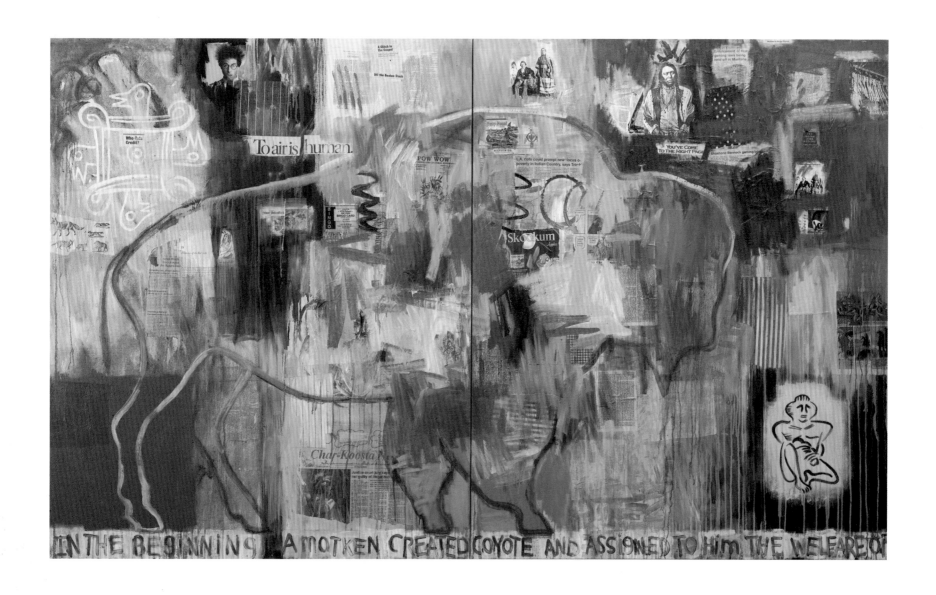

undisturbed nature is not only a perfect, complete end in itself, but a means to greater spiritual understanding. By contemplating what is represented on the surface of the portal, viewers may discover a metaphorical way through to the other side, that is, a way of gaining insight into the natural mysteries they hold dear and integral to their being.

Corn, or maize—central to many Native Americans' diets and rituals—holds specific value for Smith as a spiritual metaphor. In a separate panel installed to the left of the cornfield-painted door the artist presents aggressively overpainted Cracker Jack boxes. In relation to the cornfield, these boxes—erstwhile containers of thoroughly processed corn-type candy food—are objects of disdain. Like the detached door, they are symbols of waste produced by a throwaway culture. Profound as the content may be, it is the work's formal apparatus, the way in which it locates value in industrial waste, that achieves its spiritual resonance. The artist redeems exactly that which offends her, exhibiting a rare insight and generosity.

Smith has been influenced not only by the inwardly focused members of the New York School, but also by artists who have bridged what is frequently construed as the gap between the world of art and the world outside. Like Robert Rauschenberg and Kurt Schwitters, Smith culls litter from her backyard and the streets of places she frequents, incorporating it into her work. Often she clips articles and photographs from newspapers and periodicals—slices of life that serve as literal and material

48

springboards for incantations to a spiritualized ecosystem of which human beings are but a small part.

The two large paintings exhibited in "American Kaleidoscope," *Trade (gifts for trading land with white people)* and *Genesis* (figs. 36 and 37), exemplify Smith's technique of using found elements, as well as her most recently evolved style of painting. Both of these mixed-media canvases start with a collage of neutral, polka-dot, checked and striped fabrics, newspaper clippings from her reservation's weekly, the *Char-Koosta News,* and other periodicals, photocopies from various textbooks, and even road maps (fig. 38). She then compositionally unifies the various decorative and informational collage elements by improvisational overpainting.

Smith's work has always been about the land; her paintings have always been landscapes:

> I think of my work as an inhabited landscape, never static or empty. Euro-Americans see broad expanses of land as vast, empty spaces. Indian people see all land as a living entity. The wind ruffles; ants crawl; a rabbit burrows. I've been working with that idea for probably twenty years now.[6]

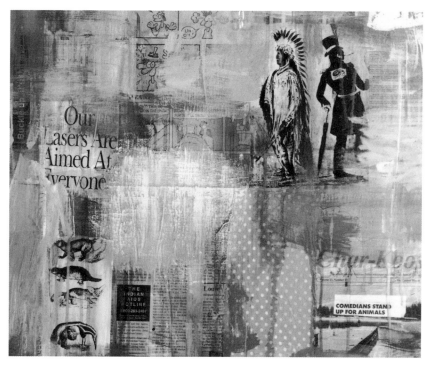

Because of their journalistic and painterly attributes, one could fairly describe *Trade* and *Genesis* as literal abstractions. But the expectations caused by naming them "landscapes" or, as critic Lucy Lippard has written about other works by Smith, "narrative landscapes" are central to their overall significance.[7] In *Mixed Blessings,* Lippard writes that "the stories hidden within [Smith's paintings] are visible only to those who know how to see the life in the arid 'empty' landscape itself."[8] In effect, by employing newspaper clippings, Smith facilitates the discovery of these stories and, consequently, the revelation of the land. She helps us to understand both the value of her culture *and* our shared world.

When confronted with Smith's abstractions, the viewer can satisfy the expectations associated with more typical landscape painting by changing how he or she perceives rather than what is being perceived. The life of the land is manifest in everything, from rocks to foliage to the animals and people that roam its surface. Learning to value these things as integral parts of the whole without feeling the need to build upon, develop, or annihilate them is a matter of shifting one's cultural perspective. Smith's self-appointed task is to create visual and conceptual links between what Euro-Americans initially fail to see in the land and what the land has always been and needs to be if all the earth's inhabitants are to survive. It is a matter of learning to understand the world with the help of Native American perspicacity.

In *Trade,* one literally can read about everything from shawl-making classes to stories of toxic contaminants and bacteria affecting the local environment. There is a flyer for the "2nd

Fig. 38. Jaune Quick-to-See Smith
Trade (gifts for trading land with white people)
(upper right detail)
1992, oil, collage, mixed media on canvas with objects, triptych, 152.4 x 431.8 cm (60 x 170 in.). The Chrysler Museum, Norfolk, Virginia, Museum purchase

Fig. 39. Jaune Quick-to-See Smith
Cornfield
1990, oil on canvas, wood, mixed media, 203.2 x 91.4 cm (80 x 36 in.). Private collection. Courtesy Steinbaum Krauss Gallery, New York
(opposite)

Annual Flathead Reservation Culture Fair," as well as cartoon images of Mickey and Minnie Mouse, Charlie Brown, and Garfield the cat. Smith incorporates photocopies of animals, fish, and reptiles taken from wildlife textbooks; they are perhaps creatures she sees from her window or those whose living habits she can witness only on television. One newspaper clipping dated 7 February 1992 lists "what's happenin'" locally; another tells us of the Indian Education Institute at the University of Montana. These, as one column heading declares, are "Notes from Indian Country."

Consisting of newspaper articles overlaying fabric swatches overlaying photocopied illustrations, *Trade* and *Genesis* evoke the complexity of a palimpsest, the earlier manuscripts of which were never erased. With the passage of time in the studio, alluded to by the drips of paint that run down the surface of the canvas, collage elements and paint occlude underlayers of narrative and landscape. Only glimpses of the paintings' pasts—literally and figuratively—show through. *Genesis* and *Trade* help us to reflect upon the spiritual and life-affirming constancy of the land. They also, like the earth itself, with its layers of geological time, and its civilizations built upon civilizations, are examples of that continuum.

In the center of both *Trade* and *Genesis,* Smith offers for consideration a single icon of the mythical American frontier. In *Trade,* the artist depicts a canoe; in *Genesis,* a buffalo. Like the corn in *Cornfield,* the canoe and buffalo hold symbolic and spiritual meanings. From a sympathetic point of view, they project a static, monumental significance, evocative of the awesome power of nature and those who live in harmony with it. However, within the purview of America's late-capitalist society these iconic outlines suggest shifting, ambivalent meanings. Just as the canoe and buffalo can be construed as potential gateways, windows of opportunity that propose a reevaluation of standard conceptions of culture and American society, they are suggestive of commercialization and the general disregard for Native American identity motivated by chauvinism and economic advancement. Like the plastic-beaded tomahawk that hangs from the chain suspended above *Trade,* the buffalo and canoe represent stereotypes of Indian culture. They are simultaneously monuments to Native American heritages and signs of a consumer culture that colonizes, stereotypes, and destroys.

Smith addresses the more sinister aspects of the historical barter deals invoked by *Trade* by including one-ounce bottles of liquor in the hanging array of toys, plastic knickknacks, and bumper stickers—small reminders of a U.S. government that profited from substance abuse and addiction. We have only to look at the pasted-on reproduction of George Catlin's *Pigeon's Egg Head (The Light) going to and returning from Washington,* a painting in the collection of the National

Fig. 40. George Catlin
Pigeon's Egg Head (The Light) going to and returning from Washington
1837–39, oil on canvas, 73.7 x 61 cm (29 x 24 in.). National Museum of American Art, Smithsonian Institution. Gift of Mrs. Joseph Harrison, Jr.

Museum of American Art, to see a nineteenth-century view of an Indian, impressed with the souvenirs of his trip to Washington, returning home with bottles of alcohol in his pockets (figs. 38, 40). Smith forges a connection between historical and modern-day representations of Native Americans. The cheap toys suspended above the painting help to realize this unity of form and content, making *Trade* poignant on many levels for viewers of diverse backgrounds.

According to the artist, the nimble play with words and images demonstrated in works like *Trade* and *Genesis* is the result of "a coyote sense of humor."[9] Like the mythic cultural figures *Esu-Elegbara* of the Yoruba, *Echu-Elegua* of Cuba, and the Signifying Monkey of African Americans, the Coyote is the Native American trickster figure.[10] In *Genesis*, Smith introduces viewers to Coyote, not only the coy magician of the Native American imagination but also the creator of her tribe. Her rendition of the Native American creation myth includes at the bottom of the canvas the statement "In the beginning Amotken created Coyote and assigned to him the welfare of," an open-ended verbal analogue of her visual imagery that constantly shifts in meaning.

However, it is in *Trade* that Coyote's cleverness is most outspoken. According to the artist, *Trade* may carry "a load of serious information," but it also makes its point with humor.[11] The plastic-beaded belts and tomahawks, the sports souvenirs of the Washington Redskins, Cleveland Indians, and Florida State Seminoles, and the cowboys-and-Indians toy doll set are trinkets Smith would like to offer back to white people for the land Indians once traded away. Lighthearted in nature, her critique of Indian stereotypes and consumerist abuse is nonetheless thoroughgoing and effective. *Trade* reminds us that no cultural group is so commonly mocked in professional and college sports arenas as Native Americans.

The various gifts for trading with white people imply the "same old deal . . . but with a 'coyote backtwist.'"[12] Explaining the mechanics of such a backtwist, Smith once declared, "I love taking what the white community does or says and then recreating it and giving it a whole new meaning—that's Indian humor when you turn it around."[13] In fact, Smith prefers humor: "I think people often can hear a message with humor much easier than with bitterness."[14]

Jonathan P. Binstock

Notes

1. Jaune Quick-to-See Smith, conversation with the author, 9 May 1996.
2. Trinkett Clark, *Parameters #9: Jaune Quick-to-See Smith* (Norfolk: Chrysler Museum, 1993), n.p.
3. Ibid., quoted in Rebecca Dimling Cochran, *Art at the Edge: Social Turf* (Atlanta: High Museum of Art, 1995), n.p.
4. Chief Seattle, quoted by Robert Houle, "Sovereignty over Subjectivity," *C* 30 (Summer 1991): 33.
5. There is controversy over the actual authorship of this speech. See Eli Gifford and R. Michael Cook, eds., *How Can One Sell the Air: Chief Seattle's Vision* (Summertown, Tenn.: Book Publishing Company, 1992), 25.
6. Smith, quoted in Clark, *Parameters*, n.p.
7. Lucy Lippard, *Mixed Blessings: New Art in a Multicultural America* (New York: Pantheon Books, 1990), 113.
8. Ibid.
9. Teresa Annas, "Native American artist's works deliver a message—with humor," *Virginian Pilot*, 14 January 1993, B1.
10. For a discussion of the mythical trickster figure in these and other cultures, see Henry Louis Gates, Jr., *The Signifying Monkey: A Theory of African-American Literary Criticism* (New York: Oxford University Press, 1988).
11. Smith, quoted in Clark, *Parameters*, n.p.
12. Annas, "Native American artist's works," B1.
13. Smith, unpublished interview with Trinkett Clark, 9 October 1992.
14. Smith, quoted in Annas, "Native American artist's works," B1.

Renée Stout

I AM TRYING TO CREATE ART THAT HELPS ME PUT TOGETHER WHAT ARE ONLY FRAGMENTS, TO TRY TO CREATE A WHOLE, SO THAT I CAN GAIN A BETTER UNDERSTANDING OF MY OWN EXISTENCE. IN DOING THIS, I HOPE THAT OTHERS, NO MATTER WHERE THEY COME FROM, WILL REALIZE SOME ANSWERS ABOUT THEIR OWN EXISTENCE.[1]

In pragmatic and symbolic terms, a saying among the Yoruba people of Nigeria—"A person uses his hands to repair [create] himself"—invokes their belief in the relationship between individual responsibility and creativity.[2] Similarly, African-American sculptor Renée Stout has embraced the mystery and revelation of identity as her goal. Stout's approach is neither ideological nor literal, for she prefers to walk a tightrope, whether between memory and experience, observation and interpretation, or reality and allusion.

Just as a tightrope implies states of balance and tension, so, too, do the choices that have historically confronted African Americans in the literary, performing, and visual arts. Does one address Afrocentric resources exclusively, embrace universal issues, pursue largely Eurocentric aesthetic goals, or strive, dauntingly, for a resonant synthesis? Whatever their decision, African-American artists have consistently affirmed the dynamic between tradition and innovation as the wellspring of their resourceful creativity, a concept that has driven interpretations of community survival and singular achievement in their culture and history. Believing in the authenticity of personal experience, they have also claimed the right to determine their self-image as artists and individuals. The currency of these concerns has intensified rather than diminished for Stout and other young African-American artists, whose emerging efforts in the 1980s coincided with the advent of multiculturalism, as well as the electronic era's impetus toward a "virtual," rather than experience-based, reality.

Stout's earliest exposure to creativity occurred as she grew up in a black working-class neighborhood in Pittsburgh during the 1960s and 1970s. Lessons in how to "make do" and "create something from nothing" abounded in her family. Her mother's sewing, her father's mechanical abilities and penchant for collecting, a grandmother's flair for decorating, and an uncle's passion for painting and drawing all produced "wondrous results."[3] Complete with improvised scarecrows, dolls, and stuffed animals, the decorated front yard of an African-American woman in Stout's neighborhood made an indelible impression. So, too, did an

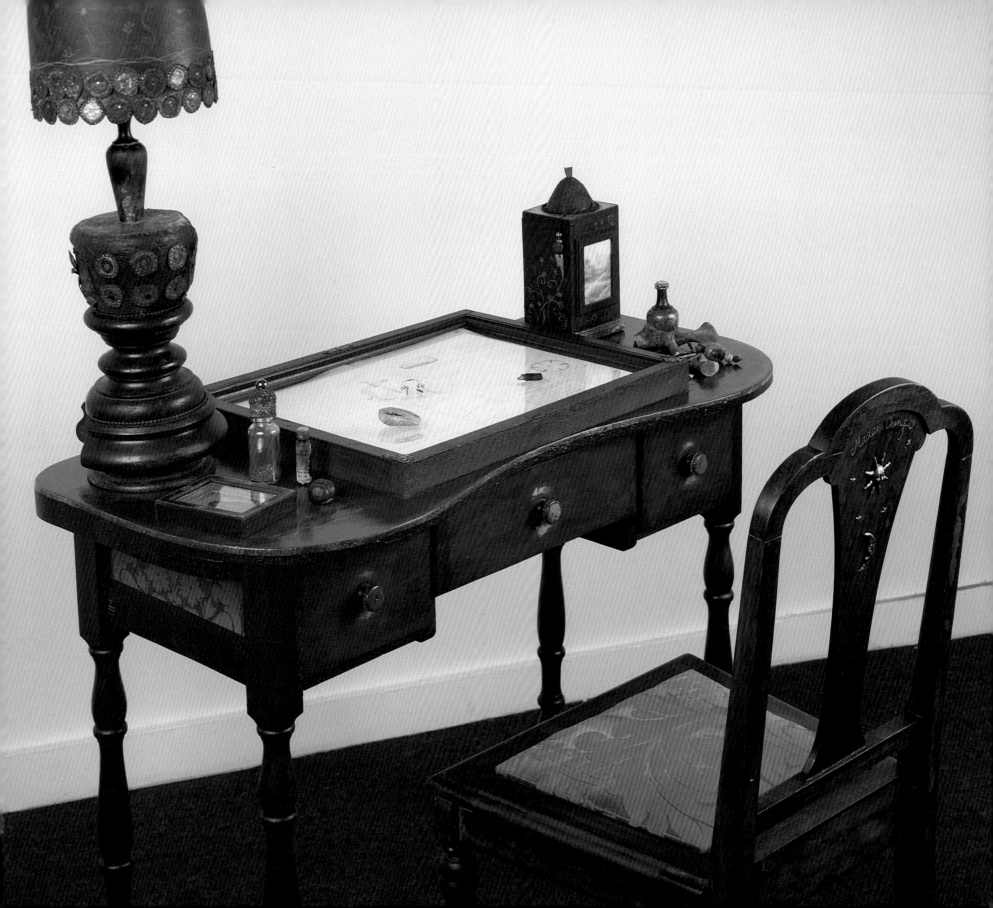

imposing Central African *nkisi nkondi* figure that she encountered while taking art lessons at the Carnegie Museum at the age of ten.[4]

Such experiences introduced Stout to her ancestry in ways that would later prove influential. In the early 1980s, however, the initial fruits of her adult training as a painter—realist scenes inspired by Pittsburgh's streets and painters such as Edward Hopper and Robert Estes—showed little evidence of their impact. In 1984 Stout's interest in painting declined considerably during an artist's residency in Boston. Separated from her closely knit family for the first time, she was particularly sensitive to the city's serious homeless problem and became increasingly introspective in response to an environment that she found unfriendly and even cruel. Stout began scavenging materials from the streets and working more three-dimensionally. Struck by Boston's abundance of palm readers, she also incorporated her earliest references to spiritualism and palmistry in order to suggest that finding outlets for hope empowers people to change their circumstances. This marked shift in Stout's work provided the first glimpse of her intuitive drive to heal and transform in artistic and spiritual terms.

After moving to Washington, D.C., in 1985, Stout completed the transition from painting to sculpture. Two years later, as she began making a series of mixed-media "fetishes," her interest in agents of power and magic had clearly incited Stout to explore artistic traditions and belief systems that originated in Africa and were often transformed in the Americas. Above all, she responded to the African understanding of art as a social practice embracing decoration, philosophy, religion, and medicine. Specifically, her childhood memory of a *nkisi nkondi* "nail fetish" figure led her to Kongo "power objects" called *minkisi*.[5]

These objects have been made for practical and spiritual purposes—to heal physical and personal problems, to mediate between people and spirits good and bad, to effect change and invoke responses positive and negative. Whether in figurative or nonfigurative form, *minkisi* incorporate materials considered medicinal because their properties are valued symbolically rather than literally. Carved or bundled, knotted or nailed, each *nkisi* represents a contained force believed capable of initiating or solving a particular condition.

Created over a period of three years, Stout's "Fetish" series evokes this sense of contained forces. Examples such as *Fetish #4* (fig. 42) are neither literal reproductions nor ethnographic reclamations of the ritualistic icons that inspired her.[6] Unlike the makers of *minkisi* who proceeded according to communal norms, Stout personalizes her intuitive combinations of forms and materials, always conscious that "it can be really hard to make the wood, the glass, the paint say it exactly the same way I'm seeing it in my head and feeling it in my heart. Sometimes a little can get lost in the translation."[7]

What has not gotten lost in the translation, however, is the equivalence that the artist grants to people and objects as gateways to her ancestry and mediators between past and

Fig. 42. Renée Stout
Fetish #4
1989, dirt, hair, paper, pigment, fiber bags, wood, glass beads, feathers, 50.8 x 30.5 x 15.2 cm (20 x 12 x 6 in.). Collection of Lee Fleming. Destroyed by fire 1994 (above)

Fig. 43. Renée Stout
She Kept Her Conjuring Table Very Neat
1990, found and handmade objects, 73.7 x 121.9 x 22.9 cm (29 x 48 x 9 in.). Collection of Dr. Regenia A. Perry
(opposite)

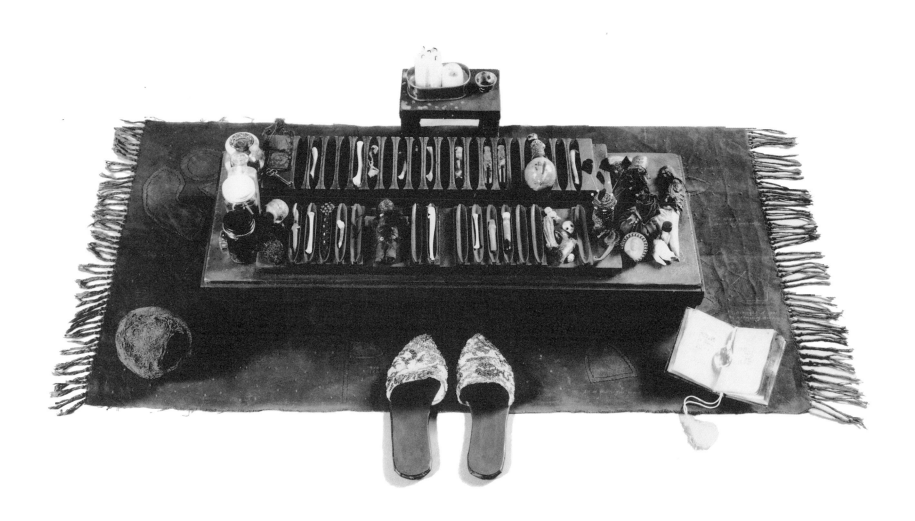

present. An assembly of medicine pouches crowned by a headdress of feathers and hair, *Fetish #4* celebrates her maternal grandmother, whose death in 1989 represented a turning point in her appreciation of family and ancestors. According to Stout, her grandmother had "this feather duster I used to like when I was little, and it had a gold painted bamboo handle on it. And, where the feathers are attached, it had rhinestones and fake pearls all around it with these bright red feathers coming out, and it always seemed like a magic wand to me. . . . Early on when she was raising her children, she had to clean houses. . . . When I thought about this and I made this connection about this feather duster and the fact that she had to clean people's houses, I . . . made the top of the head look like a feather duster, but I saw her as wearing a crown. Because even in that, she had so much dignity."[8]

In such a work, the act of conjuring comes to mind as readily as the desire to memorialize. It is not just her grandmother's spirit but her own grief and admiration of a beloved family member that Stout has tried to capture and release in *Fetish #4*. That she attaches considerable significance to conjuring as a healing ritual is made explicit in the assemblage *She Kept Her Conjuring Table Very Neat* (fig. 43). Central to the African-derived religious systems of Haitian vodou and North American hoodoo, conjuring relies not just on charms, medicines, divination, and incantations, but on a conjurer's knowledge and guidance and a follower's faith. Summoning positive changes in human relationships, especially in the areas of health, work, love, and family life, is the goal.

Stout has not been unduly shy about the potential she grants herself as a woman and an artist, having incorporated, for example, a full cast of her body in one of her most important works, *Fetish #2* of 1988. Certainly, she has embraced the inspirational, empowering functions of a conjurer in her transformation of materials and interpretation of ideas and feelings. Stout's sense of theater and performance, however, is equally strong. In world traveler Colonel Frank, his back-home lover Dorothy, an old fortune-teller and rootworker Madam Ching, and the early-twentieth-century blues singer Robert Johnson, the artist has developed a select group of characters as kindred spirits or foils through whom she reveals her efforts to understand how she relates to other people and the world. The lives of these characters unfold in complex, interrelated narratives that Stout embeds in discrete objects, tableaux, and room-size installations.

Is Dorothy, the owner of the very neat conjuring table, about to step into her beautiful beaded slippers or has she just slipped them off? Has she conjured one of her love spells to keep Colonel Frank home with her or are we waiting for her to begin working with her roots, herbs, and talismans? Stout invites our curiosity and participation as members of an audience drawn in by a tantalizingly intimate array of objects. Our powers of observation and belief in magical properties are tested as we try to sort out actual found objects from those crafted by Stout to

Fig. 44. Renée Stout
drawing for **The Colonel's Cabinet**
1994, ink on paper, 21.7 x 28 cm (8½ x 11 in.). National Museum of American Art, Smithsonian Institution, Museum purchase made possible by Ralph Cross Johnson (above)

Fig. 45. Renée Stout
The Colonel's Cabinet
1991–94, found and handmade objects, overall dimensions: 171.5 x 152.4 x 128.3 cm (67½ x 60 x 50½ in.). National Museum of American Art, Smithsonian Institution, Museum purchase made possible by Ralph Cross Johnson (opposite)

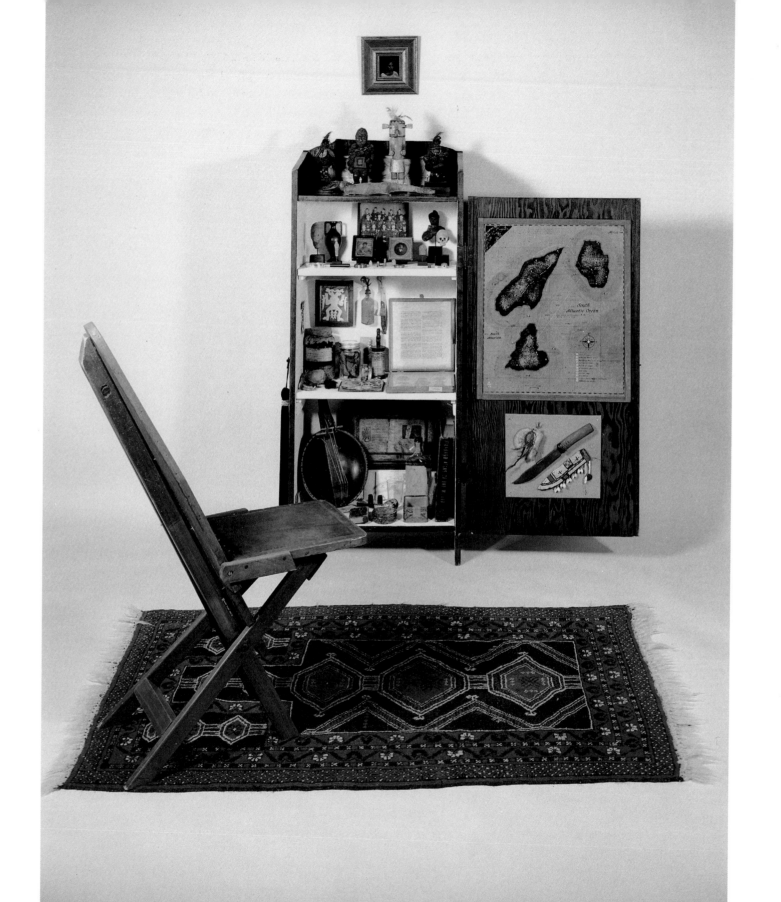

look like preexisting everyday and exotic objects from still others that she has found and subsequently reworked.

While Dorothy patiently awaits Colonel Frank's return, he faithfully sends her artifacts and souvenirs from his farflung travels for display in *The Colonel's Cabinet* (figs. 44, 45). In actuality, the personal effects of Frank Davis, an acquaintance's deceased uncle who had once done military service, inspired Stout to create a reliquary devoted to relationships and self-awareness. The introverted Dorothy is based on Stout's mother; the gregarious colonel invokes her father. Just as her father brought the world to her mother, Colonel Frank, through his explorations, brings the world to Dorothy. The colonel also embodies the artist's admiration for Robert Farris Thompson, whose ambitious intellectual travels on behalf of African, Afro-Caribbean, and African-American art have greatly advanced understanding of cross-cultural expression. Further, the colonel represents Stout herself, gathering the fragments that make up her history and heritage to sharpen her sense of identity on personal and cultural levels.

Inside the cabinet are samples of a secret language that Colonel Frank has gathered from an imaginary island's natives, Dorothy's ancestors. The same language appears in the book of spells accompanying Dorothy's conjuring table, handed down to her by her grandmother Madam Ching. In turn, Madam uses the language on the cards of her *Old Fortune Teller's Board* (fig. 47). She, too, is only semifictional, based on an old woman who advertised as Madam Ching in Stout's Pittsburgh neighborhood; the probability that she was a fortune-teller and rootworker is rather high in the artist's estimation. Relating to African traditions of divination,

Fig. 46. Renée Stout
Madam's Desk (detail)
1995, acrylic on synthetic gold leaf on wood, 11.8 x 9.2 x 2.2 cm (4⅝ x 3⅝ x ⅞ in.). Courtesy the artist and David Adamson Gallery, Washington, D.C.
(above left)

Fig. 47. Renée Stout
The Old Fortune Teller's Board from the installation *Madam Ching's Parlor*
1993, painted wood, watercolor and ink on paper, glass, mudfish bones, and leather, 10.2 x 60.6 x 59.4 cm (4 x 23⅞ x 23⅜ in.). National Museum of American Art, Smithsonian Institution, Museum purchase made possible by Ralph Cross Johnson and Mrs. William Rhinelander Stewart
(above right)

Board also evokes tarot cards, the *I Ching*, and Haitian folk religion. In designing an antiqued map in trompe l'oeil for the work, Stout pays homage as well to American artist Joseph Cornell, who once asserted that his poetic assemblages of found objects invoked "white magic" rather than the "black" magic he associated with Surrealism during the 1930s and 1940s.[9]

Since 1994 Stout's identification with the old fortune-teller has become so strong that she has created a room-size installation of magical, even romantic, constructions that comprise *Madam Ching's Museum of Love*. Among its components is *Madam's Desk* (figs. 23, 41, 46), which is also part of the installation *Madam Ching's Parlor*. Standing in front of it, we become the client petitioning the fortune-teller for help in matters of love—increasingly Ching's, and by extension, Stout's, preoccupation. Standing behind the desk or imagining taking a seat, we become the diviner or conjurer ready to listen and advise before dispensing a potion or a shaving of High John the Conqueror Root. Incorporating appointments, accounts, notes, and drawings, the desktop ledger blurs the distinction between the fortune-teller and the artist, whose diaristic writing and sketchbooks elaborate on her assembled narratives.

Madam has already summoned the spirits to her desk in the form of an iconic painting of Erzulie Freda, the "sensual and elegant, flirtatious and frustrated" vodou goddess of love and romance (fig. 46),[10] as well as a reliquary bearing the birthdates of the artist and her grandmother and inscribed, "Even in death you are my muse." The reliquary also features a small drawing of trees flanking two intersecting paths. Representing a crossroads, the detail is emblematic of Stout's perception of herself as an artist who mediates between chance and choice in hopes of forging a high, open road to creative change and insight.

Lynda Roscoe Hartigan

Notes

1. Renée Stout, quoted in wall text accompanying the exhibition "'Dear Robert, I'll Meet You at the Crossroads': A Project by Renée Stout," at Bronx Museum of Art, 1995.
2. Michael D. Harris, "From Double Consciousness to Double Vision: The Africentric Artist," *African Arts* (April 1994): 52. Harris cited the saying in both Yoruba and English; in Yoruba, it reads "Owo eni la fi ntun oro eni se."
3. Artist's Statement (Washington, D.C.: B. R. Kornblatt Gallery, Inc., n.d.).
4. When Stout first saw this particular *nkisi nkondi* of the Bakongo, Congo, in 1968, it was in the collection of the Carnegie Museum of Natural History. Ten years later the Carnegie Museum of Art acquired the object by exchange.
5. The plural of *nkisi is minkisi*.
6. Made in 1989, *Fetish #4* was destroyed in a fire in 1994.
7. Quoted from a letter to Robert Johnson in Stout's 1994 sketchbook, cited in Marla C. Berns, "On Love and Longing: Renée Stout Does the Blues," *"Dear Robert, I'll See You at the Crossroads": A Project by Renée Stout* (Santa Barbara: University of California University Art Museum, 1995), 25.
8. Stout, quoted in Michael D. Harris, "Resonance, Transformation, and Rhyme: The Art of Renée Stout," *Astonishment and Power* (Washington, D.C.: Smithsonian Institution Press, 1993), 139. Stout, interview with Harris, 1992.
9. Joseph Cornell Papers, Archives of American Art, Smithsonian Institution, Gift of Elizabeth Cornell Benton.
10. Karen McCarthy Brown, *Mama Lola: A Vodou Priestess in Brooklyn* (Berkeley: University of California, 1991), 246–52.

Shared Concerns

Terry Allen

Kim Dingle

Pepón Osorio

Frank Romero

Roger Shimomura

Frank Romero, THE DEATH OF
RUBEN SALAZAR (detail),
1986, oil on canvas

Terry Allen

‘YOUTH IN ASIA’ IS ABOUT . . . A CULTURE THAT BETRAYS ITS CHILDREN. YOU DON'T HAVE TO BE A VETERAN OF SOME WAR TO UNDERSTAND THAT.[1]

"Youth in Asia" is Terry Allen's most comprehensive body of work to date. Executed over a period of almost a decade, from 1983 to 1991, the works represent a stream-of-consciousness, multimedia exploration of the aftereffects of the Vietnam War on its veterans and the American society to which they returned. The entire series—estimated at close to 300 pieces—consists of objects and collages, books of poetry, several catalogues, at least two plays, a collection of songs, and four major installations with accompanying sound tracks.[2] Like the pun intended in his choice of a title for this series, both the visual and verbal material are meant to stimulate new meanings and connections beyond those that are overtly stated.[3] The overall impact is such that Allen's presentation purposely "fuses (confuses) art and life."[4]

The national tour of the "Youth in Asia" exhibition between 1992 and 1994 brought Allen's work to the largest audience of his career.[5] Although represented in major museum collections and recognized since the seventies for performance works such as *Juarez* (1969–76) and *The Ring* (fig. 49), which combine elements of theater with narrative and music, Allen has always resisted the idea of having his art submerged into the mainstream. His unorthodox approach to art-making certainly derives in part from his unusual upbringing and experiences in the West Texas town of Lubbock. His work not only represents an unusual mix of media and disciplines, but also demonstrates a particular regional perspective. "He turns regionalism," one critic concluded, "into a positive force that reverberates beyond provincial borders."[6]

Already described as an "aspirant to universal genius" by *Artforum* in 1970, Allen has an inclusive working style that can be traced to both an absence of certain high cultural influences and an abundance of the more populist kind.[7] According to Allen, "To most observers, [Lubbock is] a culturally deprived area. Your imagination becomes very important to you, a saving grace as a child." Lubbock does have compensations, however. In the southern tradition, Lubbock is "a story-telling culture."[8] As in Allen's productions, the creativity of such places lies largely in the narrative realm.

Fig. 48. Terry Allen
The Creature
1987, mixed media, 92 x 175.3 x 15.2 cm (36¼ x 69 x 6 in.). Courtesy the artist and Moody Gallery, Houston

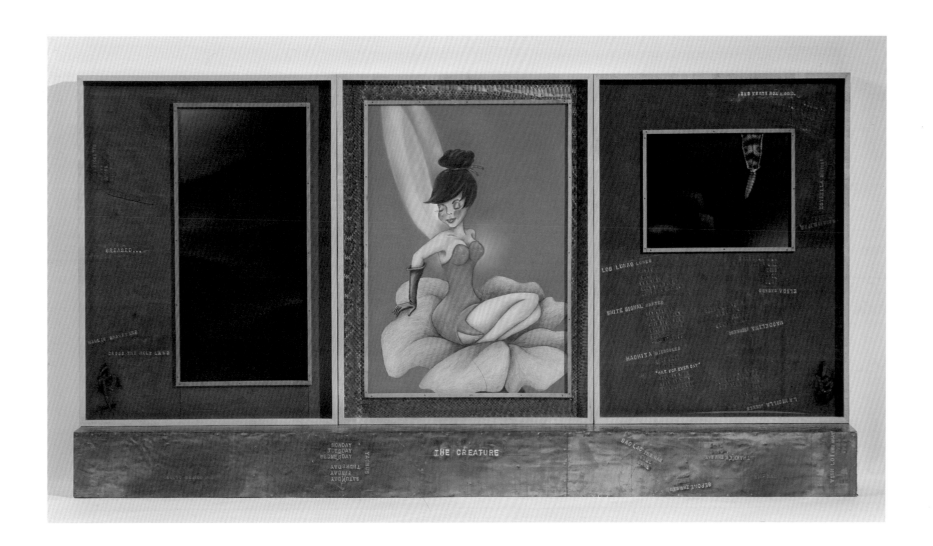

The unusual vocations of Allen's parents affected him as well. His mother was a barrel-house piano player and "the first woman to be kicked out of [Southern Methodist University] for playing jazz," according to Allen's colorful account.[9] His father, a former baseball player with the St. Louis Browns, became the local impresario after the family's move from Amarillo, Texas, to Lubbock. The elder Allen leased an abandoned airplane hangar to use as a theater that he named Jamboree Hall. There he presented wrestling matches, prizefights, dances, and concerts. Allen "grew up around this dancehall. Friday nights, there would be . . . incredible black musicians. . . . The next night would be country. . . . During the breaks . . . he and his friends spent time in the bathroom drawing suggestive pictures on the walls."[10] Allen refers lightheartedly to these early productions—the bathroom drawings with music playing in the background—as "the earliest of [my] multimedia environmental works."[11]

Out of this background, Allen has evolved an aesthetic that offers "a Buñuelian vision of red neck, Bible Belt, cowboy country and the languages and textures of those zones . . . the America of tent-meeting revivalism, truck-driver wisdom, trailerpark life, and circus sideshows."[12] It is this down-home quality in everything he does that disarms the audience into experiencing the profound nature of his art. "He exposes spooky truths while looking hokey."[13] The twang of his speaking and singing voice, and the cowboy-poet lilt to his verse and narratives, finds its visual parallel in the collage/assemblage ensembles of materials he uses in the multimedia installations, sculptures, and painted panels of the works in "Youth in Asia."

Allen describes the series as "an extended meditation on the personal consequences of geography and memory."[14] The geography involved is that of Southeast Asia as well as the American Southwest. The artist sees the two places as interconnected by the Vietnam War, and with many surprising parallels between them. Latinos, whose ethnic mixture often includes peoples indigenous to the Americas, and full Native Americans can both be presumed to have ancestors who migrated to the Americas from Asia thousands of years ago. The bizarre circumstance of the war brings these Americans back to the land of their ancient forebears to kill and be killed. In their "trekking back at the expense of Uncle Sam to fight Uncle Ho," Allen sees a macabre irony.[15]

The memory Allen refers to has a twofold nature. In creating the "Youth in Asia" works, he relies on his memory of the Vietnam era as a bystander to the conflict, as well as that of the friends and relatives who actually went to the war. "Youth in Asia" is not so much about the actual events of the war as about the

Fig. 49. Terry Allen, from **The Ring** 1978, performance installation (top)

Fig. 50. Terry Allen, from **China Night** 1985, performance installation. Museum of Contemporary Art, Los Angeles (bottom)

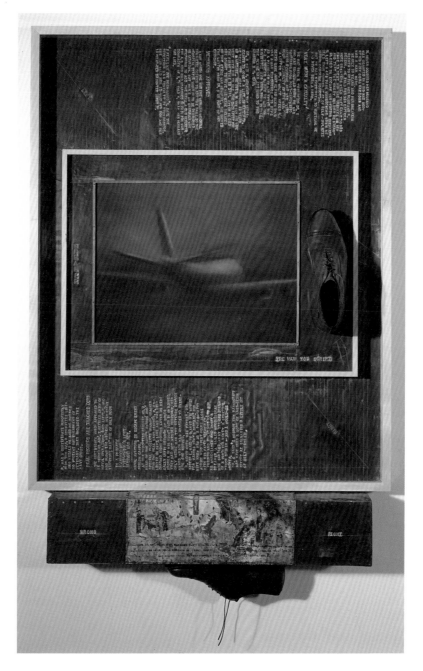

Fig. 51. Terry Allen
Sneaker
1991, mixed media, 156.2 x 94 x 19 cm (61½ x 37 x 7½ in.). Courtesy the artist and L.A. Louver, Inc., Venice, California

remembrance of it, particularly in the context of veterans returning to the American Southwest. Allen's focus on memory also has another dimension. He wants to make sure that we remember not only events and places, but the human loss of those who perished and the physical and emotional devastation of those who survived. This war, like all wars, was hell. Allen's creations are meant to ensure that we will never forget the social costs that war demands, especially from the young. Although Americans might like to perform a kind of "euthanasia" on their memories of the conflict, or arrive at a state one writer called "Vietnamnesia,"[16] Allen has no intention of allowing such an easy way out.

In late 1983 Allen already had begun what would become the first work in the series when he was commissioned by a German film company to do the sound track for a documentary called "Amerasia." The film focused on Amerasian children and the Vietnam veterans who had chosen to remain in Southeast Asia rather than return home, as well as those who had returned there after finding themselves unable to adjust to postwar life in America.

To collect ideas and materials for the sound track, Allen traveled to Thailand. There he hooked up with a Thai band—a move that familiarized him with the music of Southeast Asia, as well as with the instruments used to play it. This firsthand experience in the region brought him new insights into its culture and aesthetics and a new perspective on its relationship to the American Southwest. "Buddhists and Hopis, Laos and Taos . . . all these weird parallels and incredible collisions made a kind of sad sense for me," Allen said.[17] He observed, for example, that cries or chants in Hopi or Navajo bear a resemblance to Mnong Gar, that kachinas sacred to the Hopi and the Zuni function like the spirits associated with the religions of Asia. When Allen composed his own sound track for *China Night* (fig. 50), the elaborate installation culminating the first group of the "Youth in Asia" series, he combined his own poetry and stories and the blues of Jimi Hendrix and Credence Clearwater Revival with "the voices of Montagnard tribesmen from the central highlands of Vietnam [that] sound like Navajo or Hopi."[18]

The first "Youth in Asia" group, beginning with *The First Day (Back in the World)* (fig. 4) and ending with *China Night,* concerns the return of the young veterans to the United States ("the World" was soldier slang for America), some alive and physically intact, others mutilated, and still others—the dead—who are able to return only as memories. For many survivors, the pain of readjusting was so great that they preferred a return to Asia/Vietnam over the emotional trauma involved in fitting themselves into a niche back home.

The First Day, like many of the wall pieces in the series, consists of a lead support on which text is etched or attached along with other fragments, including hair, photos, feathers, and postcards. The text, in this case three disorienting poems entitled "Morning," "Afternoon," and "Evening," and the images and assemblage elements function as an ensemble, while "the individual elements . . . acting alone and together, set up a multidimensional manifold of narrative pathways."[19] Allen has carefully chosen each of the materials to achieve the maximum associative resonance. The choice of lead as the principal material was meant to evoke the Vietnam Memorial and the coldness of death in its slablike presence. It was meant to remind the viewer of bullets and shrapnel as well, all made from this poisonous metal. Allen has pointed out

Fig. 52. Terry Allen
Good Boy
1986, mixed media, 205.7 x 123.8 x 139.7 cm (81 x 48 ¾ x 55 in.). Courtesy the artist
(opposite right)

Fig. 53. Terry Allen
Treatment (angel leaving dirty tracks)
1988, mixed-media installation with sound, 205.7 x 82.9 x 82.9 cm (81 x 32⅝ x 32⅝ in.). Courtesy the artist
(opposite far right)

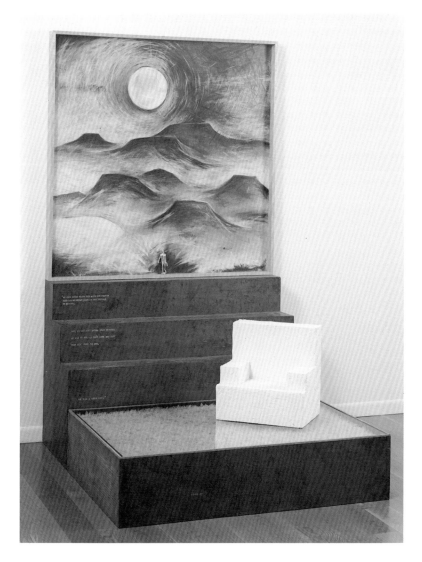

that "the surface of the lead is always changing, oxidizing to the tune of its evironment [depending on] humidity, etc."[20] Allen has also referred to lead's soft, almost fleshlike malleablility, which adds another dimension to the material's metaphorical repertoire; evil and good, death and life are all embodied in the same versatile substance.

Four works from the second part of the series executed after 1985 have been chosen for "American Kaleidoscope." Two are wall pieces in lead with mixed media: *The Creature* (fig. 48) and *Sneaker* (fig. 51); one is a freestanding mixed-media construction, *Good Boy* (fig. 52); the fourth is an installation piece with sound, *Treatment (angel leaving dirty tracks)* (fig. 53). While the earlier group deals with the return of the veterans, this second group focuses on what happens after their return—the tragedies, disillusionment, disaffection, and emotional breakdown that so often accompanied life back in "the World." These works also draw attention to the half-truths, lies, and propaganda used to make war and the sacrifice of the young palatable to society.

Good Boy, with a design resembling that of a small altarpiece, again juxtaposes the so-called familiar—an armchair and shaggy rug of an American living room—with a stylized landscape that could represent Southeast Asia or the desert terrain found in New Mexico. The piece was inspired by the story of a Roswell, New Mexico, man who, having failed at all his attempts to conduct a normal life after Vietnam, committed suicide in an armchair placed in his front yard. Allen adapted the text etched onto the lead steps between the shaggy rug and the landscape from the eulogy pronounced at the young man's funeral by his grieving mother: "He was a good boy . . . always a good boy. . . . He went to Vietnam and came back. . . . He just never gave me no trouble. . . . I don't know why they took him from me now. . . . They say God has a plan for each person. . . . I just don't know. . . . He was a good boy."[21] This devastating lament could serve for thousands of other veterans who survived the war in Vietnam but lost the battle at home when their emotional wounds ultimately turned out to be fatal.

The Creature, a tripartite wall piece, is also suggestive of an altarpiece, with its triptych and predella. The triptych's center is dominated by a Walt Disney-like rendering of a cartoon character. The wings provide a clue to her identity: Tinker Bell, Peter Pan's Never-Never Land guardian, is recognizable despite having "been slutted up some."[22] Unlike the story of Peter Pan, however, her innocence, like that of the young men who served in the "Never-Never Land" of Vietnam, has been replaced by a coarseness that exerts it own kind of seduction—superficially benign but ultimately pernicious and destructive. Tinker Bell's picture is framed by skin from a rattlesnake, a reptile that strikes unexpectedly and in a deadly manner.

As in *Good Boy,* images on the left and right—one an orientalized landscape and the other an interior with armchair— define the "here" and the "there," the two poles of the vet's universe. The text consists of words and expressions in English, Spanish, and Vietnamese balanced on both sides by the *I Ching* character translated as "Influence (Wooing)," which was formed by interweaving lead strips and strands of human hair. In this piece, Allen captures the hallucinatory and visceral nature of the mental turmoil associated with the soldier's recall of his

Fig. 54. Terry Allen
National Pastime
1991, bronze, 81.3 x 91.4 x 61 cm (32 x 36 x 24 in.). Private collection, Los Angeles. Courtesy L.A. Louver Gallery, Venice, California

Notes

1. Terry Allen, quoted in Dave Hickey, "Vietnam and a Betrayal of Childhood," *Los Angeles Times,* 4 July 1993, 3.
2. Ibid., 76.
3. Critic Erika Sunderburg commented on the title: "It is a war under whose influence we perform a type of self-directed euthenasia, as Allen implied in his

dehumanizing and disorienting Vietnam experiences.

Treatment (angel leaving dirty tracks) gives us the opportunity to see Allen working in his multimedia mode. A tall, schematic form shaped like a kachina figure stands elevated on a pedestal in the center of a space defined by wood perimeters and bright lights, transforming the figure into a disembodied, otherworldly presence. As Picasso did in his early sculptural assemblages, Allen has used a totally unexpected element to create the desired figurative illusion. An old typewriter is transformed into the kachina's head. The shape is uncannily apt, and the idea of a head with a track that produces words consecrated by its false appropriation of spiritual authority seems appropriate to Allen's theme of betrayal. While the forms are evocative, the audio element of the piece is devastating. It consists of Allen's radio play, *Torso Hell,* a surreal recounting of a grotesquely injured soldier left with only a torso, whose detached limbs are reattached to other mutilated survivors. Although "the Torso" takes revenge in horror-movie style, the unreality of events only increases the effectiveness of Allen's message. He insists that the audience confront "the process of complete psychic, emotional, and physical breakdown that occurs in the relentlessly horrific field of combat."[23]

Sneaker, the most recent of the works displayed, continues to explore the issues of betrayal and deception that, in Allen's view, were essential to the Vietnam enterprise. On looking at the wall piece, we realize that the title refers not to footwear, since a pair of dress shoes is featured rather than sneakers, but to the behavior of the character, the "sneaker" or sneak, whose story is recounted in the yellow text on the lead surface. While most of the Vietnam vets spent the years after the war trying to escape its debilitating effects, there were impostors who pretended to have fought in the war, such as a man from Arizona who inspired Allen's creation. An otherwise upstanding citizen, he lied about having been in Vietnam in order to enjoy the admiration and respect due to the real veterans. In Allen's view, when it comes to war, all manner of absurdity and misrepresentation becomes possible: "the war appropriates [human] nature to begin with, and the series concludes with some guy appropriating the war."[24]

Since the "Youth in Asia" series, Allen has continued to explore complex social issues. *Cross the Razor* (1994), a piece he did on the border between San Diego and Tijuana for a bicultural exhibition titled "Insite 94," dealt with the problems of cultural interface and coexistence created by our proximity to Mexico.[25] His recent bronze sculptures are more general in their social commentary. In a bust such as *National Pastime* (fig. 54), a respectable member of the managerial class, whacked in the back of the head by a baseball bat, finds his face falling off. According to one critic, it "speaks of a need for art that takes viewers metaphorically outside their everyday heads," and into the larger realm where real problems need to be solved.[26] As always, notes another writer, "Allen likes to work in the space between art and life."[27] "Youth in Asia" has been his most ambitious demonstration of that commitment, but it is clearly part of a continuum that informs all of Allen's creative enterprises.

Jacquelyn Days Serwer

title." "Beginning the Mourning," *Artweek,* 6 February 1988, 3.

4. Craig Adcock, "Image/Music/Text: Terry Allen's 'Youth in Asia' Series," *Youth in Asia* (Winston-Salem: Southeastern Center for Contemporary Art, 1992), 8.

5. From 1992 to 1994, the exhibition "Youth in Asia" appeared at the Southeastern Center for Contemporary Art, Winston-Salem, North Carolina; the Modern Art Museum of Fort Worth, Texas; the Newport Harbor Art Museum, Newport Beach, California; and the Contemporary Museum, Honolulu, Hawaii.

6. Suzanne Muchnic, "Allen Hones a Regional Aesthetic," *Los Angeles Times,* 9 May 1983, 1.

7. Jerome Tarshis, "Terry Allen," *Artforum* (June 1970): 92.

8. Hunter Drohojowska, "But there's more to Allen than Art," *Los Angeles Herald Examiner,* 1 May 1983.

9. Peter Clothier, "True Grit," *Art News* (January 1989): 105.

10. Drohojowska, "But there's more to Allen than Art."

11. Clothier, "True Grit," 105.

12. Jonathan Crary, "West Texas Dada," *Art in America* (September 1983): 134.

13. Muchnic, "Allen Hones a Regional Aesthetic," 1.

14. Hickey, "Vietnam and a Betrayal of Childhood," 76.

15. Craig Adcock, "Terry Allen's 'Youth in Asia' Series," *Arts* (April 1989): 51.

16. Erika Suderberg, "Beginning the Mourning," 4.

17. Allen, qouted in Hickey, "Vietnam and a Betrayal of Childhood," 76.

18. Adcock, "Terry Allen's 'Youth in Asia' Series," 57.

19. Ibid., 53.

20. Written comment to author, 14 December 1995.

21. Craig Adcock, "New Works in Terry Allen's 'Youth in Asia' Series," *Arts* (December 1987): 52.

22. Ibid., 47.

23. Ibid., 53.

24. Allen, quoted in Hickey, "Vietnam and a Betrayal of Childhood," 76.

25. Describing this fascinating piece, Allen noted that it "consisted of two vans placed in close proximity, one parked on each side with the border line running between them and people were invited to stand on these platforms and speak, sing, scream . . . whatever they wished . . . at the other side." Written statement to author, 14 December 1995.

26. Benjamin Weissman, "Terry Allen," *Artforum* (November 1991): 143.

27. Clothier, "True Grit," 107.

Kim Dingle

THESE GIRLS ARE WILDLY AGGRESSIVE. . . . THEY HAVE NO SUPERVISION AND IT ISN'T CLEAR WHERE THEY GET THEIR CLOTHES OR HOW THEY KEEP THEM SO CLEAN . . . BUT THE DRESSES ARE VERY IMPORTANT.[1]

Kim Dingle made this statement about an earlier series of works, but it applies just as accurately to her recent installations featuring little girls in cribs, entitled *Priss' Room* (fig. 55), a new version of which is presented in "American Kaleidoscope." Droll and understated in her matter-of-fact statements, both in person and in print, she is provocative and confrontational in her art, softening her message with an endearing, ironic humor that gets our smiles going rather than our backs up. Focusing on issues of gender stereotyping and race relations, Dingle uses the little girls as society's surrogates who shamelessly and aggressively battle their way through confounding human dilemmas.

Dingle's art has demonstrated a questioning if not a critical view of the status quo since she began exhibiting regularly in the early 1990s. Coming from a small-town, Southern California family that nurtured such all-American attributes as independence, self-reliance, and fairness, Dingle has often called upon that background in formulating ideas for her art. The elaborate context she constructed for her first solo exhibition after completing an M.F.A. degree at Claremont Graduate School was titled "The Portraits from the Dingle Library." In a Duchampian mode, she repainted images of famous contemporary or historical figures, transforming the original identities into portraits of female family members, most frequently her mother, Cram.

Two of the most celebrated of this group depict Cram as a clone of George Washington in *George Washington as Cram Dingle as Queen Elizabeth II* (1991) and as a ringer for boxer George Foreman in *Baby Cram Dingle as George Foreman* (fig. 56). While the works are meant to entertain with their wit and irreverence, they are serious in drawing attention to the often arbitrary nature of certain aspects of the male/female polarity. Dingle seems to suggest that some distinctions routinely taken for granted may be both optional and absurd. One critic noted the importance of Dingle's way of working as well, observing that the paintings are "created whole-cloth by Dingle, rather than . . .'ready-made,'" and this "renders the image particularly disturbing."[2]

Fig. 55. Kim Dingle
Priss' Room (detail)
1994–95, dolls: porcelain, china paint, painted steel wool; dart boards: oil on wood with darts; wallpapered panels, linoleum floor, cribs, power tools, debris. Collection of Eileen and Peter Norton, Santa Monica. Courtesy Blum & Poe, Santa Monica

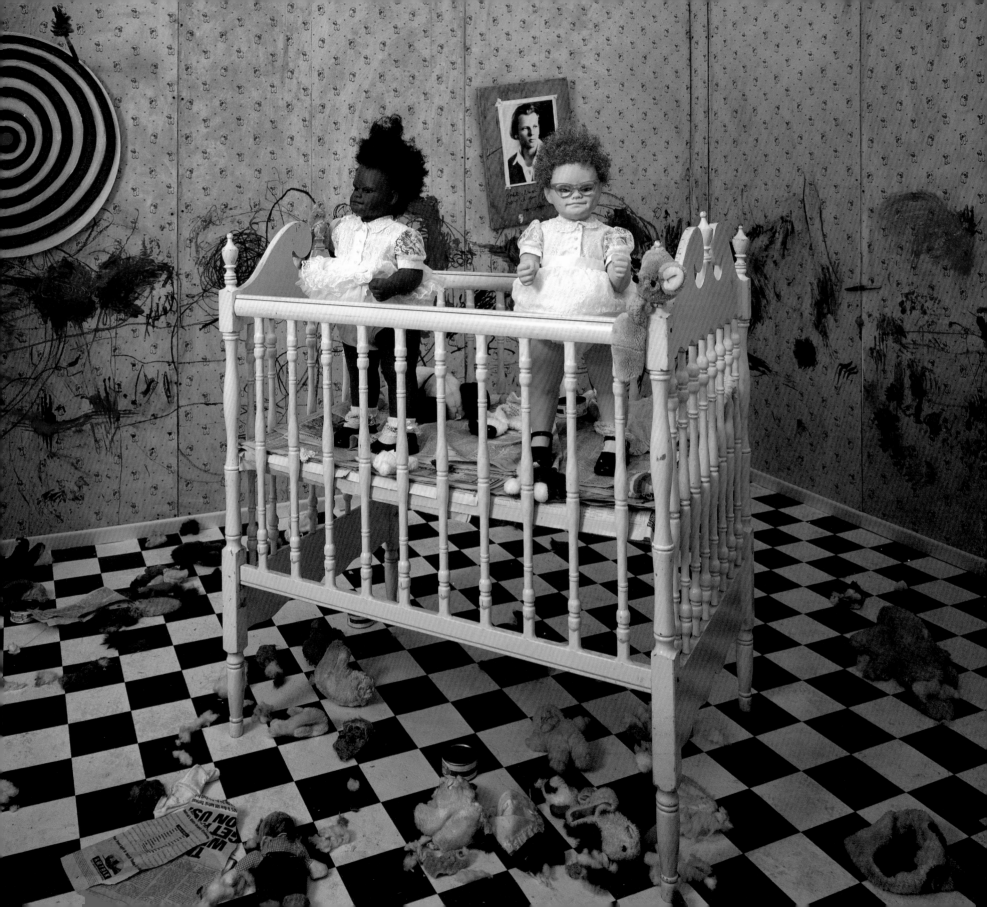

That same exhibition included a series of map paintings—perfect for the Library—
incorporating maps of the United States drawn from memory by art students who had been her
classmates at Claremont. Dingle indicated, tongue-in-cheek, that this seemingly innocuous idea
could be interpreted in psychosexual terms. The map without any peninsulas, she explained,
came from "a woman who was extremely angry at men."[3]

The second installment of the Dingle Library came later in 1991.
Entitled "Paintings of the West with Horse Drawings by Teenage Girls,"
she took the liberty of adding what she felt had been left out of this
American subject. Often using 1950s figurative wallpaper, bedspreads,
and tablecloths instead of canvas, she altered the images to include little
girls, adults of Chinese origin, and cowboys with black faces. One of the
1991 "Paintings of the West," done in oil on baby blanket, shows a scene
in which Dingle has obscured the original cowboys pictured around a
campfire, replacing them with her ubiquitous little girls who seem
perfectly capable of tending to the horses nearby. Other paintings in the
series show a little girl included in "scenes of runaway mustangs, buffalo
roundups, Indians celebrating tribal rites, and the sheriff maintaining law
and order."[4]

In another work, she dissolves any suspicion of pretension
associated with her celebrated forebears by refashioning, as one critic
noted, "wallpaper with 'classy' hunting scenes into ranch-hand kitsch
[with] doodly drawings that add horns to hounds and turn whips into
lassos."[5] Two walls of the exhibition featured a selection of horse
drawings actually executed by teenagers and collected from various
sources by Dingle's friends. Another critic observed that Dingle "sees
girls' desire to draw horses as an empowering act, and in this context it
forces them to be taken seriously as members of the West."[6] Using her
own art and that of the real-life "girls" to establish a starring role for the
players whose scenes are most often edited out, Dingle's revisionist
pageant of the American West presents it as both domesticated and
democratized.

Dingle collects marbles and erasers and has used photographs of the
eraser collection, 300 pieces in all, as the basis for a piece in which she
juxtaposed the images with text excerpted from tire billionaire Harvey Firestone's *The Romance
and Drama of the Rubber Industry*.[7] Although Dingle resisted explaining her intentions, there was
no mistaking the racist attitudes implicit in the passages she chose to include. Her marble
collection, an obvious snipe at the female stereotype—boys collect marbles, not girls—is another
way she expresses her off-beat style.

The "gentle weirdness"[8] of Dingle's 1992–93 series of paintings depicting prepubescent

Fig. 56. Kim Dingle
Baby Cram Dingle as George Foreman
1991, oil on panel, 91.4 x 61 cm (36 x 24 in.). Collection
of Clyde Beswick, Los Angeles. Courtesy Blum & Poe,
Santa Monica

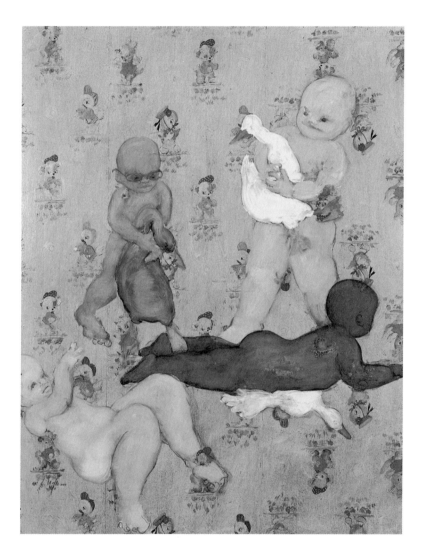

Fig. 57. Kim Dingle
Two Girls, One with Head in Heaven
1992, oil on linen, 182.9 x 152.4 cm (72 x 60 in.). Collection of John
and Kim Knight, Larkspur, California. Courtesy Blum & Poe, Santa
Monica

Fig. 58. Kim Dingle
the prisspapers: baby mashing duck
1994, oil on wallpapered panel, 152.4 x 121.9 cm (60 x 48 in.).
Collection of Blake Byrne, Los Angeles. Courtesy Blum & Poe, Santa
Monica

black and white girls in frilly white party dresses and black Mary Janes, sometimes with boxing gloves, makes these works impossible to ignore. Dingle sees the girls as growing out of an original idea she describes as "Easter girls boxing the hell out of each other."[9] The conventional, almost classic execution of the paintings in an oil-on-linen medium, along with their strong figurative presence, contrasts dramatically with the unconventional and enigmatic subject matter. Highly self-conscious yet rich in metaphorical ambiguity, these paintings offer the possibility of a wide range of scenarios. Undoubtedly they constitute another chapter in Dingle's continuing discourse on gender stereotyping, but they also introduce the issue of race relations. Dingle remembered, sometime after the paintings were executed, that she had ordered the large canvases expressly for this group of works the day after the 1992 Los Angeles riots began.[10]

Naughty but always irresistible, these liberated baby Amazons either duke it out with no intention of settling for a split decision or take turns being the aggressor and the victim. In *Two Girls, One with Head in Heaven* (fig. 57) the white kindergartener shakes her partially clothed black counterpart—in vain, we assume, since her head, Dingle tells us by the title, is already somewhere else. *Black Girl Dragging White Girl* (1992) shows instead an ill or sleeping white girl who is being pulled, with difficulty, by her black companion either out of or into—we do not know which—harm's way. In any case, these lively protagonists serve to act out our fantasies of free will uninhibited by a sense of guilt or responsibility. There is no shying away from showdowns for these "wild girls" who confront their adversaries and fight to win regardless of the consequences. They also serve as new symbols of assertiveness and competitiveness, while acknowledging the old contradictions complicating the exercise of female power—the forceful versus the feminine, the ugliness of raw aggressiveness versus the beauty of more subterranean wiles.

Dingle has followed these paintings of larger-than-life little girls with a series she calls "the prisspapers." Peopled by toddlers rather than preteens, baby girls are now let loose against a backdrop of funky wallpaper that appears to have been rescued from a condemned nursery. Multiracial and occasionally bespectacled, they cavort in their birthday suits, suggesting a *Lord of the Flies* atmosphere where they attack one another as well as other living things with gleeful, uninhibited abandon. In *the prisspapers: baby mashing duck* (fig. 58), robust babies torture their luckless pets with evil enthusiasm.[11] In another, *the prisspapers: girl on panda* (fig. 59), a sensual baby athlete, complete with tattoos to match the wallpaper patterns, sits astride a panda seeming to hug and torture the animal simultaneously. What can we make of these strange tableaux? The seductiveness of violence and the absence of innocence are surely among the ideas on Dingle's mind. Finding such weighty thoughts couched in such wacky subject matter, painted so beautifully with such obvious pleasure, gives them an added punch.

The "prisspaper" paintings were exhibited alongside the first full-scale installation of *Priss'*

Fig. 59. Kim Dingle, **the prisspapers: girl on panda** 1994, oil on wallpapered panel, 152.4 x 121.9 cm (60 x 48 in.). Collection of Eileen and Peter Norton, Santa Monica. Courtesy Blum & Poe, Santa Monica

Room at a New York gallery in 1994. Dingle presented an expanded version of the installation a few months later at Blum & Poe in Santa Monica. It had the impact of a Dingle *gesamptkunstwerk*. Room-size and obsessively detailed, it consisted of three newspaper-lined cribs containing pugnacious-looking two-year-olds. Most of the girls were confined to the cribs, but one had escaped and stood admiring the wreckage of a crib she had managed to demolish using pint-size power tools.

The girls, or "prisses," made by Dingle using classic porcelain doll-making techniques, were fetchingly outfitted in white polyester party dresses, black-patent shoes, ruffled socks, and tiny cat's-eye glasses with the same prescription as Dingle's. But their "bad hair," fashioned from rustoleumed, painted steel wool, and seemingly styled after boxing promoter Don King's electric coiffure, is simultaneously their scariest and most endearing attribute. Dingle's decision to move the girls out of the paintings and into real space relates the installation to the work of other artists who have used mannequins or dolls, such as Hans Bellmer and California artists Ed Kienholz and Bruce Conner.

The treatment of the walls and floor of the installation involved collaborators, as has often been the case with Dingle's major projects. Here the toddler-level frieze of graffiti defacing the 1950s wallpaper was the contribution of a guest artist, only three years old, who worked quickly by moving along the walls on her Big Wheel. The eviscerated stuffed animals littering the floor met their fate at the hands of the gallery owner's pit bull.

Dingle alluded to her mixed-gender "Dingle Library Portraits" with an arresting framed photograph of *Jackson Pollock as Amelia Earhart* (1995). Other expressions of homage to fellow artists came with the Jasper Johns-inspired target dart boards, the Cy Twombly-like graffiti, and the trashed, stuffed animals reminiscent of Mike Kelley. For those who dared, a peek under the party dresses revealed little painted tattoos of images associated with the West—horses, cacti, Native Americans—a reference to Dingle's "Paintings of the West," shown several years earlier.

Like the baby savages of the "prisspapers," these girls are out of control, threatening those who challenge them and trashing everything within their realm. They relish this reign of destruction and the power "high" that comes with following their unbridled impulses. As Dingle was certainly aware, we are unaccustomed to seeing such aggression and unabashed hostility on the part of little girls. Although such behavior should never be acceptable in a civilized world, we are perhaps more willing to overlook it when it appears dressed in a tie and jacket.

The most intriguing aspect of the ensemble, once we acknowledge our perverse pleasure in observing a scene of such guiltless savagery, is the fact that Dingle has included both Caucasian priss dolls and priss dolls of color; rather than being central to the action, the differences among them seem irrelevant to the mission at hand. Gone are the confrontational encounters between black and white girls we saw in the earlier painting series. Here, instead, we are struck by how much they have in common.

Jacquelyn Days Serwer

Notes

1. Artist's statement, in Bruce Guenther, *Fourth Newport Biennial Southern California 1993* (Newport Beach: Newport Harbor Art Museum, 1993), 20.
2. Susan Kandel, "Skewed Portraits," *Los Angeles Times,* 12 September 1991, F12.
3. Dingle, quoted in Cathy Curtis, "Hers is Unfinished Business," *Los Angeles Times* (Orange County ed.), 23 September 1992, 2.
4. Tobey Crockett, "Los Angeles: Kim Dingle at Richard/Bennett and Parker Zanic," *Art in America* (July 1992): 116.
5. Ibid., 116.
6. Jody Zellen, "Kim Dingle," *Artscene* (December 1991): 22.
7. Harvey Firestone, *The Romance and Drama of the Rubber Industry* (Akron, Ohio, 1932).
8. David Pagel, "What Little Girls Are Made Of," *Los Angeles Times,* 5 November 1992, F9.
9. Dingle, quoted in Curtis, "Hers is Unfinished Business," 2.
10. Conversation with the artist, 18 January 1995.
11. According to Dingle, the titles are informal and are usually provided by gallery employees or bystanders whom she asks to describe what they see. Conversation with the artist, 2 January 1996.

Pepón Osorio

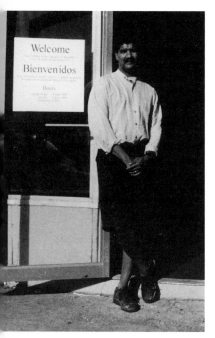

MY WORK IS SOCIALLY RELEVANT BECAUSE THAT IS THE NEED I SEE IN THE COMMUNITY. OUR COMMUNITY DOESN'T LIKE THE IDEA OF ART FOR ART'S SAKE AND THEY EXPECT ART TO TALK TO THEM AND BE PART OF THEIR LIVES.[1]

Osorio's objects and installations pulsate with energy and vitality, reflecting passionate political and cultural feelings expressed in abundantly excessive and overripe creations. The theatricality of his complex installations stems in part from his exploration of the rich communicative potential of theater and dance performance. Individual sculptures such as *La Bicicleta* (fig. 60), *El Chandelier* (fig. 61), and installations such as *Badge of Honor* (figs. 62, 63) are drenched in an aesthetic that celebrates mass pop culture and the inexpensive, kitsch-laden detritus of contemporary society. He covers his works with plastic toys, baubles, sequins, elaborate fabrics, polished metal, and other reflective and iridescent surfaces, as well as industrially produced materials in colors not found in nature.

Scattered throughout his work are reminders of Osorio's experiences with doubly harsh racism as a black Puerto Rican and the misunderstandings and stereotypes suffered by the working class. Installations such as *Badge of Honor* suggest the domestic sphere of the Puerto Rican household in exile. However, Osorio's translocated Puerto Rico is a condensed reality combining aspects of the island he left in 1975 with the excesses and urban social pressures of the mainland United States.

Osorio's mother was a part-time baker. While he was growing up in the community of Puerto Nuevo in Puerto Rico, she involved the entire family in the creation of her elaborate cakes for weddings, birthdays, and *quinciñeras* (fifteenth-birthday celebrations, or coming-of-age parties, for girls). On top of the cakes his father built elaborate wire-and-net structures that could include many levels, miniature bridges, and staircases covered with sugar coating. This sense of accumulation and application of layers of frosting and detailed ornamentation over potentially mundane foundations has remained a crucial factor in Osorio's subsequent work.[2] Over the years, he has moved from assisting in the ornamentation of baked goods to ornamenting mass-produced objects such as a bicycle, crystal chandelier, and upholstered settee

Fig. 60. Pepón Osorio
La Bicicleta/The Bicycle
1985, mixed media, approximately 106.7
x 152.4 x 61 cm (42 x 60 x 24 in.). Collection
of the artist
(below)

Fig. 61. Pepón Osorio
El Chandelier
1988, functional chandelier with mixed-media
ornament, 198.1 cm high (78 in.). National
Museum of American Art, Smithsonian
Institution, Museum purchase in part through
the Smithsonian Collections Acquisition
Program
(right)

to his more recent work, in which such objects are found in spaces where the decorative encrustation defines the entire environment.

After completing high school, Osorio entered the Inter-American University in Hato Rey, Puerto Rico.[3] In 1973 he visited New York for the first time and was intrigued by the transformation of Puerto Rican culture under the mainland influence. He moved to the Bronx in 1975, where he continues to create his work. The following year he began his studies in sociology at Herbert H. Lehman College, City University of New York. In 1980 he began working in the Department of Special Services for Children in the New York Human Resources Administration. In 1986 he received his M.F.A. degree in arts education from the Teachers College at Columbia University. During his first few years in the city, Osorio met visual and performance artists, choreographers, and designers. With their encouragement and support, he began a series of collages and drawings and had his first public exhibition at the Bronx Museum in 1978.

In the mid-1980s Osorio became disillusioned with the New York art world of museums and galleries. He felt that the work being done by his friends who were choreographers, dancers, and performance artists had greater potential to bridge gaps in communication than did the creation of individual static or precious objects. A combination of sociological observation and innovative artistic creativity was clearly evident in Osorio's first collaborations with the choreographer Merián Soto (whom he married in 1987) and other performers. Osorio was particularly attracted to the way these performers exposed the domestic sphere to public scrutiny; through his work with them, he gained a more complex understanding of the dynamics between presentation and viewer. All of his subsequent major installations demonstrate a similar approach to presenting the concerns, stereotypes, and realities of communities to the viewer. The installations or stand-alone objects provide us with an opportunity to expand our understanding of the personal histories and issues around which the works are constructed.

In the modernist tradition, the artist challenges the politically and socially dominant notion of "traditional" art by creating objects that seem to confront directly concepts of taste, appropriateness of subject matter, and overt theatricality. However, as a sociologist and teacher, Osorio also understands art's potential as a tool for social transformation and development. The mission he has set himself is the redirection of the conceptually driven world of contemporary art towards the needs of a large population for whom the contemporary art world has little relevance.

Osorio appropriates industrial mass-produced products and recontextualizes them by divorcing them from their intended purpose and recombining them in excessively baroque compositions. The result is an entirely new visual venue of mass consumerism. His appropriation of plastic *chucherías* (the word used in Puerto Rico to indicate trinkets or knickknacks, equivalent to the Yiddish word *tchotchkes*) allows him to formulate environments of personal response to a dense and overstimulating world. The materials he selects for recontextualization come from

daily life, but through their metamorphosis into the shapes and objects of elevated social, or at least financial, position they approximate status symbols of a high baroque-encrusted glamour. These *chucherías* are not merely tokens of identity for a working-class community. Rather, according to Osorio, even upper-class Puerto Ricans have *chucherías* in their homes: "Theirs are just more expensive."[4]

We need only glance at one of the artist's works to realize that Osorio embraces an attitude that "more is more" rather than the modernist notion that "less is more." Each level of applied decoration carries with it additional meaning and significance for the artist. He insists that the costume jewelry and pearls he uses in so much of his work should be viewed as they are by the Puerto Rican community, not as fake jewelry or fake pearls but as plastic jewelry and pearls. Osorio uses such materials not as substitutes for an expensive or "real" thing, but rather to demonstrate a desire to create luxury and elegance where there is none.

In most of his installations, he relies on mundane materials, but enlivens their presence by replicating them again and again, creating abundance through ingenuity. While an abundance of worthless material may have little monetary value, the objects may be invested with profound historical or sentimental connection. Osorio observes and understands the human tendency to create illusions in which one can believe. The representation of personal meaning through standardized signifiers and codes also carries with it an assumed agreement to overlook the mass culture origins of objects in favor of their more directly relevant meanings.

Osorio's approach gives voice to a society not with the methodology of a social scientist, but rather from the perspective of the working class itself. His view from within brings an understanding that is new to the art establishment.

Although some critics have accused Osorio of making fun of his own community, the artist insists that he is building upon a reality that exists, amplifying it so that it is no longer overlooked. "I grew up in a place where 'community' was not a word, community was basically the place where you lived."[5] Osorio lives and operates within two very complex spheres. Both the post-modern world of fine art and the post-modern world of relocated Puerto Ricans have very specific identities within the larger context of United States culture. "What I found at the very beginning, back in 1975," he states, "was a different culture of not so much the North American culture, but a different way of living as a Puerto Rican in a larger society."[6] That identity, like the identity of the visual artist, is usually completely unknown to outsiders and entirely taken for granted by those who live it. His artwork therefore must serve its viewers as both introduction for outsiders and reaffirmation for insiders.

Badge of Honor is a tribute to the bonds formed by families and the myriad societal forces that can build walls between family members. The installation was commissioned by the Newark Museum and, in keeping with the artist's philosophy, was exhibited in the heart of a predominantly Latino section of the New Jersey city (fig. 6). The installation was free to the public and presented in a rented storefront for several months during the summer of 1995, after which it was moved to a formal setting at the Newark Museum. Osorio has employed this same

Figs. 62 and 63. Pepón Osorio
Installation: **Badge of Honor** (details)
1995, mixed media, video, overall dimensions: 309.9
x 1005.8 x 378.5 cm (122 x 396 x 149 in.).
Commissioned by the Newark Museum. Courtesy Ronald
Feldman Fine Arts, New York
(following pages)

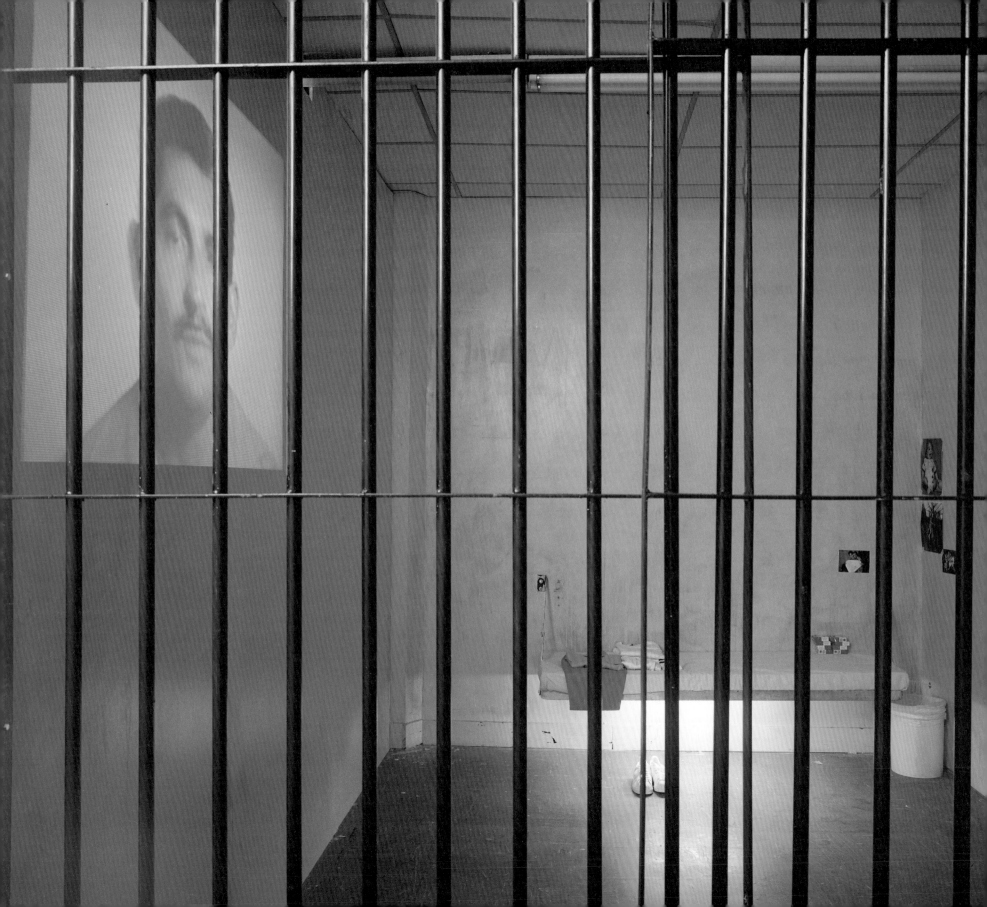

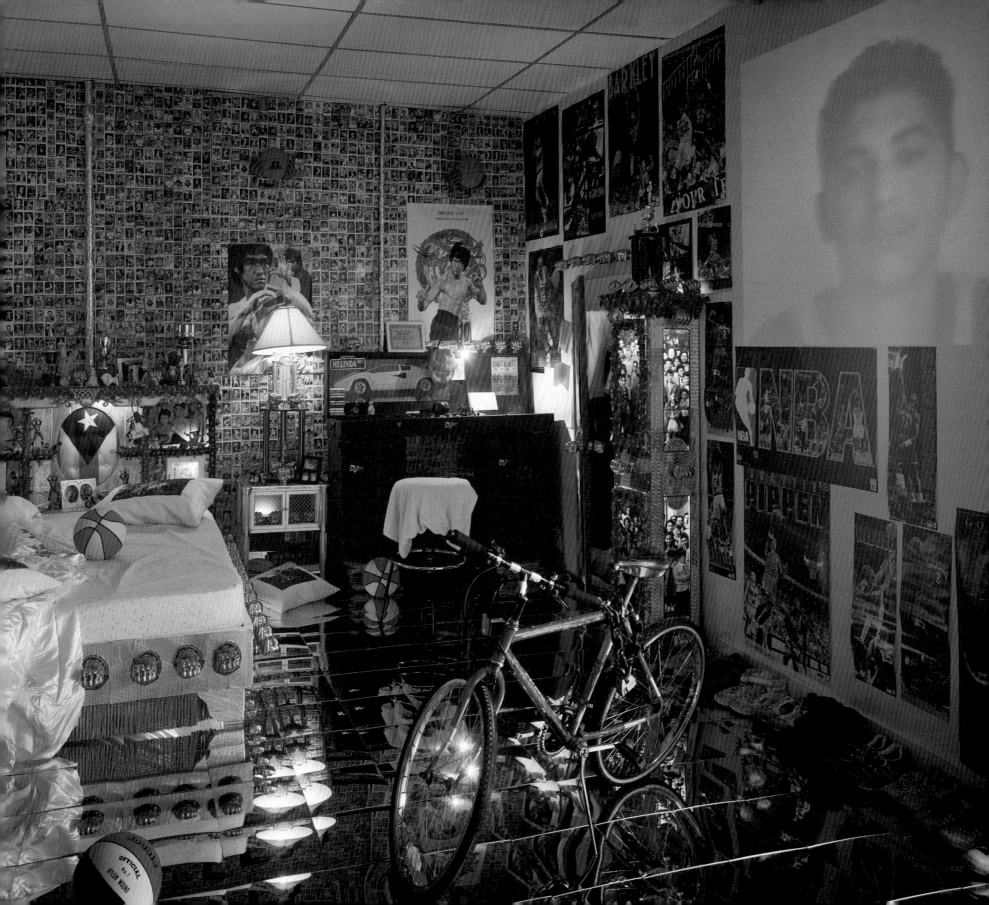

exhibition pattern—opening in a neighborhood followed by presentation in an art museum—in New York, Hartford, and Atlanta. As with all his installations planned for community exhibition, Osorio developed the theme of the family structure in contemporary society by meeting with community members and social service organizations. Students, school support groups, and local residents all supplied the artist with ideas and occasionally even materials. Osorio saw his mission as speaking about local issues to audiences made up of both the community observed through the artwork and the larger public.

The concerns Osorio raises have national resonance; for most visitors, the aesthetic aspects of the installation become secondary. The florid installation with its visual excess becomes the basis for a profound dialogue between a father and son. Their comments and questions to each other sound so very real that the artifice of setting and startling juxtaposition of cell and room are accepted as crucial to the story. Similarly, the technology of video projection controlled by computer and retrieved from CD-ROM becomes an invisible prop enabling the artist's vision.

Badge of Honor is composed of two bays sharing a common wall. One represents the world of the father, a prison cell of bare walls furnished only with a sink and a bunk with a pair of clean sneakers tucked neatly under it. The other represents the world of the son, a bedroom filled with the material possessions of a teenager's wildest dreams.

To create *Badge of Honor*, Osorio had to construct a physically impossible conversation between a son and his incarcerated father. The project depended upon his locating a family willing to have its personal emotions explored by an artist who would in turn expose those fragile sensitivities to public scrutiny. Several social service groups assisted the artist by suggesting individuals. The artist interviewed many people before discovering the father and son whose real story would become the anonymous fuel for the installation.

With the assistance of Irene Sosa, he recorded on videotape the father asking questions of the son and then took these questions to the son, recording the son's reactions to seeing his father ask the questions, and the son's responses to the questions. Osorio also asked the son for questions he would like to ask the father. He then repeated the procedure of recording on camera the father's reactions and answers to the son's questions.

These two separate tracks of the father and son were edited to be projected simultaneously, so that one speaks while the other listens, and vice versa. The black-and-white images are projected on opposite walls with a dividing wall in between. In the installation, therefore, as in life, the father and son are unable to see each other. Only we can stand back from the dividing wall and capture both projected images through peripheral vision. We therefore provide a reunion of the segregated father and son while simultaneously exploring their different physical realms.

The father's drab-colored cell is almost completely devoid of objects; we are divided from the space by a tight grid of black prison bars. A hinged bunk juts from the wall; the space beneath is lit by harsh fluorescent lights that cast stark shadows. Similarly the son's bed is lit underneath, but the effect is of a high-tech sports car hovering over a pool of cool light. The lighting is the only commonality between the two spaces.

The son's bedroom is delineated by a mirror-tile floor and floor-to-ceiling baseball cards applied as wallpaper. Posters celebrating athletes, late-model automobiles, and kung-fu movies cover the rest of the wall surfaces. The open closet door reveals brightly colored sports uniforms and casual clothes; the shelves are full of electronic audio and video equipment and bright gold- and silver-colored sports trophies. The illuminated, freestanding dresser is encrusted with transparent photo blowups of Latino prizefighters. A top-of-the-line mountain bike, basketballs, and other sports equipment fill the room. Large gilded plastic fists with brightly jeweled rings decorate the edges of the dressers, bed, and shelves. Osorio emphasizes the sense of contradictory claustrophobia and vertigo through the mirrored floor that reflects the room in an infinite space of color and glitter.

Symbols of consumerism and stereotypical male roles, identity, and *machismo* in the bedroom contrast with the overall femininity of the space, which resembles a high-tech Victorian parlor upholstered with floral chintz and filled with elaborate knickknacks. The installation is filled with many such startling contradictions between expectations/stereotypes and presented reality. At one point in the dialogue, the son tells the father that he would give up everything he has—sound system, television, VCR, new bike—just to have the father home with the family. With this one statement the son breaks the assumed spell of material possessions; at the same time, it is clear that the son realizes the impossibility of the trade and is therefore able to keep his things.

Although the mother is not seen in either of the physical spaces, or in the video, her presence and influence are clearly felt; both father and son refer to her with great respect. Reflecting the realities of many contemporary households, the unseen woman holds the family together. Osorio felt it was important to present private lives in a positive way, without relying on sentimentality or avoiding difficult issues like incarceration, divided families, honesty, and dreams.

Osorio, like other activist artists—John Ahearn and Rigoberto Torres, or Tim Rollins & KOS—is interested not in speaking *to* a community, but involving that community in the process of creating art. He realizes that a community will be interested in the process if the artist accepts its concerns and makes them his own. Osorio is therefore gradually bridging the gulf between the world of artists and pure ideas and the spaces occupied by translocated individuals whose concepts of self-identity are rarely, if ever, discussed within the group and completely unknown to those outside its invisible cultural parameters. As Osorio states,

> My work is looking at prevailing concepts and stereotypes of who Latinos are. I've always looked at it as if I put someone on a cliff and I say 'go ahead, jump.' Either the spectator flies or falls. . . . This is the way I transform, actually confine, our lives into an object.[7]

Andrew Connors

Notes

1. Author's interview with the artist, 29 June 1995.
2. Ibid.
3. Much of the biographical information about the artist was drawn from Susana Torruella Leval, *Con To' Los Hierros: A Retrospective of the Work of Pepón Osorio* (New York: El Museo del Barrio, 1991).
4. Pepón Osorio, quoted in Jonathan Mandell, "The Chronicler of El Barrio," *New York Newsday*, 20 June 1991: 70.
5. Author's interview with the artist, 29 June 1995.
6. Ibid.
7. Ibid.

Frank Romero

IT CAN BE DIFFICULT BEING TYPECAST BECAUSE IN ONE SENSE YOU ALWAYS WANT TO BE MAINSTREAM. I WANT TO BE KNOWN AS AN AMERICAN ARTIST AND OF COURSE I AM. BUT I DON'T HAVE ANY QUALMS ABOUT BEING MANY THINGS. I'M VERY PROUD THAT I'M CHICANO. . . . IT DOESN'T MAKE ME LESS AMERICAN. I THINK IT MAKES ME MORE AMERICAN.[1]

Frank Romero comes from a background that is quintessentially American, but it was only in the mid-1970s, when he became identified with a distinct minority as a member of the Chicano artists group "Los Four," that he received his first significant professional recognition. His father's family had lived for several generations in New Mexico before moving to Los Angeles, while his mother's family had settled originally in Texas. Romero grew up in East Los Angeles, which has long had a large Latino community, but, according to Romero, "it certainly wasn't a 'little Mexico.' There were a lot of Eastern European Jews, Japanese, and White Russians."[2] In Romero's neighborhood, Boyle Heights, a mixture of ethnic groups defined the character of the community, much like New York's Lower East Side in the early 1900s. The Romeros spoke English at home. Once he began to be identified with the Chicano art movement, Romero had to learn Spanish. He sheepishly admits that his wife, Nancy, of Russian-German heritage, speaks it better.

In 1974 several California museums, including the Los Angeles County Museum of Art, hosted an exhibition of "Los Four," an art collective that included Romero, his close friend Carlos Almaraz, Gilbert Luhan, and Beto de la Rocha.[3] Romero was thirty-three at the time and already a fully formed artist. As he put it, "My earliest recollections are of doing drawings and being an artist. I was accomplished by the time I was in kindergarten."[4] His innate talent was enhanced by early training at the Otis Art Institute, where he studied on a Parent-Teacher Association scholarship. Artists working there, such as Joseph Mugnaini, Howard Jepson, Paul Landacre, and Peter Voulkos, became role models. Romero also found himself drawn to the work of Edward Hopper, Ben Shahn, and Rico LeBrun.

During his years at California State College in Los Angeles, Romero met Almaraz, who was no more technically skilled but was able to introduce him to the practical realities of being an artist. After college, Almaraz moved to New York, hoping to make his reputation there; Romero joined him in 1968. Nothing about the New York art world seemed hospitable to these Southern

Fig. 64. Frank Romero
The Closing of Whittier Boulevard
1984, oil on canvas, 182.9 x 304.8 cm (72 x 120 in.).
Collection of Peter U. Schindler, ©1984 Frank Romero

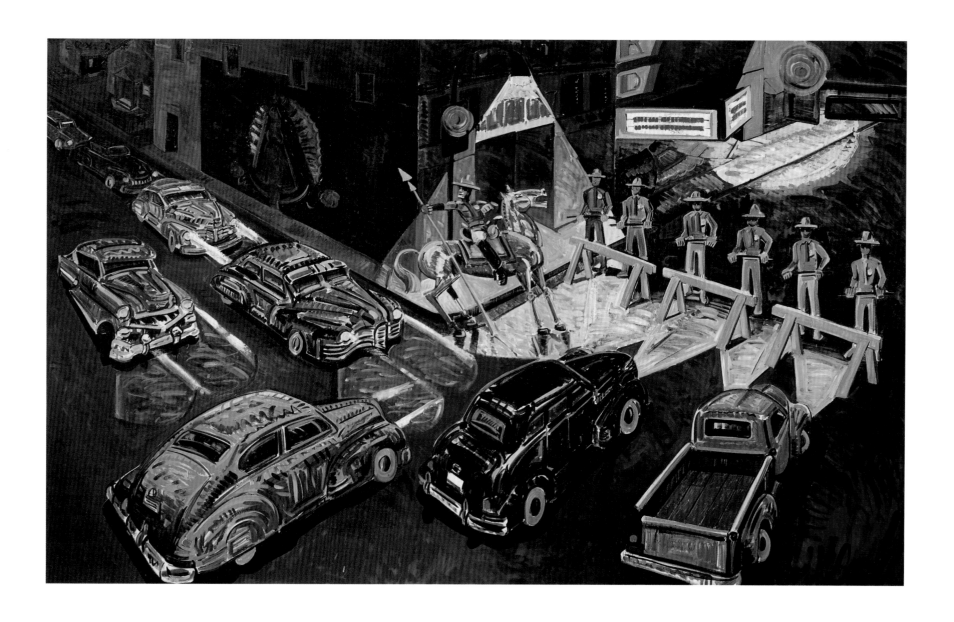

California natives. Minimalism was king, and colorful, figurative oil painting was out. Space was hard to come by; having a car, essential to a Californian, was a privilege of the more affluent. They rented a studio from Minimalist sculptor Richard Serra, which symbolizes their fish-out-of-water experience.

The Chicano civil rights movement had been building since the late 1960s, and by 1971, when both Romero and Almaraz had resettled in Los Angeles, artists were beginning to play a noticeable role.[5] Trips to Mexico, where they experienced the part of their heritage represented by muralists José Clemente Orozco and Diego Rivera, and political discussions with fellow artist Gilbert Lujan eventually led Almaraz and Romero to join with Lujan and de la Rocha in establishing "Los Four." Romero has acknowledged the consciousness-raising process that finally brought him to his activist role: "At the time, the term [Chicano] was totally alien to me. I didn't like it. I came out of that melting pot where it says we're all American."[6] And even during the height of his political consciousness, he maintains he was always "more concerned with art issues" than with politics.[7]

Nevertheless, Romero found himself first validated by the art establishment as a Chicano artist and a member of a group that had political associations. Before the milestone exhibition "Los Four" at the Los Angeles County Museum in 1974, the group had shown together and produced outdoor murals in East Los Angeles. But it was the exhibition—the first major museum show of Chicano artists—that brought both the artists and the Chicano art movement official status in the larger art community.

The exhibition featured a thirty-foot mural executed in spray paint. Romero remembers the importance of color in the show—"also content, expressionism that spoke directly to people"[8]—and the exhibition's unexpected impact: "People really responded to that show. It wasn't meant to be a major show. It was actually a small show in the back room and it sort of got out of hand. Actually, it broke attendance records at the County Museum."[9]

Not everyone was happy with the exhibition. *Artforum*'s critic Peter Plagens questioned the artists' sincerity and authenticity, suggesting that they deserved little praise since, even if they represented a legitimate aesthetic, these four "had been corrupted" by art schools and other affiliations with the establishment.[10] By this reasoning, only uneducated Chicano artists could be trusted to be "real" Chicano artists. The review reflects the dilemma then faced by these artists. The public was interested in them primarily as Chicano artists, but living with that label meant

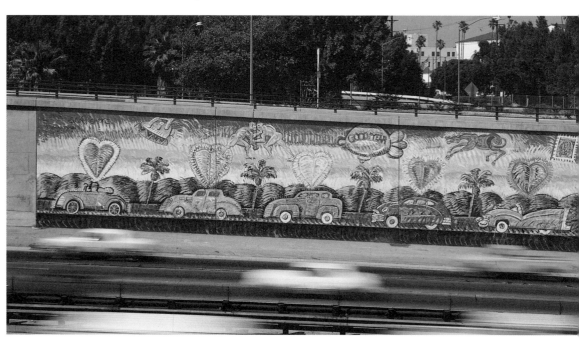

Fig. 65. Frank Romero
Going to the Olympics
1984, acrylic on concrete, 670.6 x 3,139.4 cm (22 x 103 ft.). Collection of the City of Los Angeles, ©1984 Frank Romero

Fig. 66. Frank Romero
The Death of Ruben Salazar
1986, oil on canvas, 182.9 x 304.8 cm (72 x 120 in.). National Museum of American Art, Smithsonian Institution, Museum purchase made possible in part by the Luisita L. and Franz H. Denghausen Endowment, ©1986 Frank Romero
(opposite)

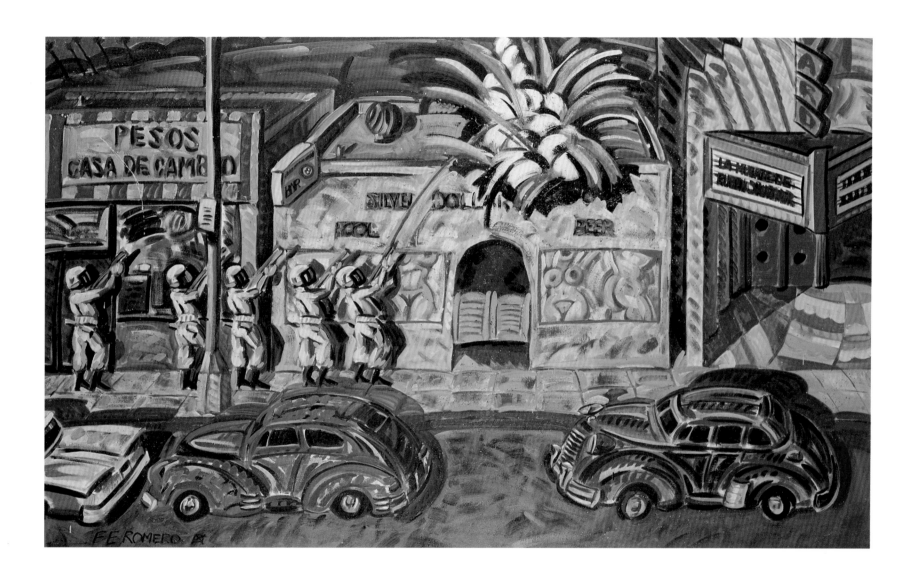

any deviation from the stereotype could lead critics to dismiss their work.

Fortunately for Romero, his association with "Los Four," which continued for several years after their landmark exhibition, had positive consequences for his career in several respects. It brought recognition for his work as well as that of other artists of Mexican-American background, which helped to validate the cross-cultural elements characterizing their styles. "Los Four" also allowed him to participate in the Chicano civil rights struggle. Moreover, Romero's street-art activities with the group taught him how to reconcile issues of content and style, bringing him into the mature phase of his art. "There was a tremendous period of growth," he said, "I learned . . . how to be a professional artist."[11]

Despite the star status Romero enjoyed after the exhibition, he claims he didn't sell a work of art for many years. Continuing to support himself as a designer until the mid-1980s (working much of the time for Charles Eames), he produced a prodigious number of paintings, employing his distinctive vocabulary of images evoking the urban environment of Los Angeles, the open spaces of the Southwest, and the simplicity and warmth of Mexican folk art. Bright reds and blues dominate the broadly painted, richly pigmented compositions depicting "low riders"— generic cars derived from late 1940s Chevrolets—hearts, horses, freeways, flying machines, and cityscapes.

By 1983 Romero's professional stature was such that the organizing committee for the Olympics selected him to paint a large mural celebrating the 1984 games in Los Angeles. Romero's whimsical composition of fantasy cars in rainbow colors, set off by fanciful hearts and cartoon palms, transports viewers to the L.A. of their dreams (fig. 65). Even when Romero's works deal with unhappy subjects like death, they are exuberant and irresistible. About such works he says, "I do very serious paintings about pain and suffering, but they are done with a Latino sensibility, where we laugh at death."[12]

Some of Romero's most serious paintings were to come soon after the Olympics project. Following the years of "Los Four," Romero stayed away from overtly political subjects, but his three major paintings in this genre, dedicated to a series of violent confrontations between the police and members of the East Los Angeles Chicano community in 1970, are among his masterpieces: *The Closing of Whittier Boulevard* (fig. 64), *The Death of Ruben Salazar* (fig. 66), and *The Arrest of the Paleteros* [ice cream vendors] (figs. 5, 67).

The Chicano rights movement, fueled by the Vietnam antiwar protests, reached its height in the early 1970s. Demonstrations in East Los Angeles often brought police officers sent by the county sheriff as well as the local Los Angeles police. The relationship between the Chicano community and the police had long been strained; the rallies and demonstrations served only to further estrange them, resulting in many episodes of violence and injury to Chicano residents. Romero says these paintings "grew out of the Chicano movement and Los Four period. They came later because I thought about them for so long. They are exhausting to do emotionally. It takes me three or four years to do an image. For *The Closing of Whittier Boulevard,* I had actually seen that event, which was the first time county sheriffs closed up the street. . . . It took me

Fig. 67. Frank Romero
The Arrest of the Paleteros (in progress)
oil on canvas, diptych, overall dimensions:
243.8 x 365.8 cm (96 x 144 in.). Courtesy the artist
©1996 Frank Romero

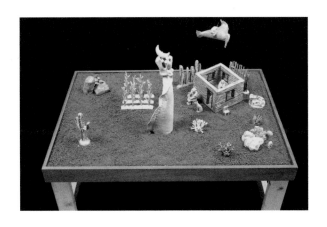

almost fifteen or seventeen years to put that image down. And the same with *Ruben Salazar*. I just thought about it till the image finally jelled."[13]

The incident depicted in *The Death of Ruben Salazar* represents one of the bitterest events in the history of the Chicano struggle. On August 29, 1970, thousands of demonstrators participated in a Vietnam War moratorium march through East Los Angeles that ended with the group gathered for a program in Laguna Park. An attempted theft nearby provided the sheriff with an excuse to send in several hundred deputies who, with clubs and tear gas, forcibly dispersed the surprised crowd. "By this time deputies numbered over 500. They moved in military formation, sweeping the park. Wreckage could be seen everywhere: the stampede trampled baby strollers into the ground; four deputies beat a man in his sixties; tear gas filled the air."[14]

Later in the afternoon, after the crowds had thinned and the arrested demonstrators had been bused away, Salazar, an investigative reporter for KMEX-TV, the Spanish-language station, joined some journalist friends for a beer in the nearby Silver Dollar Bar. A historian recounted the chilling sequence of events: "Soon afterward deputies surrounded the bar allegedly looking for a man with a rifle. When some occupants . . . attempted to leave, police forced them back. . . . Police claimed that they then broadcast warnings for all occupants to come out; witnesses testified that they heard no warning. . . . [The police] shot a 10-inch tear-gas projectile into the bar. . . . It struck Salazar in the head."[15] Salazar's unfavorable coverage of the police had brought threats on many occasions. His death and the subsequent exoneration of the policemen involved proved to many that the Chicano quest for justice was still a long way from resolution.

Romero's passionate rendering of the event communicates the horror associated with what in essence was a political crime. A formal tour de force, the work's visual impact combined with its explosive content puts us in the middle of this human-rights drama. The broad brushstrokes, strong color, and boldly defined shapes, together with the symbolic imagery used to evoke Los Angeles, make for a highly charged visual experience that underscores for all of us the tragic nature of this violent episode.

Romero's expertise as a painter of socially conscious themes is evident here. But he is an artist with a rich repertoire of symbols and subjects. An accomplished printmaker, photographer, sculptor, and ceramicist, he has developed his vision in many different media as well. In addition, he continues to do projects that have social relevance and contribute to the community in a concrete way. He has worked with high school students and inner-city disadvantaged youth to create public murals; he also has supported and contributed art to a Los Angeles organization providing legal help to victims of police misconduct. Above all, Romero has chosen to dwell more on the joys and pleasures of life than on its disasters. His enchanting ceramic landscape ensemble, *Pingolandia* (fig. 68), neon sculptures, and vibrant paintings are the creations of an artist determined to demonstrate our triumphs as well as our tragedies.

Jacquelyn Days Serwer

Fig. 68. Frank Romero
Pingolandia
1982, clay, red earth, and wood, overall dimensions: 304.8 x 213.4 x 213.4 cm (120 x 84 x 84 in.). Collection of the artist, ©1982 Frank Romero
(opposite)

Notes

1. Frank Romero, quoted in Steven Durland, "Frank Romero and Los Four," *High Performance*, no. 35 (1986): 43.
2. Ibid. The artist added more detail to the quotation in comments to the author, 18 December 1995.
3. The University of California, Irvine, and the Oakland Museum were the other two museums hosting the show.
4. Romero, quoted in Marva Marrow, *Inside the L.A. Artist* (Los Angeles: Peregrine Smith Books, 1988).
5. See Steven Durland and Linda Burnham, "Art with a Chicano Accent: An Interview with Denise Lugo-Saavedra on the history of Chicano art in Los Angeles," *High Performance*, no. 35 (1986): 41–44, 50.
6. Romero, quoted in Durland, "Art with a Chicano Accent," 43.
7. *Chicano Art: Resistance and Affirmation, 1965–1985* (Los Angeles: Wight Art Gallery, University of California, 1991), 356.
8. Romero, quoted in Todd Gold, "Painting the Streets of L.A.," *Southwest Profile* (November–January 1992–93): 1.
9. Collette Chattopadhyay, "A Conversation with Frank Romero," *Artweek*, 3 September 1992, 23.
10. See Peter Plagens, "Review: 'Los Four,'" *Artforum* (September 1974): 87–88.
11. Romero, quoted in Gold, "Painting the Streets of L.A.," 17.
12. Romero, quoted in Lisa McKinnon, "At a Museum Near You! Carnegie Survey of Frank Romero work is cause for exclamation," *Star-Free Press*, 11 September 1992, 3.
13. Chattopadhyay, "A Conversation with Frank Romero," 23.
14. Rodolfo Acuna, *Occupied America: A History of Chicanos* (Northridge: California State University, 1989), 347.
15. Ibid., 348. For a full discussion of the incident and its aftermath, see the following articles from the *New York Times*: Robert A. Wright, "East Los Angeles Calm After Riot," 31 August 1970, 32; and "U.S. Inquiry Urged For A Riot Victim," 1 September 1970, 23.

Roger Shimomura

USING IMAGES FROM MY PAST AND IMMEDIATE ENVIRONMENTS, FROM EARLIER AND CURRENT WORK AND USING THEM AS CULTURAL METAPHORS, I BECAME A DISPASSIONATE VIEWER OF MY OWN LAYERING SYSTEM.[1]

Roger Shimomura experienced an epiphany in 1971 that would establish a new direction for his art. A third-generation Japanese American and a native of Seattle, he had begun teaching art at the University of Kansas, Lawrence, two years earlier. While attending a local auction, Shimomura encountered a farmer who expressed incomprehension at the artist's American nationality and made reference to a book on Japanese art he was sure would be of interest to Shimomura. The incident led Shimomura to reexamine the relationship between his American identity and his Japanese heritage. The result was *Oriental Masterpiece,* the first in a series of many paintings and performance pieces that derive from Shimomura's ironic mix, or "layering," of Japanese imagery and American popular culture (fig. 69).

As Shimomura describes it, earlier "paintings and serigraphs . . . were directly inspired from all the toy stuff I was collecting. . . . They were large acrylic paintings that contained such things as Buck Rogers' space ship, the Big Bad Wolf, Dick Tracy, Minnie Mouse, et al. . . . At that point . . . I realized that the only difference between Minnie Mouse and one of Utamaro's beauties was race."[2] Shimomura's exploration began as an intellectual exercise, but his efforts soon led to a more profound understanding of his complex personal history and its relevance to his life as an artist. In speaking of the shift in focus away from American Pop icons towards Japanese-inspired imagery, he says, "I didn't realize the gravity of that shift. It was a reintroduction to my own background."[3]

Having survived and largely repressed the trauma of his family's internment during World War II and a childhood spent in the racially insensitive environment characteristic of the United States in the 1950s, Shimomura had learned to minimize his differences with mainstream white America. The "Oriental Masterpiece" series marked the beginning of the process that allowed Shimomura to reclaim the Japanese part of his heritage and to reconcile it with his upbringing and orientation as an American.

Fig. 69. Roger Shimomura
Oriental Masterpiece #19
1974, acrylic on canvas, 152.4 x 152.4 cm (60 x 60 in.). Private collection, Seattle. Courtesy Steinbaum Krauss Gallery, New York

Fig. 70. Roger Shimomura
Suburban Love
1995, acrylic on canvas, diptych, 213.4 x 182.9 cm (84 x 72 in.). Courtesy Steinbaum Krauss Gallery, New York
(opposite)

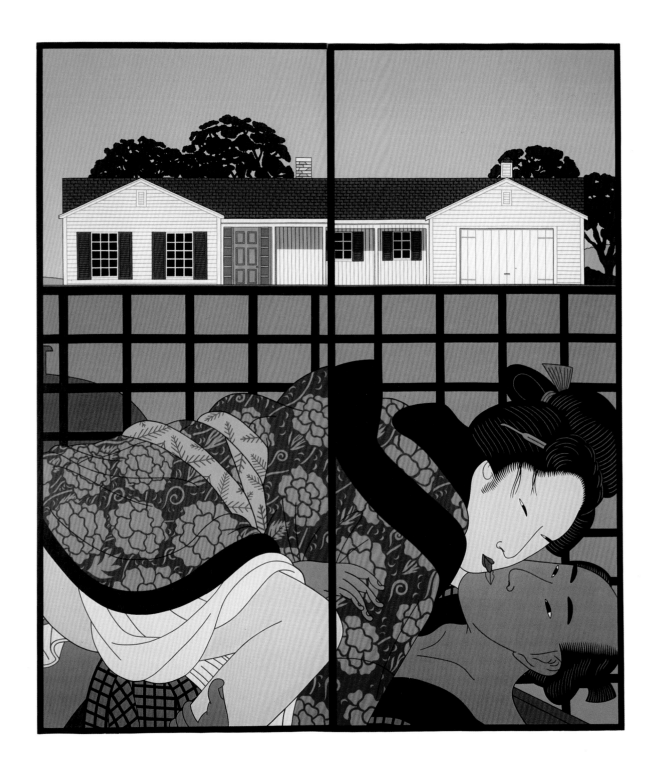

Shimomura's discovery of a rich collection of family documents and memorabilia after the death of his grandparents inspired the artist to examine their lives as immigrants to the United States and, most importantly, the part of their lives he shared most intimately with them—the internment years at Camp Minidoka in Idaho's Snake River Valley. The celebration of his third birthday there in 1942, with his parents and grandparents, is one of Shimomura's earliest and most vivid memories (fig. 22).[4]

In keeping with mid-century American attitudes, Shimomura did not pursue formal training in the language or culture of his forebears. When he began to examine his grandmother's extensive series of diaries—there were more than fifty years of diaries beginning with her arrival from Japan in 1912 and continuing until her death in 1968—he required the services of a translator. The diaries from the war years proved to be especially evocative, reviving early memories for Mrs. Shimomura's grandson and inspiring in him both the desire to commemorate this reprehensible episode in our nation's history and to share its lessons with a new generation of Americans.

Between 1980 and 1983, Shimomura completed twenty-five paintings in the "Diary" series, each paired with a specific excerpt. Uniform in size and style, these paintings constitute a powerful collection of formally and emotionally compelling images. The flat, hard-edged forms and bright colors Shimomura uses to depict his shoji screens and kimonoed figures derive from his familiarity with *ukiyo-e* woodcuts and his admiration for the slick Pop Art images of artists such as Andy Warhol and Roy Lichtenstein. Shimomura refers to this tendency as his "love of painting flat."[5] Here Japanese figures and decorative forms are combined with elements from the more mundane world of 1940s America—a radio, an apple pie, a Bible, and a silhouette of

Fig. 71. Roger Shimomura
Diary: December 12, 1941
1980, acrylic on canvas, 127.6 x 152.4 cm (50¼ x 60 in.). National Museum of American Art, Smithsonian Institution, Gift of the artist

Fig. 72. Roger Shimomura
Return of the Rice Cooker
1994, acrylic on canvas, diptych, 147.3 x 137.2 cm (58 x 54 in.). Courtesy Steinbaum Krauss Gallery, New York (opposite)

Shimomura's discovery of a rich collection of family documents and memorabilia after the death of his grandparents inspired the artist to examine their lives as immigrants to the United States and, most importantly, the part of their lives he shared most intimately with them—the internment years at Camp Minidoka in Idaho's Snake River Valley. The celebration of his third birthday there in 1942, with his parents and grandparents, is one of Shimomura's earliest and most vivid memories (fig. 22).[4]

In keeping with mid-century American attitudes, Shimomura did not pursue formal training in the language or culture of his forebears. When he began to examine his grandmother's extensive series of diaries—there were more than fifty years of diaries beginning with her arrival from Japan in 1912 and continuing until her death in 1968—he required the services of a translator. The diaries from the war years proved to be especially evocative, reviving early memories for Mrs. Shimomura's grandson and inspiring in him both the desire to commemorate this reprehensible episode in our nation's history and to share its lessons with a new generation of Americans.

Fig. 71. Roger Shimomura
Diary: December 12, 1941
1980, acrylic on canvas, 127.6 x 152.4 cm (50¼ x 60 in.).
National Museum of American Art, Smithsonian
Institution, Gift of the artist

Fig. 72. Roger Shimomura
Return of the Rice Cooker
1994, acrylic on canvas, diptych, 147.3 x 137.2 cm (58
x 54 in.). Courtesy Steinbaum Krauss Gallery, New York
(opposite)

Between 1980 and 1983, Shimomura completed twenty-five paintings in the "Diary" series, each paired with a specific excerpt. Uniform in size and style, these paintings constitute a powerful collection of formally and emotionally compelling images. The flat, hard-edged forms and bright colors Shimomura uses to depict his shoji screens and kimonoed figures derive from his familiarity with *ukiyo-e* woodcuts and his admiration for the slick Pop Art images of artists such as Andy Warhol and Roy Lichtenstein. Shimomura refers to this tendency as his "love of painting flat."[5] Here Japanese figures and decorative forms are combined with elements from the more mundane world of 1940s America—a radio, an apple pie, a Bible, and a silhouette of

Fig. 73. Roger Shimomura
After the Movies, no. 2
1994, acrylic on canvas, triptych, 121.9 x 142.2 cm (48
x 56 in.). Courtesy Steinbaum Krauss Gallery, New York

Fig. 74. Roger Shimomura
The Princess Next Door
1995, acrylic on canvas, diptych, 94 x 91.4 cm (37 x 36 in.).
Courtesy Steinbaum Krauss Gallery, New York
(opposite)

Superman all make an appearance.

The painting entitled *Diary: December 12, 1941* (fig. 71), based on an entry dated five days after the attack on Pearl Harbor, is especially effective in suggesting the psychological dynamics of guilt, fear, and resignation involved in the Japanese-American dilemma created by that event.[6] His grandmother's words express only sadness and gratitude towards the American authorities who have permitted members of the Japanese community to withdraw $100 in savings to sustain them during this period of uncertainty. Such an attitude is in keeping with the stoic behavior of the *Issei,* or first-generation Japanese immigrants. Shimomura uses the Japanese word *giri,* which means "hold it in and endure," to describe their way of coping.[7] But in the painting, he emphasizes a growing feeling of isolation and confinement, symbolized by the disposition of the converging screens that barely allows enough space for the figure. He also transforms the iconic outline of a normally benign Superman into a menacing shadow that threatens the fragile tranquillity of his grandmother as she meditates on the ominous prospects for the future.

Judged in purely formal terms, Shimomura has devised a lively composition of crisp, colorful forms functioning in a complex framework of angles and grids. The painting's attractiveness belies its serious content, which has the effect of sending a more palatable but no less disturbing message. In the 1985 catalogue for an exhibition of the "Diary" series, the author commented on their seemingly contradictory character, noting that the "dichotomy between craft and subject" is probably "appropriate, like memory brought back into focus."[8] Reflecting on the series, Shimomura explained his attitude in more colorful language: "It has always been of paramount importance to me that my work, beyond anything else, have visual interest. [These] paintings . . . were the most exciting to work on because I have to deal with the relationship between political (literal) and visual issues; in this case maybe a little like putting perfume over body odor."[9]

The late 1980s and 1990s have seen Shimomura apply his creative energies to experimental media such as performance art and installations, as well as to painting and printmaking. He has found the performance medium particularly suited to presentation of the documentary material concerning his family's history and all its political and social implications.

The Last Sansei Story (1993) is his most elaborate and fully realized theatrical piece to date. Utilizing actors, audio and video tapes, slides, and family oral history, as well as the diaries, he has organized the presentation into three parts corresponding to the three generations of his Japanese-American family: *Issei, Nisei,* and *Sansei.* A powerful mix of visual, aural, and live theater, it dramatizes the real-life story of the Shimomuras while touching on the universal themes of family pride, perseverance, and survival, and the difficulty of negotiating a path between racial stereotypes and a heritage-denying form of assimilation. Shimomura has said that "such a project does not come easily . . . because I still consider myself primarily a painter who has an adjunctive interest in performance art."[10] The second part of *The Last Sansei Story* effectively combines the two media, as each act corresponds to a painting in the "Diary" series.

99

Shimomura has also expanded his repertoire to include site-specific installations. Perhaps the most spectacular to date has been *Yellow Potluck* (1994), created for a storefront space near New York's Times Square; it was part of the 42nd Street Artists' Project that featured an entire neighborhood of installations along this urban thoroughfare. Irony and comedy based on the complex juxtaposition of cultures in America and the resulting confusions and reversals provide the background for Shimomura's provocative piece. During the months the installation was on view, he used the space as the setting for another performance work entitled *Yellow No Same*.

An installation featured in his 1996–97 traveling retrospective exhibition, organized by the Spencer Museum of Art in Lawrence, Kansas, focuses on the by now familiar theme of the three generations of his Japanese-American family. It presents a series of triptych "walls"—*Issei, Nisei, Sansei*—"partially physical, partially illusionary, each serving as either an internal or external wall with clear references to that particular generation."[11] As in the performance pieces, video, slides, voice recordings of his grandparents, along with such unique items as his grandmother's midwifery bag with instruments, autograph books, and photographs, provide a vivid sense of the grandparents' role in America's past that resonates with all of us.

In a series of paintings exhibited in the early 1990s, titled "The Return of the Yellow Peril," Shimomura presented a group of full-length portraits of Kansas friends and acquaintances. These works represent Shimomura's response to the xenophobic outcries in the popular press denouncing the influx of Japanese products and investment, the feared Japanization of America—in other words, the yellow peril. The poses, props, and costumes Shimomura incorporated into these portraits cleverly mimic Japanese art while also functioning as clues to the identity and interests of his non-Japanese sitters. The Beat generation author William Burroughs is depicted in a samurai outfit with a variety of firearms, as befits this celebrity known for his extensive gun collection (fig. 76). Shimomura's friend of Iranian background, Farah Esrafily, appears in a Japanese version of a *chador* surrounded by her beloved fishing gear. "All of the people I know personally," he said, "and I try to link them up in some way to a multicultural connection."[12]

Most recently, Shimomura has again enlisted humor as the disarming factor in a group of

Fig. 76. Roger Shimomura
William S. Burroughs, from the "Return of the Yellow Peril" series
1990, acrylic on canvas, 152.4 x 152.4 cm (60 x 60 in.).
Courtesy Steinbaum Krauss Gallery, New York

paintings he calls "Great American Neighbors." Several of these works have been selected for "Kaleidoscope." Growing out of his experience with the 42nd Street installation, the work deals with the artificial barriers that separate different races and cultures in America—symbolized by the brick walls and shoji screens that often dominate these compositions—as well as by the subtle and overt ways in which the cultures overlap. In these paintings, the overlap often occurs under hilarious circumstances. Split levels, barbecue grills, picket fences, and Superman are juxtaposed with kimonoed figures, rice cookers, and Japanese platform sandals to create a riotous cross-cultural mix. Paintings titled *Surburban Love, Return of the Rice Cooker,* and *After the Movies, no. 2* present us with tableaux of courting rituals that mock both Asian and American stereotypes (figs. 70, 72, 73).

But beneath the humor, Shimomura's paintings allude to the serious issues of racism, assimilation, and the complex interface of cultures involved in being an American of non-European descent. *The Princess Next Door* and *Beacon Hill Boy* together make a poignant statement about acceptance and marginality (figs. 74, 75). The little blonde girl, perfectly secure in her ballerina confection and admired from afar by her Asian-American neighbors, offers a clear contrast to *Beacon Hill Boy.* A stand-in for the young Shimomura, he feels neither totally American nor really Japanese, his status symbolized by the split canvas and the iconic American barbecue on one side and the empty Japanese sandals on the other. But resilient—even optimistic—despite his negative experiences, Shimomura exhorts us to move beyond the barriers into a more promising, if no less confusing, space where cultures cross and we are all the better for it.

Jacquelyn Days Serwer

Notes

1. Roger Shimomura, "Artist's Statement," *Roger Shimomura: Recent Paintings, Performance: the Trans Siberian Excerpts* (Cleveland: Cleveland State University Art Gallery, 1988), 5.

2. Shimomura, quoted in Joshua Kind, *Roger Shimomura: Diary Series* (De Kalb: Northern Illinois State University, 1983), 5.

3. Shimomura, quoted in Deloris Tarzan Ament, "Roger Shimomura's art speaks of painful history of racism," *Seattle Times,* 9 July 1992, C4.

4. See *Memories of Childhood* (New York: Steinbaum Krauss Gallery, 1994), 40–41.

5. Kind, *Diary Series,* 4.

6. The diary excerpt reads as follows: "I spent all day at home. Starting from today we were permitted to withdraw $100 from the bank. This was for our sustenance of life, we who are enemy to them. I deeply felt America's large-heartedness in dealing with us."

7. Artist's statement for Intermediary Arts/McKnight Interdisciplinary Fellowships, 1995.

8. Kind, "Introduction," *Diary Series,* 2.

9. Ibid., 4.

10. "Introduction," *The Last Sansei Story* (performance script).

11. Arts/McKnight artist's statement.

12. Shimomura, quoted in Richard LeCompte, "Arts: Lawrence in Kimonos, A Multicultural Portrait Series," *Lawrence Journal World,* 5 May 1991, 10.

Historical Perspectives

David Bates

Frederick Brown

Hung Liu

Deborah Oropallo

Mark Tansey

Hung Liu, BABY KING (detail),
1995, oil on canvas

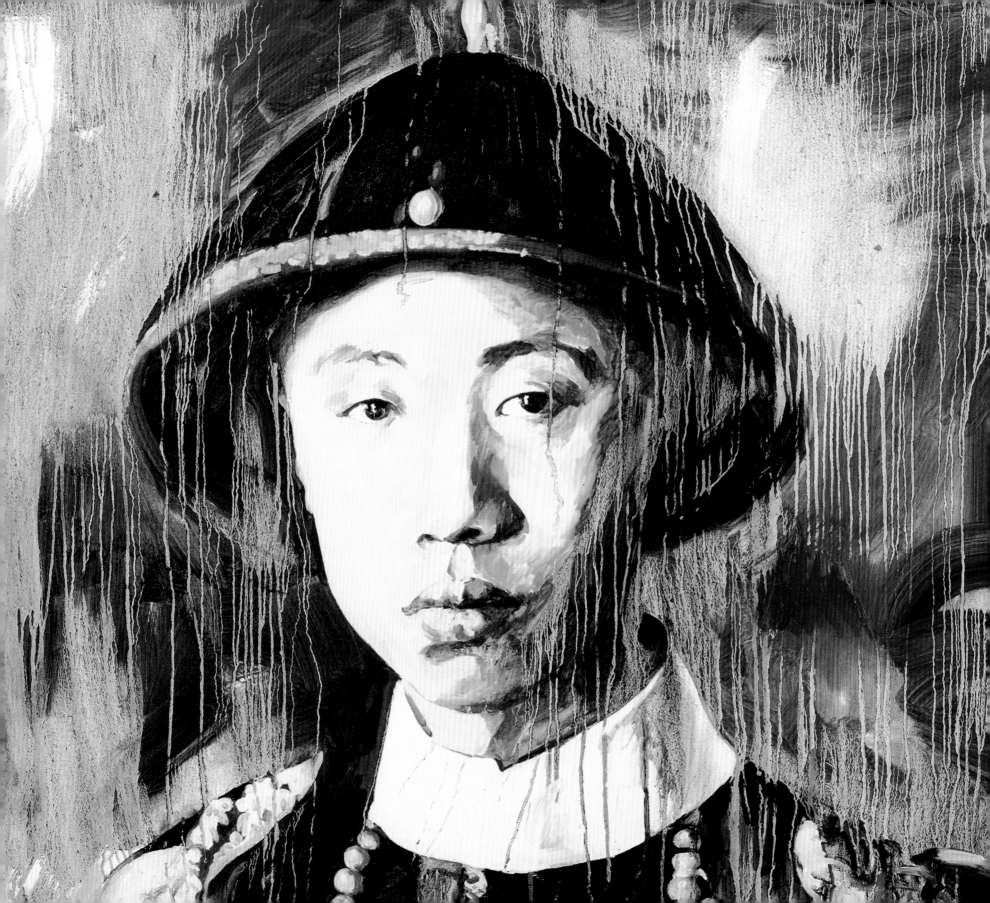

David Bates

I WANT OPEN-ENDEDNESS WITHIN THE NARRATIVE FORMAT—
NO JUDGMENTS, NO STATEMENTS, NO STORIES. IT'S ONLY
BACKDOOR NARRATIVE AND PARTIAL STORIES THAT I AM
INTERESTED IN AT THIS POINT.[1]

David Bates readily acknowledges that alternating between painting and sculpture has helped him meet different needs and effected periodic shifts in course. A decade ago he aspired to "true and complex dramas" in the paintings that first brought him national attention.[2] Today he strives for "partial stories" in the sculptures that have preoccupied him since 1993. Although Bates has moved from the explicit to the ambiguous, he continues to work, by his own admission, "within the narrative format." This inclination toward narrative has contributed to what he describes as his "fingerprint"—muscular combinations of the figurative and expressionistic and an emphasis on the integrity of man and nature—in paintings, drawings, and sculptures alike.

His artistic training in Texas and New York during the mid-1970s coincided with an unmistakable move toward change in the visual arts. Growing disillusionment with the exclusively formal and theoretical concerns of abstract, Minimalist, and Conceptual art incited young artists nationwide to develop alternatives for greater personal expression. This search for meaning has led Bates's generation in diverse directions—to metaphor, narrative, and critique, into autobiographical and cultural resources, and on to the fine and vernacular arts of different times and places.

That Bates considers regional and folk expression to be as inspirational as Spanish Baroque painting and Cubist abstractions suggests a leap of imagination befitting a tall tale. Yet the eclectic nature of his sources is in keeping with his Texas heritage. Bates was born and still resides and works in Dallas, where cultural and geographical duality has informed its history as a boundary between the Southeast and the Southwest. A comparable sense of duality challenged Dallas artists in the 1930s, when their efforts to blend the innovations of modernism with traditional southern values and subjects produced one of the country's most notable regional schools of painting at that time. Successive generations of artists not just in Dallas but throughout the South have pursued variations on the challenges of duality, usually exploring

Fig. 77. David Bates
Bait Shop
1994, acrylic and oil on canvas, 213.4 x 162.6 cm (84 x 64 in.). Collection of the artist. Courtesy Charles Cowles Gallery, New York

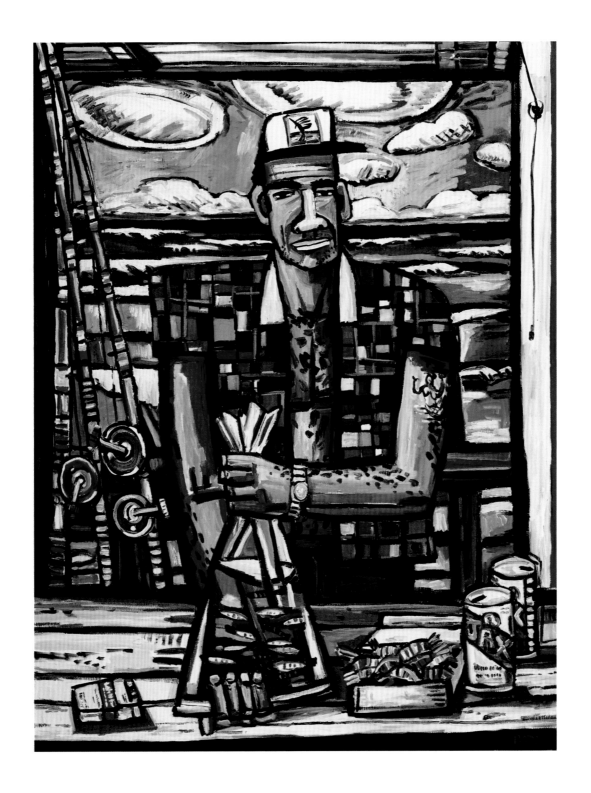

local culture as part of a larger national, often universal, picture rather than as a merely sectional statement.

A "storied region," according to folklorist Benjamin A. Botkin, the South has historically fostered oral, literary, and visual traditions with a distinctive narrative impulse.[3] Specificity of time, place, and character is often combined with a veneration of the everyday and handmade, while celebration of the eccentric, theatrical, or romantic is also prevalent. From folk tales to personal-experience narratives, storytelling is considered one of the region's primary means of channeling art into life. In laying claim to the South's narrative legacy, Bates would undoubtedly assert that his goal is exactly the reverse—endowing art with life.

That goal assumed greater clarity after 1979, when he renewed his interest in folk or self-taught artists, considered a wellspring of alternatives by many American artists since the 1920s (fig. 78). While his extensive knowledge of art history is evident, Bates views this knowledge as an inhibiting source of "cynicism and conservatism."[4] Growing up in a region rich in bottle trees, hand-lettered signs, carvings, and decorated yards, he associates folk art with unfettered creativity, "exactly the opposite to everything I had been taught. . . . It was non-pretentious, totally direct, . . . done by old great characters who have maximum personal integrity, [and it was art] that seemed to be about rural subject matter a lot of the time. It was a way of abstraction that was as important to me as Picasso's abstraction."[5] For Bates, then, endowing art with life has meant striving for vitality as much as allowing himself "to paint subjects that I really cared about—finding my own place that is special to me."[6]

Into the 1980s Bates pursued diverse subjects—friends, family, and the Texas landscape, as well as the state's popular culture, from barbecue restaurants to rodeos (Fig. 79). The evolution of a vigorous technique and expressive style was also evident in his figurative sculptures and paintings. So, too, was his ambition to work on a larger scale and his conscious incorporation of devices often associated with folk art, most notably emphatic patterning and an exuberant use of color and distortion. All of these elements coalesced at mid-decade, when Bates experienced an artistic breakthrough, triggered by a fishing trip to the Grassy Lake wildlife preserve in southwestern Arkansas in 1982. There he discovered "a place of strange beauty and complex compositions that changes completely from sunrise to noon. I knew I found something I couldn't learn in school or from other art and artists."[7]

From that encounter and numerous return visits emerged a series of

Fig. 78. William Edmonson
The Crucifixion
ca. 1932–37, carved limestone, 45.7 x 30.2 x 15.9 cm (18 x 11⅞ x 6¼ in.). National Museum of American Art, Smithsonian Institution, Gift of Elizabeth Gibbons-Hanson (left)

Fig. 79. David Bates
Fourth of July
1983, oil on canvas 182.9 x 152.4 cm (72 x 60 in.). Collection of the artist (below)

Fig. 80. David Bates
Male Bust #5
1995, painted wood, 188 x 121.9 x 61 cm (74 x 48 x 24 in.). The Barrett Collection, Dallas (opposite)

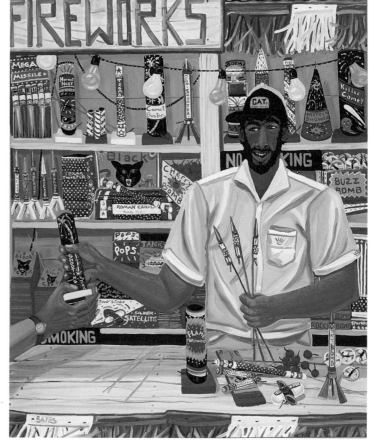

drawings and paintings of the area's cypress-swamp terrain, wildlife, and inhabitants. In each, a finely tuned tension between specificity and mystery exists, the product of an abundance of detail on the one hand and a palpable sense of awe, even transport, in the presence of nature, on the other. Not surprisingly, works such as *Anhinga* (fig. 81) and *Four Flags Trail* (fig. 82) have been perceived as both nostalgic and visionary. Yet Bates has not tried to recapture a lost history or simple view of the past, nor has he pursued the incredible or imaginary. The elemental grandeur of Grassy Lake is as real as it is timeless. The elderly fishing guides featured in many of the works embody the self-sufficient dignity of a lifestyle still so vital in a particular area that it inspires admiration rather than sentimentality across generations and even among outsiders.

Bates continued to apply these insights as he discovered new places and revisited favorite locales throughout Texas, Louisiana, and Arkansas. In 1988 and 1989 several trips to Galveston Island, where he had fished and vacationed since childhood, reaffirmed his attraction to the "water and the people who work it, the history of the place, its hurricanes, pirates, and other lore."[8] Soon he was painting full- and half-figure portraits of the area's commercial fishermen, still lifes featuring the Gulf of Mexico's bounty, from crabs to sheepsheads, and seascapes in which man's interaction with nature is often as prominent as the environment itself.

Standing on the Galveston beach for many years, an open-air bait shop provided the impetus for several works, including *Baits* (see page 6) and *Bait Shop* (fig. 77). In both examples, the weathered building's presence is minimal. A slice of countertop, hand-lettered signage, and folding blinds are all we see of "a place where the real folks were."[9] Used to compose a tightly framed scene, however, these few details define our view, directing us to an informal still life of bait and beer, to the rugged figure of a fisherman, and to a cloud-swept vista of surf and the Gulf of Mexico beyond.

Bates has an enviable flair for making details count on various levels. The sum of the individual vignettes from foreground to background is still life, portrait, figure study, and landscape—the principal categories in which he has always worked. A plastic bag of mullets, opened cans of a popular regional beer, and an unbuttoned shirt all convey the bait shop's atmosphere. Implicit also are the artist's powers of observation and self-discipline. He distilled impressions and memories, accumulated over time, in off-site preparatory drawings rather than sketching on the scene, out

Fig. 81. David Bates
Anhinga
1987, oil on canvas, 243.8 x 198.1 cm
(96 x 78 in.). Private collection. Courtesy
Charles Cowles Gallery, New York

Fig. 82. David Bates
Four Flags Trail
1984, oil on canvas, 182.9 x 152.7 cm
(72 x 60⅛ in.). Hirshhorn Museum and
Sculpture Garden, Smithsonian
Institution, Partial Gift of Charles Cowles,
and Museum Purchase, 1986

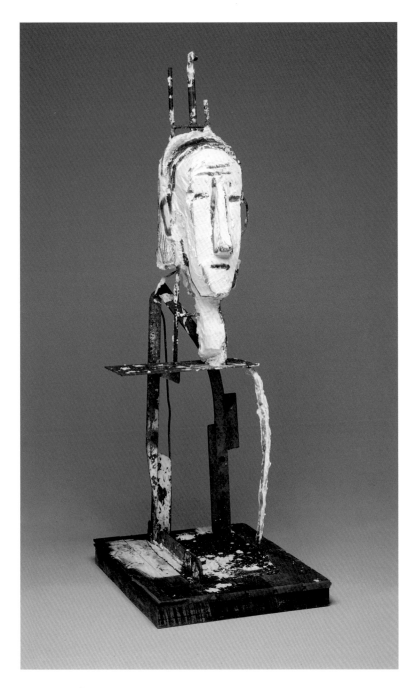

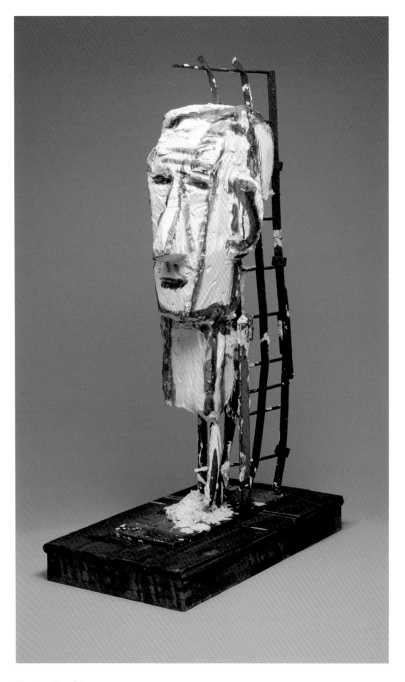

Fig. 83. David Bates
Female Head #1
1995, painted plaster and steel, 154.9 x 50.8 x 60.1 cm (61 x 20 x 24 in.). The Barrett
Collection, Dallas

Fig. 84. David Bates
Male Head #4
1995, painted plaster and steel, 96.5 x 33 x 61 cm (38 x 13 x 24 in.). Collection of the
artist. Courtesy John Berggruen Gallery, San Francisco

of deference to the fishermen who had gradually accepted him as an empathetic outsider.

In fact, the line between inside and outside is sharp and clear in these paintings. In descriptive and spatial terms, each figure occupies an interior space set against an outdoor backdrop. Symbolically, the countertop in the foreground delineates a boundary between the fisherman at home in his environment and the artist and viewer as voyeurs. Bates negotiates a relationship between the two worlds by emphasizing the hands holding the bag of bait fish in an experienced, matter-of-fact gesture, as if both he and the fisherman say, "Here, take it." Through this detail he transfers to us the insights he has gleaned from the latter's way of life.

Independent and hardworking, the men struggle to conquer nature to earn a living, yet learn to coexist with its cycles, dangers, and beauty. Like his "Grassy Lake" series, the Galveston paintings address the heroic and timeless in everyday and specific terms. We sense the artist's respect keenly in these scenarios, which also incorporate tongue-in-cheek clues to his sense of humor. Although he refers facetiously to *Baits* as his namesake painting, the wordplay is hardly accidental. In *Bait Shop,* the insignia of a sailfish on the fisherman's hat alludes to prized prey, while his mermaid tattoo suggests a fraternal badge of popular culture as well as the sea's longstanding myths and folklore.

Bates lures us with narrative detail and mood set within a deliberate structure. In *Baits* and *Bait Shop,* the centralized figure in frontal pose is assertively engaging, the repetition of receding horizontals acting as an insistent guide to the eye. The shrimp, casting rods, and shirt in *Bait Shop* incorporate patterns emphasizing variations on squares and stripes that enliven the surface, as do the staccato contrasts between light and dark. In these paintings, Bates voluntarily conjures lessons learned from diverse sources, among them Henri Matisse's sprightly goldfish paintings, Piet Mondrian's syncopated abstractions, and expressionistic portraits by Marsden Hartley and Diego Velázquez.[10] Dealing with an experience and its memory as the subject of a painting, he notes, invokes "ghosts from art history every time you pick up a brush," not because his goal is a contemporary version of one or another artist's work, but because he faces comparable, even traditional, challenges on formal and expressive levels.[11]

In the four years separating these two paintings, Bates began making, almost exclusively, wall reliefs and freestanding sculptures. The heavily manipulated surfaces and relief-like forms in the Galveston paintings had reawakened his interest in working three-dimensionally. He also aspired to greater spontaneity than his exacting painting technique and overt narrative approach provided. Having carved, modeled, and cast works over the past two decades, he believes that sculpture often does not convey an impression of immediacy because of its materials and techniques. Bates has nonetheless chosen this quality as his goal and daringly suggests that a good test of his recent sculptures "is what you'd think of them if you found them in the woods."[12]

His criteria imply not just surprise, accident, and discovery, but also fragments discarded or salvaged. Since 1993, Bates has intuitively assembled all manner of scrap materials—including foamcore, wood, paper, cardboard, and even parts of other sculptures—"slapped together and

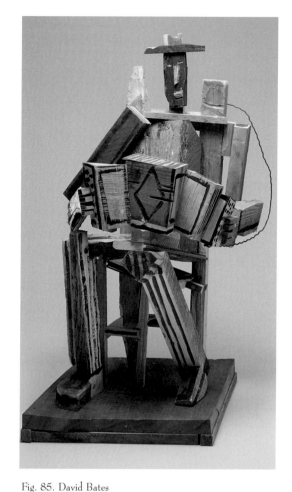

Fig. 85. David Bates
Zydeco #3
1994–95, painted wood and wire, 94 x 55.9 x 48.3 cm
(37 x 22 x 19 in.). Collection of the artist

cut apart," hot-glued here, wired there (fig. 80).[13] Ironically, he has explored this devil-may-care approach in the highly sophisticated setting of the Walla Walla Foundry in Washington State. Once Bates resolves a combination of forms, materials, and surfaces, a master carpenter strengthens the structure. The result is a relief or freestanding object built as sturdily as handcrafted furniture. Bates has kept pieces in this rugged, original state, with or without the finishing touch of color and other markings. More often, the foundry's professional staff has prepared them for casting in aluminum or bronze. Coloring completes the transformation, whether as patinas that simulate his characteristically strong palette or in the form of drawing and painting applied by Bates himself. So faithful to every nuance of the original materials is the casting process that each work, once polychromed, has attained the teasing ambiguity of trompe l'oeil in the most tangible sense.

The first group of sculptures produced in this fashion incorporated subjects directly quoted from his paintings. Elements such as a running dog, seated figure, or floral still life can still be read descriptively, yet their translation into projecting angles and open and closed spaces has extended their formal and abstract potential. As his confidence in working spontaneously has grown since 1995, his ties to overtly narrative goals have noticeably loosened. Considering versions made in 1993 to be too portrait-like, Bates made a sculpture, entitled *Zydeco #3*, a year later (fig. 85). This abstract composition of randomly selected wood parts catches the spirit and rhythm of the music that so thrilled him in southern Louisiana's dance halls and bars.

Most recently, Bates has constructed heads, busts, and skeletal figures in painted plaster and steel and mounted them in relief or in the round. Examples such as *Female Head #1* and *Male Head #4* (figs. 83, 84) attain the ambiguity and immediacy that he has set his sights on. Their weighty, even clumsy, feeling appeals to him as an aspect of sculpture that too seldom is enjoyed viscerally. Their openwork forms and sharp contrasts between light and dark convey the starkness and otherworldliness of fragments. Certainly, some "ghosts" flit about as the artist alludes to Greco-Roman sculpture and Picasso's Cubist constructions as much as to African objects and Mexican Day of the Dead figures in his recent sculpture. The implication of parts and settings missing and cultures forgotten or distant, however, lends these works evocative power and grandeur. They propose stories "still to be lived," but Bates will no longer complete them, whether for himself or his audience, in the interest of creating open-ended rather than concrete narratives.[14] Even as he now directs his energy to the physicality of materials and processes, however, the character of these sculptures reaffirms his abiding sense of humanism.

Lynda Roscoe Hartigan

Notes

1. Bates, conversation with the author, October 1995.
2. Artist's statement, in Annette Carlozzi, *50 Texas Artists: A Critical Selection of Painters and Sculptors Working in Texas* (San Francisco: Chronicle Books, 1986), 20.
3. Simon J. Bronner, "Storytelling," in Charles Reagon Wilson and William Ferris, eds., *The Encyclopedia of Southern Culture* (Chapel Hill: University of North Carolina Press, 1990), 488.
4. Bates, conversation with the author, October 1995.
5. Bob Dix, "Conversation with David Bates," *Shift Magazine* 1, no.2 (1988): 24–25.
6. Bates, quoted in Marla Price, *David Bates: Forty Paintings* (Fort Worth: Modern Art Museum of Fort Worth, 1988), 27.
7. Ibid., 10.
8. Steven A. Nash, "David Bates Then and Now," in *David Bates: Recent Works on Paper and Paintings,* (San Francisco: John Berggruen Gallery, 1989), 5.
9. Bates, conversation with the author, October 1995.
10. Ibid. Bates cites the famous Velázquez portrait of Juan de Pareja in the collection of the Metropolitan Museum of Art as a model for his portrait of the fisherman in *Baits.*
11. Ibid.
12. Ibid.
13. Ibid.
14. Ibid.

Frederick Brown

IN A CERTAIN SENSE, AMERICA IS A BEAUTIFUL MYTH. . . . IT HAS ITS DARK SIDES TO IT AND IT HAS LIGHT SIDES TO IT. . . . NO MATTER WHAT STORY YOU TELL, WHOEVER IS LISTENING WILL INTERPRET IT DIFFERENTLY FROM WHOEVER ELSE IS LISTENING.[1]

Frederick Brown, who paints large-scale figurative canvases in a freely brushed, highly colored expressionistic style, celebrates America's history, mythic past, and popular culture. Whether he depicts jazz musicians, urban folk heroes, or Native Americans, Brown's works concentrate on the spiritual and magical aspects of the subject presented.

Born in Greensboro, Georgia, on February 6, 1945, Brown grew up in a working-class neighborhood on Chicago's South Side. It was in this neighborhood of European immigrants, Hispanics, and African Americans who had migrated from the South that Brown learned to appreciate and respect the differences and similarities among all people.

After finishing Chicago Vocational High School, where he studied architecture, Brown attended Southern Illinois University in Carbondale, receiving a B.A. in art and psychology. Brown described his "real art education," however, as beginning when he moved to New York City in 1970.[2] There he was welcomed by some of the world's best-known musicians and artists. Not only did he study with them, but one, Willem de Kooning, became Brown's "artistic grandfather." It was de Kooning, according to Brown, who told him "to remember that art is a very old profession, which originated with the shaman in a cave. Basically it is magic and has healing qualities."[3] Indeed, even today, as if honoring de Kooning's advice, Brown rarely makes sketches before beginning a painting. "Sketches take as long to do as a painting," he explains. "When you are really painting, in the truest sense, it is sort of a shamanistic, magical act."[4]

In New York Brown also began to work collaboratively with jazz musicians Ornette Coleman and Anthony Braxton, combining visual art and music to create large, bold gestural abstractions. By the late 1970s and early 1980s Brown turned to figurative themes painted in a manner similar to that of the German Expressionists Emil Nolde and Max Beckmann. Critic Barbara Rose referred to Brown as a "rulebreaker" because of his expressionistic, assertive, antiphotographic style, as well as the subjects he chose to paint—individuals or types who are considered outlaws or rulebreakers themselves.[5]

Fig. 86. Frederick Brown
Black Elk
1992, oil on linen, 121.9 x 101.6 cm (48 x 40 in.).
Collection of Gerald L. Pearson

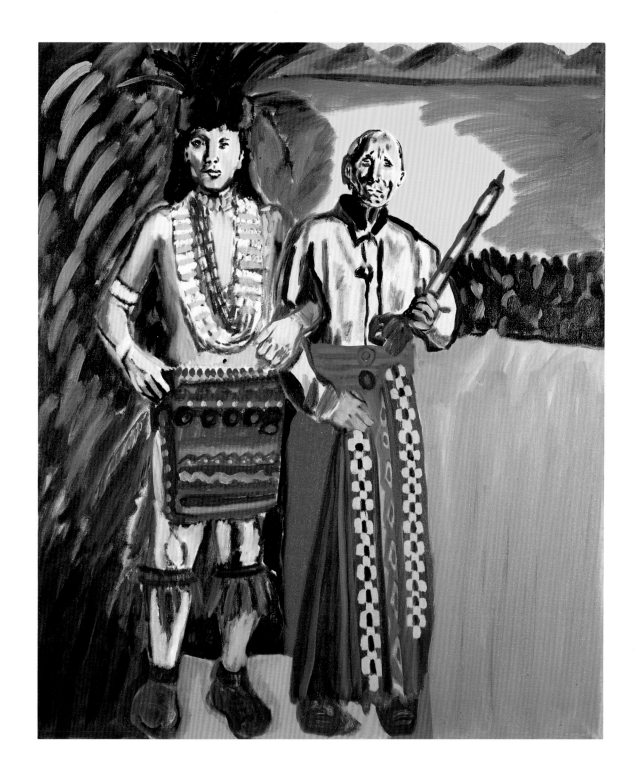

For example, the figures in *Stagger Lee* (fig. 12)—one of several paintings Brown created based on the theme of the blues song with the same title—pulsate with energy and excitement, as bright yellows, reds, and greens electrify the canvas surface. Stagger Lee is portrayed as a contemporary urban youth with dreadlocks and hightop sneakers. Instead of shooting Billy—the act immortalized in song—Lee is shown with a flock of white birds spurting from the smoking gun. Incorporating television sets, skyscrapers, a crucified Christ, and several empty crosses, Brown, as Regenia Perry writes,

Fig. 87. Frederick Brown
The Last Supper
1983, oil on linen, 213.4 x 640.1 (84 x 252 in.).
Collection of Bentley and Sebastienne Brown
(above)

Fig. 88. Frederick Brown
I Thought of Crazy Horse
1992, oil on linen, 121.9 x 101.6 cm (48 x 40 in.).
Collection of Sherry B. Bronfman
(opposite)

"weaves legend and fact and alludes to the complex and perhaps violent nature of American society."[6]

Brown's narrative is also constructed from American history, legend, and his personal life. The infamous "bad man" Stagger Lee is presented with a group of figures from America's mythic past—a Pilgrim dressed in black knee breeches and buckled shoes; Squanto, the Native American who served as interpreter and guide at Plymouth Colony, holding a peace pipe; and a figure with outstretched arms, wearing a pocket logo that reads "I Make it Work," representing the steelworkers in Chicago. The steelworker, in turn, refers to the fact that Brown, like his grandfather and stepfather, briefly worked in the steel mills in Chicago. There he met many men who had left their homes in Mississippi, Georgia, and Tennessee to find work. Many of these men brought with them blues and jazz music. In fact, musicians such as Howlin' Wolf, Muddy Waters, and Jimmy Reed lived in Brown's old neighborhood and were family friends.

Music remains an important part of Brown's work and his working environment. In the late 1980s he paid homage to several legendary blues musicians. While traveling in Europe in 1969, Brown met Chicago bluesmen Earl Hooker and Magic Sam at a music festival in Denmark. The musicians explained to Brown that even though they had an appreciative audience in Europe, they feared that after their deaths they would be forgotten. They therefore appealed to Brown to ensure that their legacy would not die; Brown agreed.

It was not until two decades later that Brown felt artistically competent to honor the promise made to his friends. Yet despite his familiarity with the musicians and their music, Brown was compelled to do further research before beginning to paint. He traveled south and visited the Delta Blues Museum in Clarksdale, Mississippi. He also met and interviewed musicians and senior members of the community who remembered the early bluesmen.[7]

Returning to New York, Brown began a series of large-scale portraits inspired by the lives

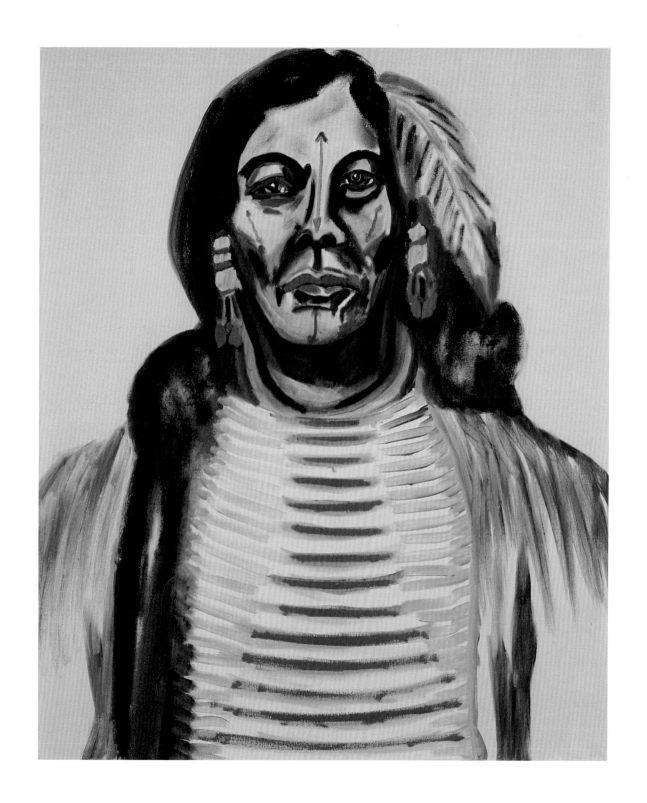

of pivotal blues artists. Using bold, expressive colors, these works are not photographic, but capture the essence of the renowned artists. Brown not only filled his studio with music, evoking the mood of each artist as he worked, but also believed that these paintings were an attempt to "get a feeling rather than just a likeness."[8] Likewise, friends, mentors, and colleagues who influenced Brown over the years inspired *The Last Supper* (fig. 87). In this monumental painting, Brown portrays the twelve men he credits with encouraging and supporting his development as an artist.[9]

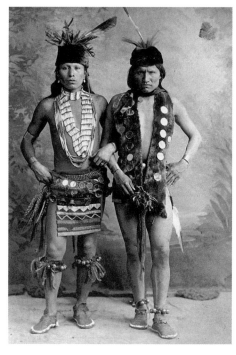

Fig. 89. Elliott and Fry, London, England, **Black Elk and Elk,** ca. 1880. National Anthropological Archives, Smithsonian Institution
(top)

Fig. 90. Joseph Epes Brown
Black Elk holding his sacred pipe
1947. National Anthropological Archives, Smithsonian Institution
(bottom)

Portraits continue to be an important focus in Brown's work. Whether he depicts the giants of twentieth-century art such as Picasso and de Kooning, or blues and jazz artists such as Jimi Hendrix and Ornette Coleman, Brown has an extraordinary ability to capture the individual through the eloquence of his brush. In fact, portraits comprise the majority of images in the "Magic Man" series, a group of twenty-five canvases produced in 1992. Described as "multicultural and multitraditional," these works are distinguished by a heroic format, intense color combinations, and impassioned brushstrokes typical of the artist's style.[10] The subjects, however, are an amalgam of cultural and personal iconography. Brown culled these subjects from his study of more than one hundred possible characters, many from Native American history and African-American music. As a whole, they allow us to "look into our inner lives and our communal history as human beings."[11]

In "American Kaleidoscope," Brown is represented by four works from this series, depicting individuals to be remembered for their spiritual convictions: *Black Elk, I Thought of Crazy Horse, Chief Seattle,* and *She Knows How* (figs. 86, 88, 91, 92). Brown, who traces his ancestry to African, European, Seminole, and Choctaw roots, was inspired after reading numerous historical and biographical accounts of Native American spiritual leaders. For example, Black Elk, leader of the Lakota nation, who was born in 1863, was discussed in John Neihardt's *Black Elk Speaks: Being the Life Story of a Holy Man of the Oglala Sioux.* Neihardt, the poet laureate of Nebraska, interviewed Black Elk on several occasions in 1930 and 1931. In his book, Neihardt recounts Black Elk's life and his visions for his people. Like his father and grandfather, Black Elk was a Lakota medicine man. However, unlike his ancestors, Black Elk converted to Catholicism in 1904.[12]

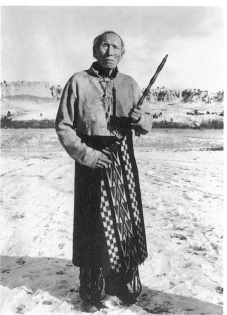

According to Brown, his portrayal represents Black Elk "with his younger self."[13] Indeed, Brown places the elderly shaman on the right. Shown holding a peace pipe, Black Elk is linked arm in arm with a youthful image of himself. Brown was inspired by two archival photographs of Black Elk (figs. 89, 90). One of them depicts Black Elk and his father, Elk, in a similar linked-arm pose. The photograph was taken in Europe, where they were touring with Buffalo Bill's Wild West show. In contrast to the photographs, Brown's painted figures stand in an abstract landscape with what appear to be rolling hills and green fields in the distance. By surrounding

Fig. 91. Frederick Brown
Chief Seattle
1992, oil on linen, 152.4 x 127 cm (60 x 50 in.). Collection of Timothy B. Francis

Fig. 92. Frederick Brown
She Knows How
1992, oil on linen, 152.4 x 127 (60 x 50 in.). Courtesy Gallery 10, Inc., Scottsdale

the head of the elderly Black Elk with an aura of yellow light and placing the two figures on a separate island of orange, the artist seems to emphasize the fact that Black Elk was unique among his people.

In *I Thought of Crazy Horse,* Brown captures the commanding presence of the defiant chief of the Oglala Sioux who was a distant cousin of Black Elk.[14] Like his cousin, Crazy Horse was also recognized as having visionary gifts. Brown alludes to Crazy Horse's spiritual powers in several ways. The torso, for example, is modeled in thin paint washes, giving the body an ethereal, transparent quality. Further allusions to Crazy Horse's spirituality are represented by the double-headed arrows adorning the nose, cheeks, and chin. According to the artist, these are symbols of the energy forces that flow from and through Crazy Horse.[15] Brown's invented image of the valiant leader who defeated General George Armstrong Custer at the Battle of Little Big Horn is riveting in its intensity.

Chief Seattle, Brown's depiction of the noted leader who frequently spoke about issues of land and water preservation in the Puget Sound region, is rendered in cool blues and greens. Brown's likeness is an arresting image of the impressive ruler who has been described as more than "six feet tall, broad-shouldered, and a powerful orator."[16] Chief Seattle also was converted to Christianity by Catholic missionaries, taking the Biblical name Noah.[17]

Not all of Brown's Native American images are based on historical figures; some have very personal meanings for the artist. *She Knows How,* for instance, was inspired by memories of Brown's grandmother, who was part Seminole. The artist fondly remembers that his grandmother proudly displayed her dual heritage by wearing her hair in long braids. Brown also recalls how people in the neighborhood recognized her as a visionary. Instead of rendering a photographic likeness of this matriarch, Brown pays tribute to her wisdom and longevity. Her face, brushed with broad strokes of warm browns and yellows, seems to glow from within. She has a timeless countenance, accentuated by the exaggerated wrinkles that take on the appearance of a vast southwestern landscape. Even her piercing gaze seems capable of looking into and reading one's very soul.

Like many contemporary artists, Brown sometimes bases his portrait works on photographs or reproductions. His use of appropriated imagery, however, is different from that of other artists who choose imagery as "nostalgia, irony or socio-political commentary. More importantly, he does not distance himself from his images, but tackles them directly and passionately."[18]

Constructed from diverse sources, both personal and historical, Brown's images are layered with meaning and references to what one critic describes as "emblems of American life which, improbably, hold us together as a people."[19] His paintings also speak to the ironies in America's past and hopes for its future. According to Brown, "America has a great, great history, but much of it is unwritten, and whole classes of people are not incorporated. Art should portray a future in which everyone participates—especially spiritually."[20]

Gwendolyn H. Everett

Notes

1. Frederick Brown, interview with author, 12 February 1993.
2. Liz Rolfsmeier, "Spirituality Key to Artist's Work: A New Dimension," *Discover,* 10 August 1993, 7.
3. Brown, quoted in David Grogan, "To Fred Brown, Blues are more than a Color on His Palette," *People,* 2 October 1989, 98.
4. Brown, quoted in Rolfsmeier, *Discover,* 5
5. Lowery Sims, "Frederick Brown: American Archetypes and Heroes," *Frederick Brown: Recent Painting 1981–1985, "Heroes and Rulebreakers"* (New York: Marlborough Gallery, 1985), 2–3.
6. Regenia Perry, *Free Within Ourselves: African-American Artists in the Collection of the National Museum of American Art* (Washington, D.C. and San Francisco: National Museum of American Art and Pomegranate, 1992), 45.
7. Eve Ferguson, "Art Sings the Blues," *Washington Afro-American,* 26 October 1991.
8. Brown, quoted in John Howell, "Painting the Blues: Fred Brown's Vivid Panorama of the Black Experience," *Elle* (August 1990): 27.
9. Sims, *Frederick Brown: Recent Painting 1981–1985,"* 2.
10. Barbara Cortright, "Frederick Brown, Spiritual Ambassador," *SouthWest Profile* (August–October 1992): 21.
11. Phillip J. Cohen, *Magic Man: New Paintings by Frederick Brown* (Scottsdale, Ariz.: Gallery 10, 1992), 1.
12. Paul R. Walker, *Spiritual Leaders* (New York: Facts on File, 1994), 103.
13. Brown, telephone interview with author, 7 September 1995.
14. Bree Burns, *Sitting Bull and Other Legendary Native American Chiefs* (New York: Crescent Books, 1993), 78. Also Walker, *Spiritual Leaders,* 96.
15. Brown, telephone interview with author, 7 September 1995.
16. Ralph Andrews, *Indian Leaders Who Helped Shape America* (Seattle: Superior, 1971), 163
17. Ibid.
18. Ruth Bass, "Frederick J. Brown," *Frederick Brown: Paintings 1986–1987* (New York: Marlborough Gallery, 1987), 2.
19. Cohen, *Magic Man,* 1.
20. Brown, interview with author, 13 November 1995.

Hung Liu

I HAVE EVERYTHING HERE IN THE PRESENT, BUT YOU CAN'T SEPARATE FROM THE PAST. . . . IT IS IMPORTANT TO BRING MY BACKGROUND INTO THIS CULTURE. . . . IT IS VERY PERSONAL.[1]

Hung Liu came of age in China during the decade of the Cultural Revolution. She not only witnessed a government's attempt to force a nation of nearly one billion people to purge itself of its national heritage, but as a teenager she felt the pressure to take an active role in destroying it. Although she resisted the authoritarian mandates that called for violence against traditional mores and cultural artifacts, and that closed schools and slowed production, she was nonetheless affected by their deleterious and widespread ramifications. These were ominous times for nearly everyone, including Communist officials already in power. The Cultural Revolution authorities, those in part responsible for the chaos, advocated the burning of books in private and public collections; archives, paintings, sculptures, and architecture were also fair targets for attacks. In order to realize the complete revolutionary transformation of the Chinese people, Mao Tse-tung demanded that even snapshots and other personal possessions redolent of Western or bourgeois values be eradicated as well. China was once again shut off from relations with the rest of the world. According to Chairman Mao, the Cultural Revolution was "destroying an old world so a new one could be born."[2] To accomplish this, people were ordered to perform the unthinkable: to forget their personal and national histories in order to realize a Communist future.

Liu's profound understanding of the intractability of history, and the necessity for thinking it through as a way to deal with the calamities of the nineteenth and twentieth centuries, is no doubt attributable to her experiences as a child and young adult. Working from documents that were meant to be destroyed during the Cultural Revolution, Hung Liu creates paintings endowed with the survivalist spirit of memories that could not be erased. Her canvases are painted evocations of history, usually inspired by forgotten photographic imagery—the results of hours spent mining archival resources in the United States and China (fig. 94). They often bestow monumental significance upon individuals, including her close relatives, who in many cases would not be remembered beyond their intimate circle of influence (fig. 95). The parallels

Fig. 93. Hung Liu
Children of a Lesser God
1995, oil on canvas with red lacquer boxes and cans, 182.9 x 203.2 x 7.6 cm (72 x 80 x 3 in.). Collection of Esther S. Weissman. Courtesy Steinbaum Krauss Gallery, New York

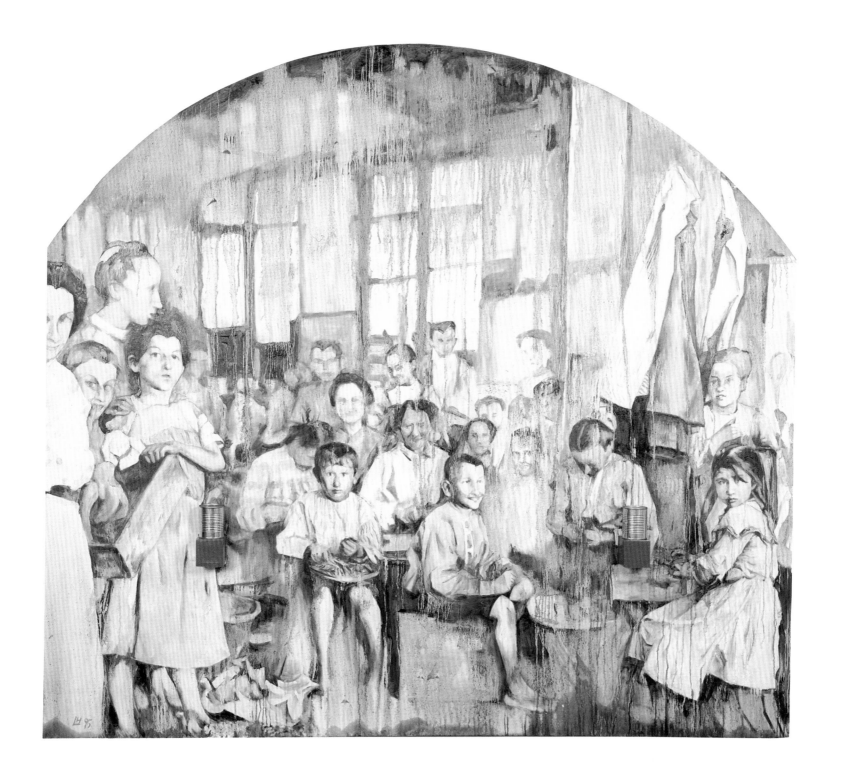

and contrasts Liu offers between seemingly unheroic people—those who have triumphed over pain and adversity at the individual level—and those who deserve to be recognized on a grand scale bring new recognition to the people, history, and politics of everyday life.

Perhaps Liu is most widely known for her paintings of anonymous, turn-of-the-century Chinese prostitutes with bound feet. *Odalisque* (fig. 7) depicts one such woman reclining on a Western-style settee in the European tradition. An image of commodified womanhood couched in the accoutrements of a distinctly Western taste, *Odalisque* highlights in an expressive, painterly fashion the dynamics of intercultural communication. However, it is more than a document of cultural hybridization. The archival photograph that informs the painting was originally intended to appeal to contemporary Chinese male patrons. *Odalisque* emphasizes the fact

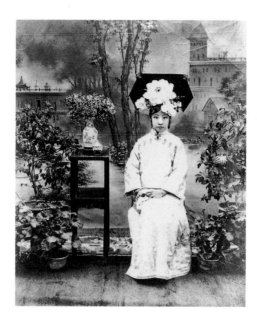

that simply seeing the cultural Other, in this case Western images of reclining women, can have fundamentally transformative effects on the way the viewer sees himself. Liu's images of reclining prostitutes illustrate China's changing conception of its own culture, as well as that of the West, at the turn of the century. Like most of her art, the story they tell is situated in a global context. They help us to understand how we perceive our own and other cultures, and how rationalizations of self and difference are always impacted by fluid relations between the two.

The importance of certain autobiographical details cannot be underemphasized; they provide a necessary introduction to Liu's work, which is often quite personal, and are crucial to any deeper understanding of its technique, content, and place within a historical context. Liu was born in Changchun, Manchuria, in 1948, one year before the founding of the People's Republic of China. That same year her father, Xia Peng, then a captain in Chiang Kai-shek's Nationalist army, was banished to a prison labor camp by Mao Tse-tung's Communist party. Except for the first six months of her life, Liu never saw her father again while she lived in China. She was raised in Beijing by her mother, Liu Zong-guang, who was advised to divorce her husband with the promise that she and her daughter would live safely under the new Communist system.[3] In 1968, when Liu was to enter college, the Cultural Revolution had been under way for two years. As the universities were closed, she was forcibly separated from her family and friends and sent to the countryside for ideological reeducation, where she labored in the fields with rural peasants for four years. In 1972, two years after the schools effectively had reopened, she returned to her home, where she enrolled in the Revolutionary Entertainment

Fig. 94. Yun Ying
Zai Feng's first daughter
n.d. Palace Museum, Beijing, China
(above left)

Fig. 95. Hung Liu
Grandma
1993, oil on canvas, antique architectural panel, 252.7 x 141 cm (99½ x 55½ in.). Courtesy Steinbaum Krauss Gallery, New York
(above right)

Fig. 96. Hung Liu
Baby King
1995, oil on canvas, 182.9 x 152.4 cm (72 x 60 in.). Collection of Penny and Moreton Binn, New York. Courtesy Steinbaum Krauss Gallery, New York
(opposite)

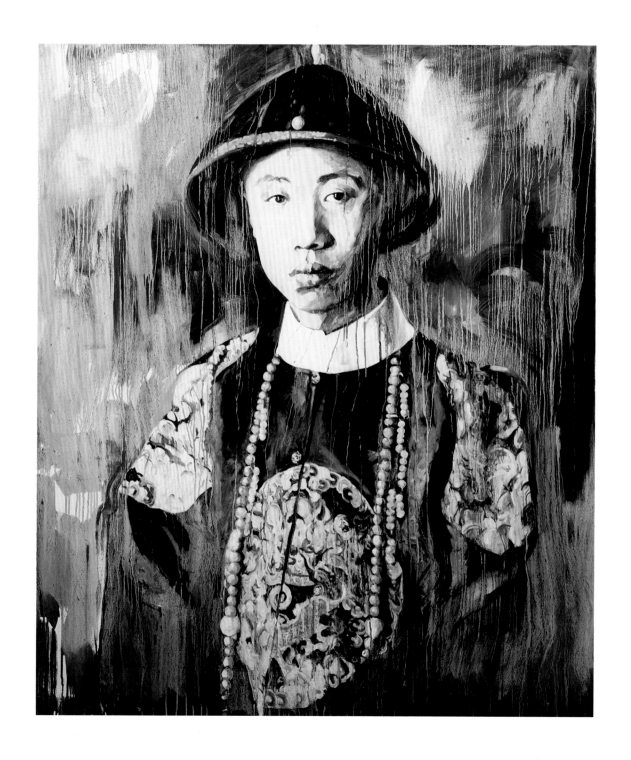

Department at Beijing Teachers College. After college, Liu taught art at an experimental school for elementary and high school students and then enrolled as a graduate student at Beijing's Central Academy of Fine Arts, where she later taught mural painting.

In 1981 Liu was accepted by the fine arts department of the graduate school at the University of California, San Diego, but was unable to matriculate until 1984, when she was finally granted a passport by the Chinese government. For those three intervening years she was, in her own words, "some kind of abstract artist who never showed up."[4] She was "abstract" in the eyes of the university because she existed only as an application and a portfolio of slides; she was also an "abstract artist" because that was the type of artist she might become, given the opportunity. She had seen a few reproductions of work by postwar Western painters such as Jackson Pollock, but, in the main, the parameters of Liu's art education and public repertoire as a teacher and professional muralist were determined by Chinese state cultural regulations.

As in most Communist countries, the only officially sanctioned style was socialist realism, which limits artistic expression to representations of the moral horizons of the masses as defined by the political agenda of the party. In order to practice her own art—landscapes that she executed outdoors with a portable painting box—she had to act in secrecy, stealing away when she could to explore the whims of her imagination and intellect. To this day, she almost always refuses to work from live models—a tenet of socialist realism—choosing to use photography instead; the choice gives Liu the satisfaction of a personal revolution every time she paints.

Before arriving in the United States, Liu's search for her artistic identity—the private self she might have fashioned for public audiences, given the freedom to express herself in ways that she wished—was constrained, to say the least. Speaking of her role as an artist and individual in China, she has said, "As soon as you were born, you had a place in the system. . . . As an artist, [I was] asked to serve a political purpose."[5] Upon arriving in the United States, Liu was confronted with a challenge that many Americans take for granted: she had to find her own voice and identity independent of any predetermined context. As she states, "I shifted my art work from socialist realism, the style in which I'd been trained, to social realism; and it transformed my personal identity crisis to a crisis of cultural collision."[6]

The intention here is not to reduce Liu's formative experiences to the maturation of a longing for freedom, nor her recent art to the mere expression of that desire.[7] Rather, it is to highlight what Liu has so poignantly called her "crisis of cultural collision," a conflict near the core of her experience as a world traveler and cross-cultural innovator, which has provided her with the material and means to create an impressive body of artwork since her arrival in the United States.

Liu's experiences in America have impelled a radical change in her initially unencumbered, theoretically formulated vision of what it meant to be "free." Without the support and direction of government patrons, Liu has felt the burden of freedom and its accompanying responsibility. In the United States, she has been asked to invent new visions, unique interpretations, and to submit to the demands of being an artist in a capitalist economy. Here individual expression is

Fig. 97. Hung Liu
The Ocean is the Dragon's World
1995, oil on canvas, architectural panel, birdcage, 243.8 x 208.3 x 45.7 cm (96 x 82 x 18 in.). National Museum of American Art, Museum purchase in part through the William R. and Nora H. Lichtenberg Endowment Fund. Courtesy Steinbaum Krauss Gallery, New York

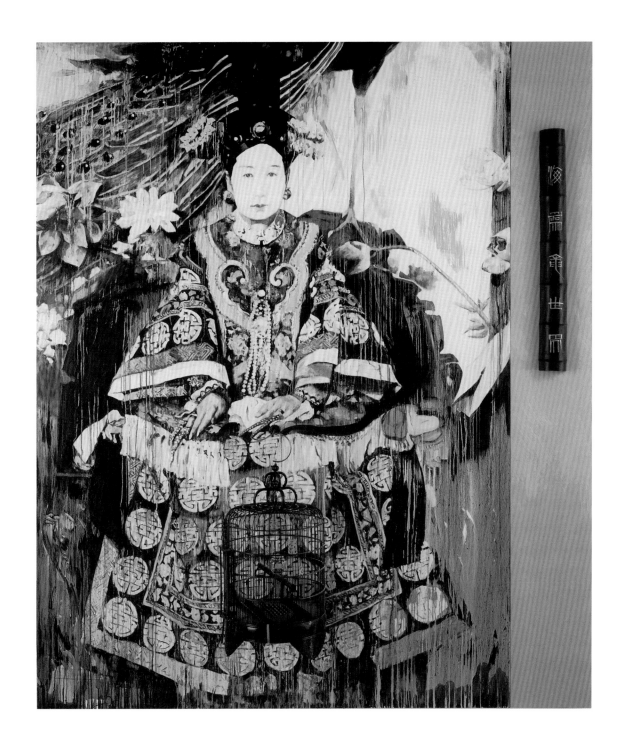

not a privilege but a right—the consequence of the gift of freedom. It is also a requirement for staying afloat in the highly competitive art educational system and marketplace. The problem Liu's art poses is more than a matter of escaping an all-consuming government's oppression of its people, or of redressing the social imbalances caused by a nation's historical, systematic subjugation of women. Rather, it is the task of making these injustices and violent acts against basic human rights resonate in terms of a deeply personal aesthetic, even for those viewers who may not share the artist's experience of having to reconcile various cultural contexts. In fact, many people, whether of one culture or two, of one or diverse racial backgrounds, experience the private confusion caused by the tearing apart and reintegration—the constant colliding—of what the artist insightfully terms "identity fragments."

Liu's art questions what it means to be a Chinese American, or for that matter an American, without submitting to the possibility that either of these appellations could refer to just one thing. Liu states, "Over time I realized that I didn't have to combine my Chinese past with my American identity. They could co-exist but the tension, the collision would always be there."[8] Just being herself, a woman who combines a Chinese background with recent American experiences, has enabled her to create an iconography that transcends the boundaries of at least two cultures, providing important insights into both, as well as the fluid nature of cultural identification itself.

As a group, the paintings exhibited in "American Kaleidoscope" can be seen as an attempt to pursue the full range of Liu's, and our, American potential. They vary in subject matter from the historically Chinese to the experiences of European immigrants. *Children of a Lesser God* (fig. 93) is the product of research Liu conducted on the history of Baltimore's Chinese community while she was preparing for her 1995 solo exhibition at the Contemporary, an imaginative art forum in Baltimore whose installation space changes location with each exhibition. A story of the work and hardship associated with immigrant life, the painting describes the harsh reality of child laborers in a canning factory in Canton, a Baltimore neighborhood in which a thriving canning industry was located during the first half of the century. It is no coincidence that Canton was also host to Liu's solo exhibition organized by the Contemporary, which was installed at the site of the former Canton National Bank.

Canton was named after the port in southern China by Captain John O'Donnell, an eighteenth-century trader who established economic ties between Baltimore and Asian countries.[9] Lisa G. Corrin, curator of the Contemporary, writes in her essay about Liu's "Can-ton: The Baltimore Series" that, about a century after O'Donnell's death, "some locals began pronouncing the neighborhood 'Can-Town,' because of the many canneries that became the area's main industry, a twist which delighted Liu."[10] *Children of a Lesser God*, an image that documents the abusive working conditions suffered by immigrant children, is also a veiled reference to Canton's now forgotten historical connection with Asia. It suggests the layering of ethnic communities and the integration of cultural differences unique to the American experience.

Fig. 98. Hung Liu
Five Eunuchs
1995, oil on canvas, cigar boxes, 177.8 x 243.8 x 10.2 cm (70 x 96 x 4 in.). Collection of Bernice and Harold Steinbaum. Courtesy Steinbaum Krauss Gallery, New York

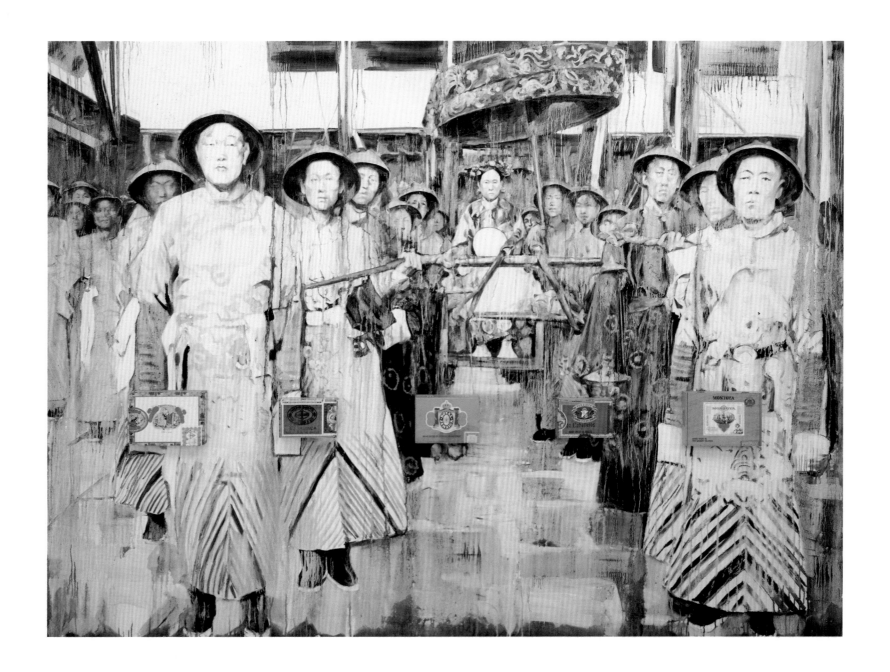

Although not exhibited in "American Kaleidoscope," *Customs* (fig. 8) is another painting central to Liu's research on U.S. immigration, which was also executed for her show in Baltimore. Inspired by two historical photographs, Liu's work depicts a female immigrant of ambiguous European origin entering the United States through the port at Baltimore, and a young Chinese man entering through Angel Island at San Francisco. Both submit themselves to thorough physical and verbal examinations. This juxtaposition of immigration on the East and West Coasts elucidates what was often the dehumanizing experience of crossing the nation's borders. Liu presents a vision of America that does not discriminate between immigrants according to their race or cultural orientation. However, by dint of the throngs that entered this country each day during peak periods of immigration, this lack of discrimination often devolved into an insensitivity toward cultural difference—a kind of cultural blindness—metaphorically represented here by the participants' obscured vision throughout the picture.

Blindness is a form of denial. For many immigrants, entering the United States involved the painful violation of their privacy—the woman on the left is having the inside of her eyelids examined—just as it ignored their individuality. Names were often simplified or changed for the simple reason that they could not be understood. As Liu has observed, these experiences were not limited to categorically oppressed groups or people of color, but affected the nation's immigrant population as a whole.[11] If we did not arrive on American shores this way, it is likely that our parents, grandparents, or great-grandparents did.

Children of a Lesser God concerns a form of child abuse that exists to this day in sweatshops and other illegal work environments across the country. *Baby King* (fig. 96), one painting from Liu's recent "Last Dynasty" series, is about a different kind of child abuse. *Baby King* depicts Pu Yi, the last emperor, who was named heir to the Chinese throne in 1908 at the age of three by the Empress Dowager Ci Xi. Wrenched from his family as an infant, and from his wet nurse as a teenager, then manipulated by the Japanese in World War II as the puppet emperor of Manchuria, Pu Yi spent his life adrift in personal and political currents well beyond his control. This indefatigably sensitive portrait shows the emperor at age seventeen, with the burden of an entire nation resting on slight shoulders that barely support his heavy, decorated costume. On the eve of his marriage to two women and still unable to tie his shoes, he seems overcome by the fear of an uncertain future. This image, subtly yet thoroughly critical of the glorified abuse it represents, bespeaks Liu's Chinese heritage. But it also speaks to the pain of lost childhood everywhere. Like the painterly drips that shroud the faces of the anonymous children in *Children of a Lesser God*, Pu Yi appears as if behind a veil of tears, a testament to the ineffability of lost innocence.

In *The Ocean is the Dragon's World* (fig. 97), a painting of the Empress Dowager Ci Xi recently acquired by the National Museum of American Art, the full-frontal pose of the sitter is an intentionally exaggerated example of grand court portraiture. In its austerity and overwhelming stability, this is not only an image of Pu Yi's forebear, but also the iconographic embodiment of traditional monarchical power and, more abstractly, a representation of the power of imagery itself.

Fig. 99. Hung Liu
Father's Day
1994, oil on canvas with architectural panel, 137.2 x 182.9 cm (54 x 72 in.). Collection of Bernice and Harold Steinbaum. Courtesy Steinbaum Krauss Gallery, New York

Considering the opulence of the empress's backdrop (the peacock feathers, for instance) and the overtly calculated formal arrangement of the subject taken from a documentary photograph, historically bound interpretations can be inferred from Liu's mysterious, self-dissolving surface. About her "Last Dynasty" paintings, the artist has stated:

> I am trying to emphasize the decorative abstraction of the photographic settings as well as the figure/ground relationships between those settings and the people being photographed, since they were arranged almost like abstract elements in a formal composition. These are relationships of power, and I want to dissolve them in my paintings.[12]

All historical imagery suffers a certain wear and tear over time, in the actual physical sense and conceptually, as ideological currents are exposed and interpreted. By employing linseed oil in excessive amounts, Liu exposes her paints to the chance effects of gravity, causing them to drip, and offers a visual metaphor for the time-bound processes of physical deterioration and historical disclosure. The paint that runs more or less uncontrollably down the surface of the canvas simultaneously defines the artist's representations even as it undermines them, making her paintings meaningful just as it tears them apart. In one way, the saturated surface of *The Ocean is the Dragon's World* and other "Last Dynasty" paintings functions as an empathetic screen through which to view the subject. However, it also distorts the relationship of foreground to background—of subject to context—metaphorically laying bare the mechanics by which official imagery is constructed and undone. In this way, Liu's painterly screens suggest a prying open of the power dynamics established by the dynastic facade and traditions of official portraiture.

Five Eunuchs depicts the empress dowager before her seventieth birthday, flanked and carried by a phalanx of eunuchs (fig. 98). These men were sold to the court by poor and lower-class families, then castrated in order to serve the imperial family. Histories tell of the political resourcefulness of eunuchs, who, despite being deprived of their biological manhood, sometimes acquired great power as government officials since only they were permitted as personal servants to the emperor. The two eunuchs at the front of the imperial train, Cui Yugui on the left and Li Lianying on the right, were famous for their ability to manipulate the dowager.[13] While a great number of eunuchs are pictured as escorts, Liu inserts only five cigar boxes—containers of dismembered eunuch "status"—into the surface of the canvas. The paucity of boxes suggests the inability of all eunuchs to maintain possession of their emasculated parts, a requirement for promotion within eunuch ranks.[14] It also indicates that even among court servants all were not equal. *Five Eunuchs* represents a complex network of privilege, power, and oppression—politics of dominance and subjugation that have important consequences in every epoch.

Although devoted to the elite and bizarre population that inhabited the Forbidden City, *Five Eunuchs*, like *Children of a Lesser God* and *Customs,* is heir to Liu's socialist realist training. Each of these paintings probes the identity of the anonymous ones, exploring how a story can be

Notes

1. Hung Liu, quoted in Mary-Katherine Nolan, "NewPainting Teacher Challenges Students," *Mills College Weekly,* 5 October 1990, 6.
2. Jung Chang, *Wild Swans: Three Daughters of China* (New York: Anchor Books, 1991), 283.
3. Bernice Steinbaum, "Once Upon a Time. . . ," in

written or painted about those who have been erased from historical consciousness. However, in contrast to socialist realism, which could never resolve this dilemma because of its refusal to recognize the individual behind the veneer of "the masses," Liu's aesthetic mission for more than a decade now has been defined by a persistent search for the content behind the surface. This not only signifies a break from her training, but also from major styles of late twentieth-century Western art, such as post-painterly abstraction and Pop Art.

In a recent conversation, Liu stated that there are no labels on the aluminum cans that adorn *Children of a Lesser God* because their content is not important. Is there more than a negligible difference between tomato or chicken noodle soup, canned asparagus or creamed corn?[15] Unlike Andy Warhol's soup cans, Liu's emphatically are not about labels. Giving form to the content behind the surface of the representation is not merely a matter of naming that content or, for that matter, simply identifying unknown individuals. Liu's cans, cigar boxes, and oftentimes her birdcages signify offerings to the nameless. They are important not for what they actually contain, but for how they contribute to an aesthetic that personalizes broadly construed notions of oppression, making them intimate and meaningful, perhaps even tangible, for the individual viewer.

Perhaps no painting more poignantly illustrates Liu's zealous refusal to let the self-perpetuating cycle of historical anonymity subsume her personal project of recovery than *Father's Day* (fig. 99). A week before Father's Day, 1994, Liu learned from a friend that her father was still alive and living on a labor farm near Nanjing. On Father's Day she flew to China and, two days later, arrived in Nanjing. The source for the painting exhibited in "American Kaleidoscope" is a snapshot taken of Liu and her father the day they met each other for the first time in forty-six years. By recovering both the person and the name, Liu apparently has accomplished the nearly impossible. However, the evidence of the painting, the modeling of its features, its coloration, suggests otherwise. Liu is grasping her father, clinging to him with a passionate tenacity. But her vitality is no match for his ravaged visage and seemingly translucent body, marked with the withering, pale tones of earthen gray. Xia Peng can be for the artist no more than the material trace of a long and lovingly harbored yet well-faded memory. The wishes and failings represented in *Father's Day* belong to people worldwide. Liu's painting represents both a private victory and the shared struggle with the divisive forces that make reuniting with lost loved ones a necessary reality.

Jonathan P. Binstock

Memories of Childhood . . . so we're not the Cleavers or the Brady Bunch (New York: Steinbaum Krauss Gallery, 1994), 9.

4. Hung Liu, "Interview with Hung Liu," by Janet Bishop and John Caldwell, *Society for the Education of Contemporary Art Award (SECA)* (San Francisco: San Francisco Museum of Modern Art, 1992), n.p.

5. Hung Liu, quoted in Nolan, "New Painting Teacher Challenges Students," 6.

6. Hung Liu, quoted in Moira Roth, "Interactions and Collisions: Reflections on the Art of Hung Liu," an excerpt of a larger essay published on the occasion of Hung Liu's solo exhibition "Sittings," at the Bernice Steinbaum Gallery, New York, in 1992.

7. Thanks to Lisa G. Corrin's recent essay, which poignantly warns against reducing Hung Liu's work in this way. See Lisa G. Corrin, *In Search of Miss Sallie Chu: Hung Liu's "Can-ton: The Baltimore Series"* (Baltimore: The Contemporary, 1995), note 1.

8. Hung Liu, quoted in Roslyn Bernstein, "Scholar-Artist: Hung Liu," in *Hung Liu: Year of the Dog* (New York: Steinbaum Krauss Gallery, 1994), 9.

9. Corrin, *In Search of Miss Sallie Chu*, 4.

10. Ibid.

11. Hung Liu, conversation with the author, 17 September 1995.

12. Hung Liu, artist's statement on the occasion of her 1995 solo exhibition, "The Last Dynasty," at the Steinbaum Krauss Gallery, New York.

13. My gratitude to Hung Liu for this bit of knowledge and for providing me with the book that reproduces the photographs that inspired *Five Eunuchs, Baby King,* and *The Ocean is the Dragon's World.* See Liu Beisi and Xu Qixian, eds., *Exquisite Figure-Pictures from the Palace Museum* (Beijing: Forbidden City Publishing House, 1994), figs. 16, 41, and 2.

14. Historian Mary Anderson writes, "To be promoted to a higher grade, [a eunuch] was obliged to first display his emasculated parts and be reexamined by the chief eunuch." If a eunuch did not still own his emasculated parts—they might have been lost or stolen—he could be promoted only by purchasing ones from the eunuch clinic, or by borrowing or renting. Thanks to Professor Frederic Wakeman, director of the Institute of East Asian Studies at University of California, Berkeley, for this citation from Mary M. Anderson, *Hidden Power: The Palace Eunuchs of Imperial China* (Buffalo: Prometheus Books, 1990), 309.

15. Hung Liu, conversation with the author, 17 September 1995.

Deborah Oropallo

IN PAINTING, THERE IS A CONTINUOUS THREAD OF
REVELATION. . . . THE LONGER YOU LOOK AT ONE
OBJECT, THE MORE OF THE WORLD YOU SEE IN IT.[1]

Deborah Oropallo mixes nostalgic and instructive texts gleaned from disparate sources—magic manuals, folklore, children's games, alphabet rhymes, and historical events—to remind us of humankind's collective optimism, our sheer will to survive through resourcefulness and steadfast determination. Recognized for her virtuosity in handling paint, Oropallo produces canvases with a mesmerizing quality. They are also evocative conveyors of the ambiguity of contemporary existence and the power of visual perception.

Born in Hackensack, New Jersey, in 1954, Oropallo comes from a family that traces its history to the southern Italian city of Sant'Agata dei Goti, near the ancient city of Pompeii. References to her Catholic upbringing, her two immigrant grandfathers, and her Neapolitan genealogy appear often in Oropallo's works.[2] In fact, her early paintings have been described as "self-referential." Some critics have asserted that Oropallo's works relate to ancient Italian art, especially the Pompeiian frescoes.[3]

Oropallo's fascination with Pompeii led to a visit in the late 1980s. Standing among the ruins, she experienced a powerful revelation: "I was struck by the strong resemblance between the women depicted in the frescoes and the women in my family."[4]

Oropallo's interest in art surfaced when she was about fourteen years old. Her older sister, an art student at the time, frequently took her to visit New York City museums. After graduating from high school, Oropallo traveled to France to study painting in Aix-en-Provence, where her brother-in-law was an instructor at the Leo Marchutz School of Drawing and Painting. Oropallo returned to the United States and earned her B.F.A. in sculpture from Alfred University in New York in 1979. Entering the graduate program in painting at the University of California, Berkeley, Oropallo received an M.A. in 1982 and an M.F.A. in 1983.

While in graduate school, Oropallo began to experiment with oil pigment and its various qualities.[5] The artist's delight in the sensuousness of painting is obvious; critics describe her as a "superb technician" and an "exceptionally talented artist who has . . . a real old master's touch."[6]

Fig. 100. Deborah Oropallo
The Wolf
1993, oil on canvas, 218.4 x 162.5 cm (86 x 64 in.).
Collection of Anne Marie MacDonald. Courtesy Stephen
Wirtz Gallery, San Francisco

133

Other critics describe as "too beautiful" her intuitive use of multiple, superimposed layers of oil glazes that endow the surfaces with an inner, glowing light. [7]

Her image-text paintings are based on ideas and issues she finds personally and universally meaningful. For example, in 1986, when Oropallo began producing the works known as her "How-To" paintings—characterized by charts and diagrams that examine how certain things are put together (fig. 16)—her subjects included anatomical figure studies, blueprints for violin assembly, instructions for animal taxidermy, and plans for brick foundations. The construction motif may allude either to Oropallo's brick-mason grandfather or to the fragility of human existence despite the "best-laid foundations."[8]

Floating passages of texts began to materialize in Oropallo's work in 1987. Initially her sources were news stories related to natural disasters such as earthquakes, tornadoes—even the sinking of the *Titanic.* In *Partial List of the Saved*

(fig. 19), Oropallo superimposes the alphabetized list of survivors over an image of the doomed ship. She integrates the text and images, achieving a haunting effect as the names, painted in red oxide, blur and run, as if dematerializing before our eyes.[9]

Some of her image-text paintings are inspired by contemporary events. The Los Angeles riot, for example, motivated Oropallo to create *Three Man Patrol* (fig. 20). Her tripartite composition of larger-than-life police officers dressed in riot gear, holding their truncheons in combat-ready position, establishes a confrontational relationship with the viewer. Although the image is devoid of actual violence, the officers' stances, their armatures of power, and the accompanying excerpts were culled from a police riot-control manual.[10]

The image-text paintings often invite multiple interpretations and associations. For example, in discussing the work entitled *O* (fig. 102), the artist confessed her affinity for the alphabet—*o* is the first letter in her last name as well as the first letter in the familiar fairy-tale phrase "once upon a time."[11] However, the alphabet litany "A is for axe and that we all know; B is for boy who can use it also" was selected from the lyrics of *Lumberman's Alphabet,* an old logging song.[12] Juxtaposed with an eerie line of owl silhouettes, it invokes a disturbing notion of gradual annihilation. In fact, critics have linked the work to environmental concerns, specifically the endangered spotted owl, noting how "overlying this depressing metaphor is a series of

Fig. 101. Francisco de Goya
The Marquesa de Pontejos
ca. 1786, oil on canvas, 210.3 x 127 cm (82¾ x 50 in.).
Andrew W. Mellon Collection, ©1996 Board of Trustees,
National Gallery of Art, Washington
(above left)

Fig. 102. Deborah Oropallo
O
1992, oil on canvas, 218.4 x 193 cm (86 x 76 in.). Private
collection. Courtesy Stephen Wirtz Gallery, San Francisco
(above right)

Fig. 103. Deborah Oropallo
Snow White
1994, oil and paper on canvas, 243.8 x 175.3 cm (96 x 69
in.). Collection of William R. and Judith P. Timken.
Courtesy Stephen Wirtz Gallery, San Francisco
(opposite)

stripes, much like a set of vertical blinds that if we could close, we would be able to shut out the disaster at hand."[13]

In her more recent works, Oropallo derives startlingly visual narratives from well-known fairy tales and folk myths. Using texts and illustrations gleaned from classic children's stories about temptation, transformation, and rescue, she constructs "a world in which events or actions and their consequences are clearly linked."[14] Three of these masterful paintings are represented in "American Kaleidoscope."

Oropallo's version of the popular tale of Little Red Riding Hood, *The Wolf* (fig. 100), depicts the girl and the wolf as the two emerge from a dense, dark forest. By eliminating unessential details, Oropallo causes the viewer to focus on the spotlit pair standing in the shadowy clearing. She underscores the intimacy between the figures through their stance and eye contact. Red Riding Hood, who coyly turns to glance towards the wolf at her side, is portrayed, according to one critic, as a "capable, brunette pre-teen in mantilla fit for a Goya seductress."[15] Further allusions to Goya are evident. For example, Oropallo's lone female accompanied by a canine figure in a vague landscape setting seems compositionally related to Goya's portrait of *The Marquesa de Pontejos* (fig. 101). Even the elegantly splayed feet, standing on an island of green, are similar. Oropallo's use of strong contrasts of light and shadow differs, however, from Goya's pastel colors and silvery tonalities adapted from eighteenth-century French rococo elements. Her dramatic lighting and use of shallow space—devices common in seventeenth-century European paintings—suggest an affinity to Caravaggio and Rembrandt, as well as later works by Goya. Despite her tendency to evoke European masters, Oropallo's interpretation is personalized.

Note Red Riding Hood's downturned gaze, which directs attention to the concentric oval rings of a shooting target superimposed on the wolf. Is Oropallo suggesting a new ending for the centuries-old story? Is she implying that instead of the girl's tragic end, the wolf should be murdered "before he commits mayhem?"[16] Or does Oropallo propose that the best resolution for beasts—not just male seducers, but all asocial, animalistic tendencies in society that prey on innocent children—is their annihilation? On the other hand, might she be suggesting that happy endings are not assured, even in fairy tales?

To reinforce the concept of altering perspectives and beliefs, Oropallo paints the figures as if they are literally shifting from one location to another.[17] To create this rippling impression, as figures and fabric folds appear to "reduplicate themselves in midair," Oropallo uses rollers, rags, and squeegees, and smears the paint.[18] This sense of restless movement metaphorically suggests both the difficulties of perception and comprehension, as we actually have to shift from one physical location to another in order to examine the painting.[19]

The Wolf is one of three paintings devoted to Little Red Riding Hood. An earlier work, titled

Fig. 104. Deborah Oropallo
Little Red Riding Hood
1992, oil on canvas, 243.8 x 162.5 cm (96 x 64 in.). Collection of Peggy and Timm Crull. Courtesy Stephen Wirtz Gallery, San Francisco

Fig. 105. Deborah Oropallo
Pinocchio
1994, oil and paper on canvas, 147.3 x 132.1 cm (58 x 52 in.). Courtesy the artist and Zolla/Lieberman Gallery Inc., Chicago. Courtesy Stephen Wirtz Gallery, San Francisco
(opposite)

The Forest (fig. 9), where Little Red Riding Hood appears dressed in a similar red, white, and blue ensemble, shows Oropallo dealing with the same issues of shifting perspective and comprehension. Instead of solid white stockings, Red wears striped leggings. The wolf, at her side, is barely visible. Again, the two are alone in a clearing, but instead of narrow, vertical lines that blur and alter the scene, large dark ovals loom over the painting's surface. These ominous forms, which gradually obliterate the figures, metaphorically eliminate any hope for either's rescue.[20]

In another version, *Little Red Riding Hood* (fig. 104), Oropallo was inspired by events from real life. In this disquieting composition, narrow stripes in the color of fresh blood merge into a solid red field at the painting's lower half. The artist places strings of photocopied newspaper text as if it were cutout paper dolls dangling across the upper half of the canvas. Silhouetted against overlapping layers of stripes, these half-hidden silhouettes of dancing dolls look benignly innocent. The text, once we read it, turns out to be the story of a little girl's abduction.[21]

One of the world's best-known fairy tales inspired *Snow White* (fig. 103). The sparse compositional grouping of four blood-red apples, an ornate frame, and flecks of white paint alludes to this classic story of sorcery and revenge. However, Oropallo's reduction of the fairy-tale narrative to a rhythmic interplay of swelling contours and soft dabs of paint encourages further interpretations. As the snowflakes float both in front of and through the apples and mirror, they suggest limitless space and time. The fruit and mirror—time-honored symbols of *vanitas*—are reminders of human mortality, while the pristine snowflakes hint at freshness and renewal.

The concept of loss and renewal also seems to be a preoccupation in *Pinocchio* (fig. 105). A scattered pile of wooden logs is stacked like a funeral pyre, while murky shadows envelop the pieces of timber, heightening the grim atmosphere. Yet across this desolate setting, Oropallo places seven text ovals. Working as both poet and painter, she has produced a gracefully lettered Times Roman text—excerpts from the delightful Italian folk tale about a mischievous marionette who longs to be a human boy—describing how the fairy allows woodpeckers to restore Pinocchio's nose to its normal size. The image, which upon first glance seems to suggest melancholy and despair, is altered to a visual metaphor of hope, transformation, and redemption. Even the text ovals, magically suspended in space, complement this hopeful theme. Instead of effacing the image, as in *The Forest,* here the shifting ovals help to establish a sense of joyful buoyancy and an illusion of depth, as the hovering elliptical forms appear to both recede and drift forward.

Oropallo's use of images from popular culture, her tendency to efface works, her manipulation of text and letters, and her use of layered and repetitive forms can be compared to that of Jasper Johns and Larry Rivers.[22] Take, for example, Johns's *Gray Alphabets* (fig. 106), in which the twenty-six letters of the alphabet and numerals from zero to nine are barely discernible. In spite of our familiarity with alphabets and numbers, these are still hard to see. They blur and dissolve before our eyes. Johns's letters and the numerals of decimal notation

Fig. 106. Jasper Johns
Gray Alphabets
1968, color lithograph on paper, 129.5 x 86.4 cm (51 x 34 in.). National Museum of American Art, Smithsonian Institution, Transfer from National Endowment for the Arts, ©1996 Jasper Johns/Licensed by VAGA, New York

Notes

1. Deborah Oropallo, telephone conversation with the author, 22 January 1996.
2. Jamie Brunson, "Deborah Oropallo: The Painted Text," *ARTSPACE* 13 (September/October 1989): 59.
3. Maria Porges, "Text and Image Metaphors," *Artweek,* 28 May 1988, 3.

have been characterized as symbolic of modern civilization—tools of our literacy, our existence as an economy, and our scientific civilization.[23]

Like Johns, Oropallo seems to pose questions about our civilization and how it can be rescued for future generations. Indeed, at a time when few American artists are producing history paintings, Oropallo's morally uplifting images are meant to inform and enlighten society.[24] Her works reveal that the history we are making relies less on ancient, classical texts and the glorious deeds of august individuals, and more on the common language of our collective consciousness. The paintings, with or without text, are populated by images that speak to time-honored ideas—fidelity, morality, virility, truth, and survival.

Oropallo reminds us that it is through childhood stories and fairy tales that we learned how to deal with suffering and loss, and also learned to dream of hope and triumph. Thus her works seem to parallel the belief that fairy tales can be a "dynamic part of the historical civilizing process."[25] When confronted with the possibility of obliteration, Oropallo also suggests humankind will resort to "lessons learned" as a means to endure and survive.

Gwendolyn H. Everett

4. Oropallo, telephone conversation with the author, 22 January 1996.
5. Oropallo, telephone conversation with the author, 8 November 1995.
6. See Mark Levy, "California Contemporary Art," *Art and Antiques* (September 1988): 72; Walter Thompson, "Deborah Oropallo at Germans van Eck," *Art in America* (December 1991): 111.
7. Oropallo, telephone conversation with the author, 8 November 1995.
8. Brunson, *ARTSPACE*, 60.
9. See Bill Berkson, "Deborah Oropallo," *Artforum* (September 1988): 149; Porges, "Text and Image Metaphors."
10. Oropallo, telephone conversation with the author, 22 January 1996.
11. Oropallo, telephone conversation with the author, 22 January 1996.
12. Oropallo, telephone conversation with the author, 22 January 1996. Oropallo explained how she found the lyrics in a children's book with the same title, *Lumberman's Alphabet* (1938), in a local library.
13. See Terri Cohn, "Narratives," *Artweek,* 3 June 1993, 18; Maria Porges, "Deborah Oropallo," *43rd Biennial Exhibition of Contemporary American Painting* (Washington, D.C.: Corcoran Gallery of Art, 1993), 74; Bill Berkson, "Apparition as Knowledge," *Oropallo* (San Francisco: Stephen Writz Gallery, 1993), 7. In a telephone conversation with the author, Oropallo denies any direct relationship with environmental issues, citing instead a personal tragedy.
14. Maria Porges, "Deborah Oropallo," *Oropallo (*San Francisco: Stephen Wirtz Gallery, 1993), 11.
15. Berkson, "Apparition as Knowledge," 8.
16. Porges, "Deborah Oropallo," *Oropallo,* 12.
17. Porges, "Deborah Oropallo," *43rd Biennial Exhibition of Contemporary American Painting,* 74.
18. Berkson, "Apparition as Knowledge," 7.
19. Porges, "Deborah Oropallo," *Oropallo,* 12
20. Ibid., 13
21. Cohn, "Narratives," 18; Porges, *Oropallo,* 12.
22. Porges, "Text and Image Metaphors," 3.
23. Philip Fisher, *Making and Effacing Art: Modern American Art in a Culture of Museums* (New York and Oxford: Oxford University Press, 1991), 58–59.
24. Maria Porges, "Quick, Quick, Pause," *Artforum* (May 1991): 111–12.
25. Jack Zipes, *Fairy Tales and the Art of Subversion: The Classical Genre for Children and the Process of Civilization* (New York: Wildman Press, 1983), 11.

Mark Tansey

A PAINTED PICTURE IS A VEHICLE. YOU CAN SIT IN YOUR
DRIVEWAY AND TAKE IT APART OR YOU CAN GET IN IT AND
GO SOMEWHERE.[1]

In major paintings of the early 1990s, Mark Tansey uses irony and surreal combinations of places and historical figures to make uncanny but coherent connections between ideas and events. By unifying frankly illustrational imagery with the analytical terms of literary criticism, Tansey crafts paintings that amount to nothing less than philosophical incursions into widely held beliefs about the nature of representation, art, and history. Inasmuch as the artist approaches painting from at least two points of entry, the illustrational and the conceptual, his works encompass modes of artistic thinking traditionally considered to be the antithesis of each other.

In this regard, the work of Jasper Johns is an important precedent to Tansey's. Johns's abstract renditions of flags and other familiar symbols, emerging from the tyranny of nonobjectivity imposed by Abstract Expressionism and formalist critics during the late 1940s and 1950s, asserted that the distinction between figuration and conceptually rich abstraction might, in fact, be an empty one (fig. 108). Despite the tightly representational quality of Mark Tansey's work, he similarly questions the nature of representation, but he also refracts these questions into an array of corollaries that at times go so far as to critically undermine the same traditions of art history and criticism that have maintained the international importance of his work since the early 1980s.

Forward Retreat (fig. 109), for example, metaphorically refers to the concept of an artistic avant-garde by reminding us of the military origin of the French term. Here French soldiers and one polo player scouting a battlefront are merely the shimmer of a reflection in a stagnant pool, the shore of which is littered with frames and vases—objects that stand for the detritus of art history. Presumably the avant-garde soldiers, who appear in the painting upside-down, pursue the most forward artistic thinking. However, even when imagined right-side up, these vanguardists sit backwards while their horses furiously gallop; toward where or for what, of course, is uncertain. Mark Tansey has assumed the serious task of analyzing the way in which

Fig. 107. Mark Tansey
Landscape
1994, oil on canvas, 181.6 x 365.8 cm (71½ x 144 in.).
Stefan T. Edlis Collection. Courtesy Curt Marcus Gallery,
New York

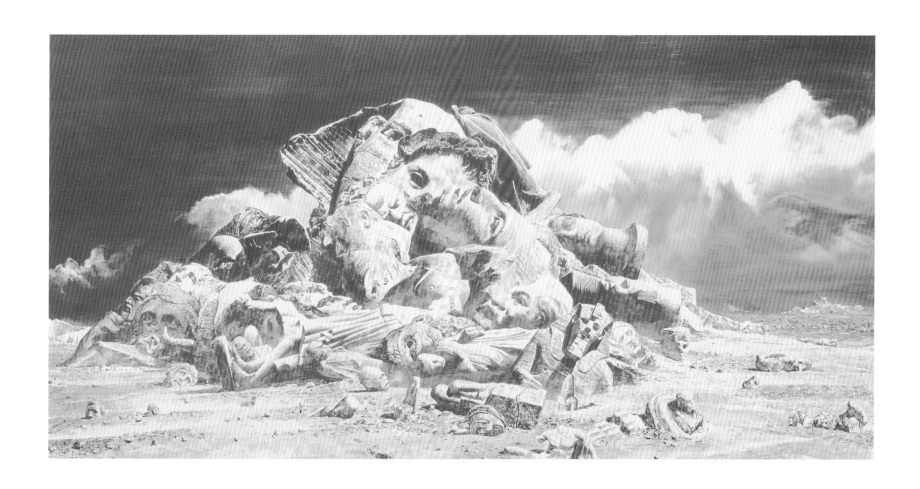

the past, in this case art history, is recorded and consequently remembered, but he does it with a wry intelligence and uncommon wit. This is not to say he seeks to undermine the value of historical inquiry or to separate his work from the past. Indeed, the intellectual prowess of his paintings depends upon the history of ideas, as well as a long tradition of highly crafted artistic technique, for the force of its effect.

Tansey's paintings are the results of a calculated system of opposition, reversal, and contradiction. This is evident not only in the content of his finished works, but also in the process by which he creates them. The artist's studio provides a key to understanding his art. In one area he keeps his library of books and files of art-historical images and popular illustrations. Here published sources range from popular journals of the 1940s and 1950s to manifestos by post-structuralist writers Jacques Derrida, Paul de Man, Jacques Lacan, and Roland Barthes, all of whom have played an important role in defining the character of continental philosophical discourse and literary criticism since the 1960s. Also present are art-historical tomes such as Helen Gardner's *Art Through the Ages,* revised many times in part by his father, art historian Richard G. Tansey.

The artist begins his work with a thumbnail sketch of a composition expressing an idea. He then elaborates by juxtaposing images and figures culled from his collection of iconographic illustrations, which he began compiling in the late 1970s as a graduate student at Hunter College. Clipped from popular magazines and journals, these illustrations represent a distinctly American graphic visual consciousness developed over the last century. As a group they are an encyclopedia of figural sources from the mass media, the key to the conceptual problems posed by Tansey's pictorial narratives. With the photocopier he keeps in his studio, Tansey reproduces, enlarges, shrinks, lightens, and otherwise manipulates the figures to cohere as a collage within the composition previously sketched out. Seen in their new context, these singular visual elements contribute to hyperrealized, intensely conflicted pictorial statements.

After appropriating and recontextualizing the images, Tansey initiates a "toner drawing," the next stage in the long process of producing a painting (fig. 110). Building upon previous developments in the evolution of his pictorial notion, the artist photocopies the collage, along with whatever else might enhance the drawing he envisions. But before the photocopy machine finishes its task, before it heats the toner so that the dry black ink fuses with the surface of paper, Tansey turns off the copier and delicately removes the sheet from the paper path. The slightest jarring movement can upset the page and destroy the image, which at this moment sits precariously on the sheet, affixed to the surface only by electrostatic charges. Tansey then selectively manipulates and alters the image. He may use turpentine and various found tools to remove the toner or merely suspend a brush above the surface, which often provides sufficient static attraction to lift the fine black powder. Ultimately the image is secured with four or five layers of fixative. Captured somewhere between the realms of the machine and unique artistic expression, the drawing frequently prevents us from knowing whether it was mechanically reproduced or finished by hand.

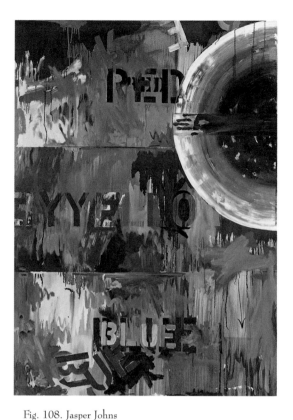

Fig. 108. Jasper Johns
Periscope
1963, oil on canvas, 170.2 x 121.9 cm (67 x 48 in.).
National Museum of American Art, Smithsonian
Institution, Lent by the artist, ©1996 Jasper
Johns/Licensed by VAGA, New York

Similar to this method of manipulation and removal is the artist's monochromatic painting technique. Beginning with a layer of oil-based pigment, Tansey again uses turpentine and found tools—what he calls his "extended," or "unlimited" brush—to remove what has already been applied to the surface of the support. He describes his unlimited brush as

> anything from crumpled paper or Kleenex to brushes to carved wood to lace to wadded-up cloth or string. The game in a sense is to invent or find a tool that has a tactile resonance with the object it will be used to denote. If, for instance, I want to depict a tree, well, maybe there is something that feels a little bit like foliage, that has the same complexity of detail and natural form—like a knotted ball of string or crochet work, something that can be used if a direct tactile impression leaves a visual result that is uncannily like a tree.[2]

The nature of oil paint, which dries after a period of time, makes it difficult to remove, so that Tansey must limit his work at any given time to a particular part of the canvas. He divides the composition into sections and then applies no more paint than he can remove before it dries—a method borrowed from Italian Renaissance fresco painters, who applied only as much wet plaster as they could paint in one day. Straddling the fault lines of tradition, Mark Tansey is a cultural scavenger and stylistic handyman. Just as he combs his archives for the scraps of paper and bits of imagery that will ultimately constitute his monumental painting, he uses a variety of tools and techniques to make his images visually convincing.

One would think that these craft-intensive methods, laborious to the point of obsession, would result in thoroughly convincing, illusionistic representations of the three-dimensional world. Tansey, however, never represents what is visible per se. His pictorial realities are invented; we cannot rightly call them realistic. Nonetheless it is fair to say that his paintings suggest a reality of a different order. The techniques of paint and toner removal—a kind of archaeological excavation for the hidden truth beneath the surface—produce images that appear to have always been buried there, waiting to be extracted. Though seemingly self-evident glimpses into a familiar world, these images rarely make sense. They are always both matter-of-fact *and* abstruse, redolent of the effects of documentary photography in their monochromatic character and attention to texture, while depicting wholly impossible situations—the result of previously inconceivable juxtapositions. By representing a tree with the look and feel of foliage, Tansey seduces the viewer into entering into and believing in his paintings. At the same time, he

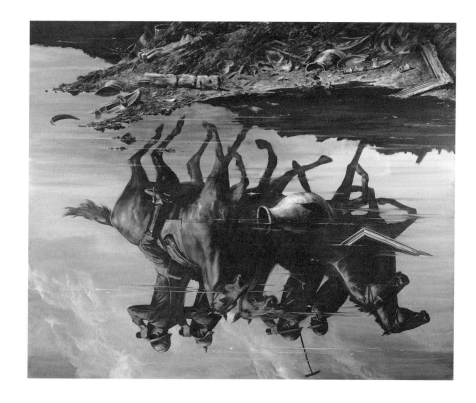

Fig. 109. Mark Tansey
Forward Retreat
1986, oil on canvas, 238.8 x 294.6 cm (94 x 116 in.).
Eli Broad Family Foundation, Santa Monica. Courtesy
Curt Marcus Gallery, New York

positions an obstacle for us—an underlying and sometimes obscure concept, the surface of which can be difficult to penetrate.

The monumental *Landscape* is an excellent example of Tansey's method (fig. 107). Like most of his work, its origins can be found in the manipulated photocopies of visual icons from his library. The likenesses of famous men and monuments—the Sphinx, Constantine, George Washington, Stalin, Hitler, Lenin, Augustus, and Julius Caesar, assorted pharaohs and Mayan kings, among others—have been reconfigured to comprise this junk heap of history in the shape of an Egyptian pyramid.

The jumbled icons beg us to identify them, but the process inevitably devolves into a chaotic guessing game, owing to the density of the conglomeration and subsequent sensory overload. *Landscape* represents both an excess of content and its effacement. It is a monument to the pantheon of figures associated with political dominance and a place where differences between individual rulers become irrelevant. This monolithic metaphor of world history is unified by at least two underlying motifs. First, most of the figures illustrated claimed territory and expanded the boundaries of what was originally defined as their dominion. In fact, the busts, statues, and monuments depicted were—some still are—embodiments of political power and territorial acquisition. Second, we cannot help but note that Tansey depicts only men. This is not, then, a landscape of world culture, but one of Western patriarchal culture.

As both an ancient, canonical monument and a historical landfill, *Landscape* represents an either/or proposition, shifting between apparently oppositional conceptions of Western history. We may choose to enshrine particular traditions and histories, or we can relegate them to the dump and forget them. Either way, *Landscape* shows us that the two acts are intimately related and yield similar outcomes. The painting does not offer an alternative historical tradition to the one depicted, but if we construe the pyramid form as a mound of refuse, then we imply that somewhere is another newly dominant tradition that has presumably replaced it. *Landscape* unravels the mechanics behind such decision-making and reminds us that we not only make monuments out of what we remember, but also out of what we choose to forget. As one critic notes, "Tansey's only ideology is the ideology of every good American: pluralism. And if he reaffirms the coexistence of contradictions again and again in his works, it is also to praise the peaceful coexistence of ideas."[3]

The three Tansey paintings included in "American Kaleidoscope"—*Landscape, Columbus*

Fig. 110. Mark Tansey
Continental Divide
1992, toner on paper, 17.8 x 22.2 cm (7 x 8¾ in.). Private collection, San Francisco. Courtesy Curt Marcus Gallery, New York

Discovers Spain, and *Continental Divide*—all put forth ambivalent, constantly shifting notions of history and cultural identity without sacrificing a sense of pictorial unity or inclusiveness. This is immediately apparent in the title *Columbus Discovers Spain,* which declares a historical reversal that does not seem to be supported by the evidence of the painting (see frontispiece). In fact, the painting appears to suggest a double reversal, or the inversion of the title. There are not many clues to support this interpretation, as the painting consists of little more than a carefully rendered ship being tossed about on an ocean by furious winds and waves. However, in the far distance, dramatically reflecting the gleam that just manages to break through the storm of the clouds above, there appear two monumental arches. The monochrome surface that gives the painting its photographic realism at the same time limits its ability to convey likeness, making it difficult to determine exactly what those arches are. They could be golden, like those of McDonald's—an international sign of American commercialism. More likely, they are the steel handrails of the type of ladder found in the swimming pools of suburban homes. Either hypothesis leads to the probable conclusion that Columbus is discovering America, not Spain. Anyway, isn't this how the story goes? Why, then, the inversion in the title?

Columbus Discovers Spain invokes the Surrealist tradition of painter René Magritte (fig. 111). The sparse visual and verbal economy asks viewers to reconsider the ways in which images and words effect meaning. Just as Magritte's renowned pronouncement "This is not a pipe," juxtaposed with a picture of a pipe, still disrupts easily arrived at relationships between word and image, Tansey's substitution of Spain for America and the inclusion of the arches ask us to reevaluate widely held beliefs about the meaning of historical discovery. Tansey grounds Magritte's theoretical sleight-of-hand in the real and hotly contested terrain of history, culture, and national identity. He does not question the fact that Columbus landed on foreign shores, but rather the ways in which centuries of historical interpretation have imbued this discrete kernel of information with layers of cultural connotations.

This is not merely a representation, but proof that representations—illustrational, historical, verbal—are inherently sites of dilemma. Tansey challenges our perception of an immediately recognizable historical moment, illustrated like those in elementary school textbooks, and leaves us with open-ended questions, not answers. How does picturing the world's oceans as a swimming pool—a self-contained body of water—or, as the title suggests, the Italian explorer returning from uncharted territories to "discover" the already populated shores of Spain, inform our preconceived notions of discovery? On the other hand, if the painting is a depiction of Columbus discovering America, as the image initially appears to suggest, what are the intellectual ramifications of associating the New World of the fifteenth century with a twentieth-century nation of suburban swimming pools, such as those that dot the landscape of

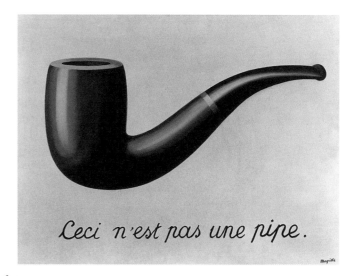

Fig. 111. René Magritte
La Trahison des Images (Ceci n'est pas une pipe)
ca. 1928–29, 64.5 x 94 cm (25⅜ x 37 in.). Los Angeles County Museum of Art, Purchased with funds provided by the Mr. and Mrs. William Preston Harrison Collection

Fig. 112. Mark Tansey
Continental Divide
1994, oil on canvas, 162.6 x 217.2 cm (64 x 85½ in.).
Collection of W. Scott Hedrick. Courtesy Curt Marcus
Gallery, New York

Tansey's hometown, San Jose, California? Like other implicitly historical events, *Columbus Discovers Spain* is subject to inflection by the perspective of the interpreter or teller of the story. Telescoping centuries, it is a well-articulated, solipsistic vision that conflates the artist's and Columbus's vision of the landmass now called America, implying the importance, and the relativity, of both.

Continental Divide (fig. 112), from the "Frameworks" suite, gives pictorial form to geopolitical debates and identity controversies. Tansey offers a metaphorical map of cultural or perhaps political contention, showing two points of view on either side of a dividing line, at once diametrically opposed and inextricably bound to each other by their differences. Once again he works in terms of opposition. However, rather than reversing or inverting the terms of a subject, as in *Columbus Discovers Spain*, *Continental Divide* clearly displays the contrary yet equally necessary sides of a cultural equation.

A continental divide is a barrier separating river systems that flow to opposite sides of a continent. From the peaks of the Rocky Mountains, for example, water divides and flows to both the Atlantic and Pacific Oceans. Such is the case, it would seem, with Tansey's painting, which shows an expansive table receding sharply and infinitely into the space of the picture, separating verdant, uncontrollable nature from the dour implacability of civilized culture, with its complex codes of manners and dining etiquette. It is not too great a leap to ascribe to this picture the theme of nature versus culture or, for that matter, an interpretation of post-colonial societies that have appropriated and decontextualized the social rituals and protocols of colonizers.

Like many works by Tansey, *Continental Divide's* absurd content, rendered in detail, enables us to understand it in a variety of ways, making it relevant to a number of pressing contemporary social issues. Yet despite its apparent specificity, the painting speaks in general terms, analyzing the nature of the relationship of its various components and leaving conclusions to us. In a post-industrial, post-colonial world, natural forces and peoples traditionally subjugated by dominance or oppression are allowed to approach the meeting table as they wish. The culture side sports napkins, place settings, and crystal; the nature side is defined by leaves and branches resting on the table. This meeting place is not necessarily common ground, for disagreements between the parties, whether fundamental or habitual, exist along the surface of the border. Tansey presents us with a dinner party to which the invited guest is *difference*, shared and accepted by all participants.

Perhaps most importantly, neither side forgoes the opportunity to meet and consequently preserve, by means of mutual efforts at understanding, the boundary that both separates and delimits the uniqueness of the two parties. In this regard, the meeting was both inevitable and alluring. In *Continental Divide*, each side depends upon the other to help define its character. Since nature and culture are readily construed antitheses, each side is what the other is not. And without preserving the line demarcating the differences between them—that point of contention—neither could endure.

Jonathan P. Binstock

Notes

1. Jerry Saltz, Roberta Smith, and Peter Halley, *Beyond Boundaries: New York's New Art* (New York: Alfred van der Marck, 1986), 128; quoted in Judi Freeman, *Mark Tansey* (Los Angeles: Los Angeles County Museum of Art, 1993), 26, n. 18.
2. Mark Tansey, "Notes and Comments," interview by Christopher Sweet, in Arthur C. Danto, *Mark Tansey: Visions and Revisions* (New York: Harry N. Abrams, 1992), 127–28.
3. Jörg-Uwe Albig, "Ein Denker malt Kritik," *Art: Das Kunstmagazin* 4 (April 1988): 36–54; translation provided by Curt Marcus Gallery, New York.

Artists' Biographies

Terry Allen

Born 1943, Wichita, Kansas
Lives and works in Santa Fe, New Mexico

Education
1966 B.F.A., Chouinard Art Institute, Los Angeles

Selected Solo Exhibitions
1994 "Poison Amor" (collaboration with James Drake), Blue Star Art Space, San Antonio
1992 "A Simple Story (Juarez)," Wexner Center for the Visual Arts, Ohio State University, Columbus
"Youth in Asia," Southeastern Center for Contemporary Art, Winston-Salem, North Carolina
1991 "The Artist's Eye," Kimbell Art Museum, Fort Worth
1989 "Big Witness (living in wishes)," San Francisco Art Institute
"Them Ol' Love Songs," Cranbrook Academy of Art Museum, Bloomfield Hills, Michigan
Installation and concert, Laumeier Sculpture Park and Museum, St. Louis
1988 "Big Witness (living in wishes)," organized by Santa Barbara Contemporary Arts Forum, Santa Barbara, California
"Treatment (angel leaving dirty tracks)," John Weber Gallery, New York
"Youth in Asia Series," Pittsburgh Center for the Arts
1986 "China Night," Florida State University Fine Arts Gallery, Tallahassee

Selected Group Exhibitions
1994 "Mapping," UTSA Art Gallery, University of Texas, San Antonio
1993 "La Frontera—The Border," Museum of Contemporary Art, San Diego
1991 "Singular Visions," Museum of Fine Arts, Santa Fe
"Selections from the Permanent Collection: 1975–1991," Museum of Contemporary Art, Los Angeles
"On the Road: Selections from the Permanent Collections of the San Diego Museum of Contemporary Art"
1990 "CCA/2: Second Annual Invitational," Center for Contemporary Arts of Santa Fe
1989 "Forty Years of California Assemblage," Wight Art Gallery, University of California, Los Angeles
1987 "Documenta 8," Museum Fridericianum, Kassel, Germany
"Avant-Garde in the Eighties," Los Angeles County Museum of Art
"War and Memory," Washington Project for the Arts, Washington, D.C.
1986 "The Texas Landscape, 1900–1986," Museum of Fine Arts, Houston
"Boston Collects: Contemporary Painting and Sculpture," Museum of Fine Arts, Boston
1985 "São Paulo Biennial," Brazil

Selected Performances
1994 "Chippy" (with Jo Harvey Allen), American Music Theater Festival, Plays and Players Theater, Philadelphia; Lincoln Center Serious Fun! Festival, New York
1993 "Amarillo Highway (and other roads)," St. Anne's Cathedral, Brooklyn, New York
1987 "War and Memory," Washington Project for the Arts, Washington, D.C.

Selected Recordings
1996 "Human Remains," Sugar Hill Records
1995 "Lubbock (on everything)," Sugar Hill Records (original release on Fate Records, 1978)
1994 "Songs from 'Chippy,'" Hollywood Records
1985 "Pedal Steal," Fate Records

David Bates

Born 1952, Dallas, Texas
Lives and works in Dallas

Education
1977 M.F.A., Southern Methodist University, Dallas
1976 Independent Study Program, Whitney Museum of American Art,
 New York
1975 B.F.A., Southern Methodist University, Dallas

Selected Solo Exhibitions
1996 Gerald Peters Gallery, Dallas
1995 Charles Cowles Gallery, New York
1994 "Roughshod," John Berggruen Gallery, San Francisco
1993 The Art Museum at Florida International University, Miami
1992 Charles Cowles Gallery, New York
 John Berggruen Gallery, San Francisco
1991 John Berggruen Gallery, San Francisco
 Charles Cowles Gallery, New York
1990 Arthur Roger Gallery, New Orleans
1988 "David Bates: Forty Paintings," Modern Art Museum of Fort Worth
1985 John Berggruen Gallery, San Francisco
 Charles Cowles Gallery, New York

Selected Group Exhibitions
1994 "The Label Show, Contemporary Art and the Museum," Museum of
 Fine Arts, Boston
 "Vividly Told, Contemporary Southern Narrative Painting,"
 Morris Museum of Art, Augusta, Georgia; Gibbes Museum
 of Art, Charleston, South Carolina
 "Outside: In, Outsider and Contemporary Artists in Texas,"
 Texas Fine Arts Association, Laguna Gloria Art Museum,
 Austin
1993 "In & Out of Place in Contemporary Art & Fiction," Museum of
 Fine Arts, Boston
1991 "American Realism & Figurative Art 1952–1991," Miyagi Museum of
 Art, Sendi, Japan
 "The State I'm In," Dallas Museum of Art
 "The Landscape in 20th Century Art: Selections from the
 Metropolitan Museum of Art," Philbrook Museum of Art, Tulsa,
 Oklahoma
1990 Group Exhibition, Eugene Binder Galerie, Cologne, Germany
 "Concentrations 23: Texas Figurative Drawings," Dallas Museum of Art
 "Northwest By Southwest, Painted Fictions," Palm Springs Desert
 Museum, California
 "Tradition and Innovation, A Museum Celebration of Texas Art,"
 Museum of Fine Arts, Houston
 "Texas Figurative Drawings," Dallas Museum of Art

1989 "The Blues Aesthetic: Black Culture and Modernism," Washington
 Project for the Arts, Washington, D.C.
 "10 + 10: Contemporary Soviet and American Painters," Ministry of
 Culture of the U.S.S.R. and InterCulture, Fort Worth
1988 "Texas Art," Menil Collection, Houston
 "The 1980s: A New Generation," Metropolitan Museum of Art,
 New York
1987 "1987 Biennial Exhibition," Whitney Museum of American Art,
 New York
1986 "The Figure in Landscape," Art Museum at Florida International
 University, Miami
 "Texas Landscape 1900–1986," Museum of Fine Arts, Houston
 "The Texas-Berlin Art Exchange," Amerika Haus, Berlin, Germany
1985 "50th Anniversary Acquisitions," San Francisco Museum of Modern
 Art

Frederick J. Brown

Born 1945, Greensboro, Georgia
Lives and works in New York City and Carefree, Arizona

Education
1968 B.A., Painting, Southern Illinois University, Carbondale

Selected Solo Exhibitions
1994 "The History of Art," Kemper Museum of Contemporary Art,
 Kansas City
1993 "The Assumption of Mary," Xavier University, New Orleans
1992 "The Magic Man," Gallery 10, Santa Fe
1991 National Museum of American Art, Smithsonian Institution,
 Washington, D.C.
1988 "A Retrospective," National Museum of the Chinese Revolution,
 Beijing, China
1987 Tomasulo Gallery, Union County College, Cranford, New Jersey
 Marlborough Gallery, New York
 Miami Dade Community College Museum, Miami
1985 Hokin-Kaufman Gallery, Chicago
 Marlborough Gallery, New York
 Davis-McClain Gallery, Los Angeles

Selected Group Exhibitons
1993 "Twenty-Five Years of Afro-American Art: Selections from the Studio
 Museum in Harlem," Paine Webber Gallery, New York
 "Free Within Ourselves: African-American Art in the Collection of the
 National Museum of American Art," National Museum of American
 Art, Smithsonian Institution, Washington, D.C.
1991 "Recent Acquisitions," Studio Museum in Harlem, New York
1990 "Recent Acquisitions," National Museum of American Art, Smithsonian
 Institution, Washington, D.C.

"Marlborough en Pelaires," Centre Cultural Contemporani Pelaires, Palma de Mallorca, Spain

1989 "American Resources: Selected Works of African American Artists," Bernice Steinbaum Gallery, New York

1988 "The 1980s: A New Generation," Metropolitan Museum of Art, New York

"Revelations: Drawing in America," Art Gallery of Bosnia and Herze-govina, Sarajevo, Yugoslavia

1986 "The Foundation Veranneman Invites Marlborough," Kruishoutem, Belgium

"50th National Midyear Exhibition," Butler Institute of American Art, Youngstown, Ohio

1985 Marlborough Gallery, New York

Kim Dingle

Born 1951, Pomona, California
Lives and works in Los Angeles

Education
1990 M.F.A., Claremont Graduate School, Claremont, California
1988 B.F.A., California State University, Los Angeles

Selected Solo Exhibitions
1995 Otis Gallery, Otis College of Art and Design, Los Angeles
Blum & Poe, Santa Monica, California
1994 Jack Tilton Gallery, New York
1993 Jason Rubell Gallery, Miami Beach
1992 "New Work," Kim Light Gallery, Los Angeles
1991 "Dingle Library Presents Painting of the West with Horse Drawing by Teenage Girls," Parker/Zanic Gallery, Los Angeles
"Portraits from the Dingle Library," Richard/Bennett Gallery, Los Angeles
"The Romance and Drama of the Rubber Industry," Closet of Modern Art (COMA), California State University, Los Angeles

Selected Group Exhibitions
1996 "Narcissism: Artists Reflect Themselves," California Center for the Arts Museum, Escondido
1995 "Inside Out: Psychological Self-Portraiture in the 90s," Aldrich Museum of Contemporary Art, Ridgefield, Connecticut
1994 "Arrested Childhood," Center of Contemporary Art, Miami
"Bad Girls West," Wight Gallery, University of California, Los Angeles
"Mapping," Museum of Modern Art, New York
1993 "Fourth Newport Biennial: Southern California," Newport Harbor Art Museum, Newport Beach
"43rd Biennial Exhibition of Contemporary American Painting," Corcoran Gallery of Art, Washington, D.C.

"Contemporary Identities: 24 Artists, the 1993 Phoenix Triennial," Phoenix Art Museum, Arizona

1992 "I Thought California Would Be Different, New Work in the Permanent Collection," Laguna Art Museum, Laguna Beach

1991 "Les Fleurs," Parker/Zanic Gallery (in conjunction with Sue Spaid Fine Art), Los Angeles
"The Store Show," Richard/Bennett Gallery, Los Angeles

1990 "Con-Text," Richard/Bennett Gallery, Los Angeles

Gronk

Born 1954, Los Angeles
Lives and works in Los Angeles

Selected Solo Exhibitions
1995 "Gronk—Past & Present," University of Colorado Museum, Boulder
"Gronk in the Galleries," San Francisco Museum of Modern Art
"Iron Weave," Elvehjem Museum of Art, University of Wisconsin, Madison
1994 "GRONK! A Living Survey, 1973–1993," Mexican Museum, San Francisco
1992 "Hotel Tormenta," Galerie Claude Samuel, Paris
"Fascinating Slippers/Pantunflas Fascinantes," San Jose Museum of Art, California
1991 "50 Drawings," Daniel Saxon Gallery, Los Angeles
1990 "Hotel Senator," Daniel Saxon Gallery, Los Angeles
"King Zombie," William Traver Gallery, Seattle, Washington
"Coming Home Again," Vincent Price Gallery, East Los Angeles College, Monterey Park, California
"Hotel Zombie," Laguna Art Musuem, Laguna Beach, California
1989 "Grand Hotel," Saxon-Lee Gallery, Los Angeles
1988 "She's Back," Saxon-Lee Gallery, Los Angeles
1987 "Bone of Contention," Saxon-Lee Gallery, Los Angeles
1986 "The Rescue Party," Saxon-Lee Gallery, Los Angeles
1985 "The Titanic and Other Tragedies at Sea," Galerie Ocaso, Los Angeles

Selected Group Exhibitoins
1995 "The mythic present of Chagoya, Valdez, and Gronk," Fisher Gallery, University of Southern California, Los Angeles
1993 "Chicano-Chicana: Visceral Images," The Works Gallery, Costa Mesa, California
"Sin Frontera: Chicano Arts from the Border States of the US," Corner House, Manchester, England
"Revelations/Revelaciones," Johnson Museum of Art, Cornell University, Ithaca, New York
1992 "The Chicano Codices: Encountering Art of the Americas," Mexican Museum, San Francisco

1991 "Myth and Magic in the Americas: The Eighties," Museum of Contemporary Art, Monterrey, Mexico
1990 "Chicano Art: Resistance and Affirmation, 1965–1985," Wight Art Gallery, University of California, Los Angeles
1989 "Three," Galerie Claude Samuel, Paris, France
"Le Demon des Anges: Chicano Artists from Los Angeles," Center for Research for the Cultural Development, Nantes, France, and Department of Culture, Barcelona, Spain
"Hispanic Art on Paper," Los Angeles County Museum of Art
1988 "Cultural Currents," San Diego Museum of Art
"Ten Latino Artists," Jack Tilton Gallery, New York
"Two Artists/Recent Works," University of California, San Diego
1987 "Hispanic Art in the United States: Thirty Contemporary Painters and Sculptors," Museum of Fine Arts, Houston
"On the Wall," Santa Barbara Contemporary Arts Forum
"LA Hot and Cool: Pioneers," Bank of Boston Art Gallery, Boston; organized by MIT List Visual Arts Center
1986 "Crossing Borders/Chicano Artists," San Jose Museum of Art, California

Selected Performances
1995 "A Musical Tardeada in Celebration of the César E. Chávez Center," University of California, Los Angeles
1988 "Installation/Performance," Creative Time, New York
1985 "Jetter Jinx," Los Angeles Theatre Center
"Morning Becomes Electricity," Museum of Contemporary Art, Los Angeles

Selected Special Projects
1996 Set designs for *Journey to Cordoba,* Los Angeles Opera
1991 Set designs for *Bowl of Beans,* Los Angeles Theatre Center, broadcast on PBS Great Performances
Set designs for *Canton Jazz Club,* East/West Players, Los Angeles
1990 Set designs for *The Chairman's Wife,* East/West Players, Los Angeles
Set designs for *The Mission,* Los Angeles Theatre Center
1989 Set designs for Paris Jazz Festival, France

Sharon Kopriva

Born 1958, Houston
Lives and works in Houston

Education
1981 M.F.A., University of Houston
1970 B.S., Art Education, University of Houston

Selected Solo Exhibitions
1995 "New Sculpture, Paintings and Constructions," Dutch Phillips & Co. Fine Art, Dallas
1994 "New Constructions and Paintings," Hall-Barnett Gallery, New Orleans

1993 LewAllen Gallery, Santa Fe
Southwest Texas State University, San Marcos, Texas
1992 "Conflicting Rituals," Corpus Christi State University, Texas
1991 "Rite of Passage," Art Center Museum, Waco, Texas
"Penances," Art Museum of Southeast Texas, Beaumont
1989 "Scultpures and Paintings," J. Rosenthal Gallery, Chicago
"Sculptures and Paintings," Graham Gallery, Houston
1988 Jung Center, Houston

Selected Group Exhibitons
1995 "Bridge: Works and Images from Houston/Sarajevo," A.R.M. (Artist Rescue Mission), Davis/McClain Gallery, Pennzoil Place, Houston
"Elvis + Marilyn = 2 X Immortal," Contemporary Arts Museum, Houston
"Texas Art for Russia," Yekaterinburg, Moscow
"Made in Texas," Parchmen/Stremmel Gallery, San Antonio
"Figuration," Virginia Miller Gallery, Miami
"Civil Disobedience," Lanning Gallery, Houston
1994 "Of Body and Spirit," Galveston Art Center, Texas
"Speaking of Artists: Words and Works from Houston," Museum of Fine Arts, Houston
1993 "Hope—Houston Exchange Exhibition," Moody Gallery, Houston; Faith and Charity Gallery, Hope, Idaho
"Texas Contemporary Acquisitions of the '90s," Museum of Fine Arts, Houston
"Texas Biennial," Dallas Museum of Art
"Talleres en Fronteras: An Exhibition of Contemporary Art from South Texas and Baja California," Corpus Christi, Mexicali, and El Paso, Texas; Tijuana, Mexico
"Fur, Fins, Feathers and More," Galveston Art Center, Texas
"A Sense of Place," Transco Tower, Houston
"In the Beginning," Art Museum of Southeast Texas, Beaumont
1992 "Dreams and Shields," Salt Lake City Art Center
1991 "Three Person Exhibition," Center for Research in Contemporary Art, University of Texas at Arlington
1990 "Day of the Dead Show," Lynn Goode Gallery, Houston
1989 "A Century of Texas Sculpture," Huntington Museum, Austin
"Another Reality," Hooks-Epstein Gallery, Houston
1988 "Houston Area Exhibition," First Place Award, Blaffer Gallery, University of Houston
"1988 Texas Exhibit," National Museum of Women in the Arts, Washington, D.C.
1987 "Line and Form: Contemporary Texas Figurative Drawing," Art Museum of South Texas, Corpus Christi
"Estes and Others," Allan Stone Gallery, New York
1986 "Memento Mori," Centro Cultural Arte Contemporaneo, Mexico City
"Empowered Painting," Museum of Fine Arts, Santa Fe
"Texas Invitational," Fort Worth Art Festival
"Dead Days," Blue Star Art Center, San Antonio

1985 "Fresh Paint: The Houston School," Museum of Fine Arts, Houston
Allan Stone Gallery, New York

Hung Liu

Born 1948, Changun, China
Lives and works in Oakland, California

Education
1986 M.F.A., Visual Arts, University of California, San Diego
1981 Graduate Student (M.F.A. Equivalent), Mural Painting, Central
 Academy of Fine Art, China
1975 B.F.A., Education, Beijing Teachers College, Beijing, China

Selected Solo Exhibitions
1996 Rena Bransten Gallery, San Francisco
1995 "Can-ton: The Baltimore Series," The Contemporary, site at the former
 Canton National Bank, Baltimore
 "The Last Dynasty," Steinbaum Krauss Gallery, New York
 "Parameters #19: Hung Liu," Chrysler Museum of Art, Norfolk, Virginia
1994 "The Year of the Dog," Steinbaum Krauss Gallery, New York
 "Jiu Jin Shan: Old Gold Mountain," Installation, M. H. de
 Young Memorial Museum, Golden Gate Park, San Francisco
 "Identity Fragments," Mary Porter Senson Art Gallery, Porter College,
 University of California, Santa Cruz
1993 "Two Small Bodies," Churchill County Library—Churchill Arts Council,
 Fallon, Nevada
1992 "Sittings," Bernice Steinbaum Gallery, New York
1991 "Bad Women," Rena Bransten Gallery, San Francisco
1990 "Trauma," Diverseworks, Houston
1988 "Where is Mao?" Southwestern College Art Gallery, Chula Vista,
 California
 "Resident Alien," Capp Street Project, Monadnock Building,
 San Francisco
1987 "Combinations," Bath House Cultural Center, Dallas
1986 "Canto," Annex Gallery, University of California, San Diego

Selected Group Exhibitions
1995 "Making Faces: American Portraits," Hudson River Museum of
 Westchester, Yonkers, New York
 "About Faces," Santa Barbara Museum of Art
 "[dis]Oriented: Shifting Identities of Asian Women in America," Henry
 Street Settlement and Steinbaum Krauss Gallery, New York
1994 "Memories of Childhood: so we're not the Cleavers or the Brady
 Bunch," Steinbaum Krauss Gallery, New York
 "Asia/America: Identities in Contemporary Asian American Art,"
 Asia Society Galleries, New York

"Painting: An Asian American Perception," Marjorie Barrick Museum,
 University of Nevada, Las Vegas
 "New Voices 1994," Allen Memorial Art Museum, Oberlin College,
 Ohio
1993 "Picasso to Christo: The Evolution of a Collection," Santa Barbara
 Museum of Art
 "43rd Biennial Exhibition of Contemporary American Painting,"
 Corcoran Gallery of Art, Washington, D.C.
 "In Transit," New Museum of Contemporary Art, New York
 "Twelve Bay Area Painters: The Eureka Fellowship Winners," San Jose
 Museum of Art, California
 "Redefining Self: 6 Asian Americans," San Jose State University Art
 Galleries, California
1992 "In Plural America: Contemporary Journeys, Voices and Identities,"
 Hudson River Museum of Westchester, Yonkers, New York
 "Society for the Education of Contemporary Art Award (SECA) 1992,"
 San Francisco Museum of Modern Art
 "Counterweight: Alienation, Assimilation, Resistance," Santa Barbara
 Contemporary Arts Forum, California
1991 "Counter Colon-Ialismo," Centro Cultural de la Raza, San Diego
 "Mito y Magia en America: Los Ochenta," Museo de Arte Contempora-
 neo de Monterrey, Mexico
 "Viewpoints: Eight Installations," Richmond Art Center, Richmond,
 California
1990 "Precarious Links: Emily Jennings, Hung Liu and Celia Munoz," San
 Antonio Museum of Art, Lawndale Art and Performance Center,
 Houston

Deborah Oropallo

Born 1954, Hackensack, New Jersey
Lives and works in Berkeley, California

Education
1983 M.F.A., University of California, Berkeley
1982 M.A., University of California, Berkeley
1979 B.F.A., Alfred University, Alfred, New York
1975 Leo Marchutz School of Drawing and Painting, Aix-en-Provence,
 France

Selected Solo Exhibitons
1995 "Lessons," Stephen Wirtz Gallery, San Francisco
1992 Weatherspoon Gallery, University of North Carolina, Greensboro
1990 "Currents/Deborah Oropallo" Institute of Contemporary Art, Boston
 "1990 Painting Award Exhibition," Artspace, San Francisco
1988 Stephen Wirtz Gallery, San Francisco
1987 Memorial Union Art Gallery, University of California, Davis
 Oropallo/Pijoan, Raab Gallery, Berlin, Germany
1986 Stephen Wirtz Gallery, San Francisco

Selected Group Exhibitions

1995 "New Acquisitions," University Art Museum, Berkeley
1994 "U.S.A. 'Within Limits,'" Documenta, Galleria de Arte, São Paulo, Brazil
 "Selections from the Anderson Collection," San Jose Museum of Art, California
 "Lyricism and Light," Palo Alto Cultural Center, California
1993 "43rd Biennial Exhibiton of Contemporary American Painting," Corcoran Gallery of Art, Washington, D.C.
 "The Return of the Cadavre Exquis," Drawing Center, New York
1992 "Somewhere Between Image and Text," Krakow Gallery, Boston
 "Corollaries of Apprehension," California College of Arts and Crafts, Oakland
 "California: North and South," Aspen Art Museum, Colorado
 "Voices," Shea & Bornstein, Los Angeles
1991 "Her Story," Oakland Museum, California
 "Cruciformed," Cleveland Center for Contemporary Art, Ohio
 "Contemporary Painting," Wake Forest University, Fine Arts Gallery, Winston-Salem, North Carolina
1990 "Word As Image," Milwaukee Art Museum
 "Word As Symbols," Aldrich Museum of Contemporary Art, Ridgefield, Connecticut
 "Drinking and Driving," Cleveland Center for Contemporary Art
 "Crossing the Line: Word and Image in Art, 1960–1990," Montgomery Gallery, Pomona College, Pomona, California
1989 "Whitney Biennial," Whitney Museum of American Art, New York
 "Bay Area: Fresh Views," San Jose Museum of Art
 "New Works," Capp Street Project, San Francisco
1987 "Passages: A Survey of California Women Artists, 1945 to Present: Emerging California Women Artists," Fresno Art Museum
 "Oropallo/Pijoan," Raab Gallery, Berlin, Germany
1986 "Emerging Artists: A Macedonia," Museo Italo Americano, San Francisco
 "Paravent: Extending the Range of Expression," Artspace, San Francisco

Pepón Osorio

Born 1955, Santurce, Puerto Rico
Lives and works in New York

Education

1985 M.A., Columbia University, New York
1978 B.S., Herbert H. Lehman College, New York
1974 B.A., Universidad Inter-Americana, Rio Piedras, Puerto Rico

Selected Solo Exhibitions

1995 "Project 5: Pepón Osorio—Badge of Honor," Newark Museum, New Jersey
1993 "Scene of the Crime (Whose Crime?)," Cleveland Institute of Art, Ohio
1992 Atlantic Center for the Arts, Smyrna Beach, Florida
 Fleisher School of the Arts, Philadelphia
 Pennsylvania Academy of the Fine Arts, Philadelphia
1991 CU Art Galleries, University of Colorado, Boulder
 "Con To' Los Hierros: A Retrospective of the Work of Pepón Osorio," El Museo del Barrio, New York

Selected Group Exhibitions

1995 "Art at the Edge: Social Turf," High Museum of Art, Atlanta
1993 "1993 Biennial Exhibition," Whitney Museum of American Art, New York
1992 "The Edge of Childhood," Heckscher Museum, Huntington, New York
 "Americas," Monasterio de Santa Clara, Seville, Spain
 "First Invasion: Contemporary Artists of the Caribbean," Galeria de la Raza, San Francisco
1990 "The Decade Show," Museum of Hispanic Art, New Museum of Contemporary Art, Studio Museum in Harlem, New York
1989 "Día de los Muertos II: Los Angelitos," Longwood Art Center, Bronx, New York
1987 "The Sculpture Show," Longwood Art Center, Bronx, New York
1986 "Caribbean Art/African Currents," Museum of Contemporary Hispanic Arts, New York
1985 "Ocho artistas," Voluntariado de las Casas Reales, Santa Domingo, Dominican Republic

Frank Romero

Born 1941, East Los Angeles
Lives and works in Los Angeles and Arroyo Seco, New Mexico

Selected Solo Exhibitons

1995 "Flores!: An exhibition of unique silkscreen monoprints," Alitash Kebede Gallery, Los Angeles
 "Some New Paintings," Robert Berman Gallery, Santa Monica
 "Lowrider: Vehicle for Expression: The Painting and Sculpture of Frank Romero," Mesa College Art Gallery, San Diego
1993 "Chamacas, Grecas y Tumbas," Remba Gallery, Santa Monica
1992 "Frank Romero at the Boathouse," Plaza de la Raza, Lincoln Park, California
 "Frank Romero! A Survey of Recent Work," Carnegie Art Museum, Oxnard
1991 "Oil, Wood and Light," Robert Berman Gallery, Santa Monica
1990 "An Exhibition of Paintings and Prints," Future Perfect Gallery, Los Angeles

1989 Lizardi-Harp Gallery, Pasadena
1988 "Cajas de Sombra," Lizardi-Harp Gallery, Pasadena
1987 "Travels in Spain and Other Stories," Robert Berman Gallery, Santa
 Monica
1986 "New Work," Karl Bornstein Gallery, Santa Monica

Selected Group Exhibitions
1995 "The Horse Show," Sylvia White Gallery, Santa Monica
1994 "Los Four 20 Years After: Then (1974) and Now," Robert Berman
 Gallery, Santa Monica
 "Vehicles," California State University, Hayward
 "City Art," Millard Sheets Gallery, Los Angeles County Fairgrounds,
 Pomona, California
 "The Mystical in Art: Chicano Latino Painting," Carnegie Art Museum,
 Oxnard, California
1993 "Then and Now: Chicano Art after CARA," Jansen Perez Gallery, San
 Antonio
 "Chicano/Chicana: Visceral Images," The Works Gallery, Costa Mesa,
 California
1992 "Ojo Abierto/Open Eye," Santa Barbara Contemporary Arts Forum
 "L.A. Drives Me Wild," Sherry Frumkin Gallery, Santa Monica
 "Bare Essentials," Couturier Gallery, Los Angeles
 "Mexican Traditions in Contemporary Chicano Art," Armory Center for
 the Arts, Pasadena, California
 "A Mexican Legacy," Riverside Museum of Art, California
1991 "California Citiscapes," San Diego Museum of Art
 "Motion as Metaphor: The Automobile in Art," Virginia Beach Center
 for the Arts, Virginia
1990 "Chicano Art: Resistance and Affirmation, 1965–1985," Wight Art
 Gallery, University of California, Los Angeles
 "Aquí y Allá," Los Angeles Municipal Art Gallery and Centro Cultural
 Tijuana, México
 "Artists' Artists," Long Beach Museum of Art, California
 "Aquí Estamos y No Nos Vamos," University Art Gallery, California
 State University, San Bernardino
1989 "American Pop Culture Today," Laforet Museum, Harajuku, Tokyo
 "Visions: An exhibit of Mexican and Chicano Art," Clark Humanities
 Museum, Scripps College, Claremont, California
 "Le Demon des Anges," Jallu du CRDC Nantes, France
 "Hispanic Art on Paper," Los Angeles County Museum of Art
1988 "Frank Romero, Ibsen Espada, Jesús Bautista Morales," Janus Gallery,
 Santa Fe
1987 "Hispanic Art in the United States," Museum of Fine Art, Houston
 "Los Angeles Today: Contemporary Visions," Amerika Haus, Berlin,
 Germany
1986 "Chicano Expressions," INTAR Latin American Gallery, New York
 "Perspectives in Glass, Present," Craft and Folk Art Museum,
 Los Angeles
1985 "Spectrum of Los Angeles: Neue Kunst aus California," Hartje Gallery,
 Frankfurt, Germany

Roger Shimomura

Born 1939, Seattle
Lives and works in Lawrence, Kansas

Education
1969 M.F.A., Syracuse University, New York
1968 Cornell University, Ithaca, New York
1967 Stanford University, Palo Alto
1964 Cornish School of Allied Arts, Seattle
1961 B.A., University of Washington, Seattle

Selected Solo Exhibitions
1996 "Delayed Reactions," Spencer Museum of Art, University of Kansas,
 Lawrence
1995 Steinbaum Krauss Gallery, New York
 Greg Kucera Gallery, Seattle
1992 Cheney Cowles Museum, Spokane
 "A Billboard Project," Creative Time, New York
 Lewis-Clark State College, Lewiston, Idaho
1991 Carnegie Arts Center, Leavenworth, Kansas
1990 Gallery 181, Iowa State University, Ames
1989 Bernice Steinbaum Gallery, New York
 Tyler School of Art, Temple University, Philadelphia
 Loyola University, New Orleans
1988 Cleveland State University Art Gallery
 Greg Kucera Gallery, Seattle
1986 University of Oregon Museum of Art, Eugene
 Whatcom Museum of History and Art, Bellingham, Washington
 Center for Contemporary Arts, Santa Fe
 Emporia State University, Emporia, Kansas

Selected Group Exhibitions
1994 "Elvis + Marilyn: 2 x Immortal," Institute of Contemporary Art, Boston
 "Memories of Childhood," Steinbaum Krauss Gallery, New York
 "Yellow Potluck," Creative Time—42nd Street Development Project,
 installation and performance, New York
1993 "The Art of Microsoft," Henry Art Gallery, University of Washington,
 Seattle
 "We Count! The State of Asian Pacific America," Tweed Gallery at City
 Hall, New York
 "Multicultural Americana," Florida Community College at Jacksonville
1992 "Relocations and Revisions: The Japanese-American Internment
 Reconsidered," Long Beach Museum of Art, California
1991 "Syncretism: The Art of the XXI Century," Alternative Museum, New
 York
 Philbrook Art Center, Tulsa, Oklahoma
 Nelson-Atkins Museum, Kansas City, Missouri
 Fort Wayne Museum of Art, Indiana
 "Other Voices: Mediating Between Ethnic Traditions and the Modernist

Mainstream," Baxter Gallery, Portland School of Art, Maine
1990 "Midlands Invitational 1990: Painting and Sculpture," Joslyn Art Museum, Omaha, Nebraska
American Academy Institute of Arts and Letters, New York
Palm Springs Desert Museum, Palm Springs, California
Huntington Museum of Art, Huntington, West Virginia
1989 National Building Museum, Washington, D.C.
Grey Art Gallery, New York University, New York
"Where Two Worlds Meet," Washington State University Museum of Art, Pullman
1988 Center of Contemporary Art, Seattle
Cheney Cowles Museum, Spokane
"Alice, and Look Who Else, Through the Looking Glass," Bernice Steinbaum Gallery, New York
Nelson-Atkins Museum, Kansas City, Missouri
1987 "A Kansas Collection: A Harvest of the Best," National Museum of Women in the Arts, Washington, D.C.
The Public Art Space, Seattle Center House
1985 University of Maryland, College Park

Selected Performances
1995 "Campfire Diary," Carmichael Auditorium, National Museum of American History, Smithsonian Institution, Washington, D.C.
1994 "Yellow No Same," Creative Time—42nd Street Development Project, New York
"Campfire Diary," Walker Art Center, Minneapolis
1993 "The Last Sensei," University of Kansas School of Fine Arts, Lawrence
1989 "Make Rice Not War, Valeda Daze & K.I.K.E." (from "California Sushi"), Bernice Steinbaum Gallery, New York
"California Sushi," Center for Contemporary Art, Seattle
1988 "Make Rice, Not War" (from "California Sushi"), The Bottleneck, Lawrence, Kansas
1987 "Trans-Siberian Excerpts" and "Funky Odori," Grand Ballroom, Eastern Illinois University, Charleston
1985 "Seven Kabuki Plays Project (excerpt)," Crafton-Peyer Theatre, University of Kansas, Lawrence

Jaune Quick-to-See Smith

Born 1940, Indian Mission (Flathead Tribe), St. Ignatius, Montana
Lives and works in Corrales, New Mexico

Education
1980 M.A., Art, University of New Mexico, Albuquerque
1976 B.A., Art Education, Framingham State College, Massachusetts

Selected Solo Exhibitions
1995 Steinbaum Krauss Gallery, New York

1994 Jan Cicero Gallery, Chicago
Santa Fe Institute of Fine Arts
LewAllen Gallery, Santa Fe
1993 "Parameters #9: Jaune Quick-to-See Smith," Chrysler Museum, Norfolk, Virginia
Sweet Briar College, Sweet Briar, Virginia
1991 Anne Reed Gallery, Sun Valley, Idaho
1990 Lawrence Art Center, Lawrence, Kansas
Bernice Steinbaum Gallery, New York
1989 California State University, Long Beach
Cambridge Multi-Cultural Art Center, Cambridge, Massachusetts
1988 Marilyn Butler Gallery, Santa Fe
1986 Yellowstone Art Center, Billings, Montana
1985 Bernice Steinbaum Gallery, New York

Selected Group Exhibitions
1995 "Art at the Edge: Social Turf," High Museum of Art, Atlanta
"Old Glory, New Story: Flagging of the 21st Century," Capp Street Project, San Francisco
"Indian Humor," organized by the American Indian Contemporary Arts, San Francisco
1994 "Current Identities: Recent Paintings in the United States," Aljira Center for Contemporary Art, Newark, New Jersey (traveled internationally throughout Latin America)
"Memories of Childhood . . . so we're not the Cleavers or the Brady Bunch," Steinbaum Krauss Gallery, New York
"Cultural Signs in Contemporary Native American Art," Herbert F. Johnson Museum, Cornell University, Ithaca, New York
1993 "Into the Forefront: American Indian Art in the 20th Century," Denver Art Museum
"For the Seventh Generation: Native Americans Counter the Quincentenary," Art in General, New York
"Narratives of Loss: The Displaced Body," University of Wisconsin, Milwaukee
1992 "Counter Colon-ialismo," Centro Cultural Tijuana, Mexico
"Decolonializing the Mind," Center on Contemporary Art, Seattle
"In Plural America: Contemporary Journeys, Voices and Identities," Hudson River Museum of Westchester, Yonkers, New York
"Shared Vision: Native American Sculptors and Painters in the Twentieth Century," Heard Museum, Phoenix, Arizona
1991 "Encuentro: Invasion of the Americas and the Making of the Mestizo," Artes de Mexico, Venice, California
"Myth and Magic in the Americas," Museo de Arte Contemporaneo de Monterrey, Mexico
"Other Voices: Mediating Between the Ethnic Traditions and the Modernist Mainstream," Baxter Gallery, Portland Museum of Art, Maine
1990 "Menagerie," Museum of Modern Art, New York
"The Decade Show," New Museum of Contemporary Art, Studio Museum in Harlem, Museum of Contemporary Hispanic Art, New York

1989 "Beyond Survival: Old Frontiers/New Visions," Ceres Gallery, New York
1988 "Cultural Currents," San Diego Museum of Art
 "Committed to Print," Museum of Modern Art, New York
 "Alice, and Look Who Else, Through the Looking Glass," Bernice Steinbaum Gallery, New York
1987 "Motion and Arrested Motion," Chrysler Museum, Norfolk, Virginia
 "Contemporary Native American Artists," Fort Wayne Museum of Art, Indiana
 "Connections Project/Conexus," Museum of Contemporary Hispanic Art, New York
1986 "American Women in Art: Works on Paper—An American Album," Nairobi, Kenya
 "Whoa! Contemporary Art of the Southwest," Tampa Museum of Art, Florida
 "Visible/Invisible," Palo Alto Cultural Center, California
1985 "Cowboys and Indians, Common Ground," Lock Haven Art Center, Orlando, Florida
 "New Ideas from Old Traditions," Yellowstone Art Center, Billings, Montana
 "Women of Sweetgrass, Cedar and Sage: Contemporary Art by Native-American Women," American Indian Community House (AICH), New York

Renée Stout

Born 1958, Junction City, Kansas
Lives and works in Washington, D.C.

Education
1980 B.F.A., Carnegie-Mellon University, Pittsburgh

Selected Solo Exhibitions
1995 "'Dear Robert, I'll See You at the Crossroads': A Project by Renée Stout," University Art Museum, University of California, Santa Barbara
1992 Pittsburgh Center for the Arts
1991 B. R. Kornblatt Gallery, Washington, D.C.
1987 Chapel Gallery, Mount Vernon College, Washington, D.C.

Selected Group Exhibitions
1994 "Mujeres de Poder/Women of Power," Fondo del Sol, Washington, D.C.
 "Luxor v1.0: An Interactive Installation by Y. David Chung, Matt Dibble, and Renée Stout," Corcoran Gallery of Art, Washington, D.C.
1993 "Free Within Ourselves: African-American Art in the Collection of the National Museum of American Art," National Museum of American Art, Smithsonian Institution, Washington, D.C.
 "Astonishment and Power: Kongo Minkisi and a New World Resonance," National Museum of African Art, Smithsonian Institution, Washington, D.C.
1992 "Homeplace," Henry Street Settlement, New York

"Houses of Spirit/Memories of Ancestors," Woodlawn Cemetery, Bronx, New York
"Migrations of Meaning," INTAR Hispanic American Arts Center, New York
"Present Tense," University of Wisconsin—Milwaukee Art Museum, Milwaukee
"Sites of Recollection: Four Altars and a Rap Opera," Williams College Museum of Art, Williamstown, Massachusetts
1991 "SITEseeing Travel and Tourism in American Art," Whitney Museum of American Art Downtown at Federal Reserve Plaza, New York
"Power and Spirit," Washington Project for the Arts, Washington, D.C.
1990 "Gathered Visions," Anacostia Museum, Smithsonian Institution, Washington, D.C.
1989 "Black Art: Ancestral Legacy," Dallas Museum of Art
1988 "New Directions," Marie Martin Gallery, Washington, D.C.
1987 Carlow College, Pittsburgh
1986 Wayland House Gallery, Washington, D.C.
 Martin Luther King Public Library, Washington, D.C.
1985 "Black Creativity," Museum of Science and Industry, Chicago
 Massachusetts College of Art, Boston

Mark Tansey

Born 1949, San Jose, California
Lives and works in New York City

Education
1978 M.F.A., Painting, Hunter College, New York
1974 Harvard Summer Session, Institute of Arts Administration, Cambridge, Massachusetts

Selected Solo Exhibitions
1995 "Borders," Galleri Faurschou, Copenhagen, Denmark
1993 "28 Pictures," Curt Marcus Gallery, New York
 Los Angeles County Museum of Art
1990 "Art and Source," Seattle Art Museum
1987 Curt Marcus Gallery, New York
1986 Curt Marcus Gallery, New York
1985 Contemporary Arts Museum, Houston

Selected Group Exhibitions
1995 Group Show, Curt Marcus Gallery, New York
1994 "Mountains of the Mind," Aspen Art Museum, Colorado
 "Visions of America: Landscape as Metaphor in the Late Twentieth Century," Denver Art Museum and Columbus Museum of Art, Ohio
 "Connections—Mark Tansey," Museum of Fine Arts, Boston
1993 "Brief Encounters: Meetings in Art," Grey Art Gallery, New York University, New York

"I am The Enunciator," Thread Waxing Space, New York
1992 "Quotations: The Second History of Art," Aldrich Museum of Contemporary Art, Ridgefield, Connecticut
"Photography Reproduction Production: The Work of Art in the Age of Mechanical Representation," Suzanne Lemberg Usdan Gallery, Bennington College, Vermont
"The Word-Image in Contemporary Art," James Howe Gallery, Kean College of New Jersey, Union
1991 "1991 Biennial Exhibition," Whitney Museum of American Art, New York
1990 "The Charade of Mastery: Deciphering Modernism in Contemporary Art," Whitney Museum of American Art Downtown, New York
"Harmony and Discord: American Landscape Painting Today," Virginia Museum of Fine Arts, Richmond
"Vertigo," Galerie Thaddaeus Ropac, Paris, France
"Color and/or Monochrome," National Museum of Modern Art, Tokyo
1989 "Romance & Irony in Recent American Art," Art Gallery of Western Australia, Perth
"Image World: Art and Media Culture," Whitney Museum of American Art, New York
"10 + 10: Contemporary Soviet & American Painters," Modern Art Museum of Fort Worth
1988 "Classical Myth & Imagery in Contemporary Art," Queens Museum, New York
"American Art Today: Narrative Painting," Art Museum at Florida International University, Miami
1987 "Morality Tales: History Painting in the 1980s," Grey Art Gallery, New York University, New York
"Documenta 8," Museum Fridericianum, Kassel, Germany
"Contemporary Diptychs: Divided Visions," Whitney Museum of American Art, Stamford, Connecticut; Whitney Museum of American Art at Equitable Center, New York
"Avant-Garde in the Eighties," Los Angeles County Museum of Art
"Tragic and Timeless Today: Contemporary History Painting," Gallery 400, University of Illinois, Chicago
1986 "Correspondences: New York Art Now," Tsuromoto Room, Tokyo
"Second Sight: Biennial IV," San Francisco Museum of Modern Art
"Figure as Subject: The Last Decade," Whitney Museum of American Art at Equitable Center, New York
"Aperto 86," Corderie at the Arsenal, Venice Biennale, Italy
"The Window in 20th Century Art," Neuberger Museum, State University of New York, Purchase; Contemporary Arts Museum, Houston
1985 "Figure in 20th-Century American Art," Metropolitan Museum of Art, New York

Photo Credits

Photographs of Artists

Exhibition Checklist

Terry Allen

Good Boy
1986
mixed media
205.7 x 123.8 x 139.7 cm
 (81 x 48¾ x 55 in.)
Courtesy the artist

The Creature
1987
mixed media
92 x 175.3 x 15.2 cm
 (36¼ x 69 x 6 in.)
Courtesy the artist and Moody
Gallery, Houston

Treatment (angel leaving dirty tracks)
1988
mixed-media installation with
sound
205.7 x 82.9 x 82.9 cm
 (81 x 32⅝ x 32⅝ in.)
Courtesy the artist

Sneaker
1991
mixed media
156.2 x 94 x 19 cm
 (61½ x 37 x 7½ in.)
Courtesy the artist and L.A.
 Louver, Inc., Venice, California

David Bates

Baits
1990
oil on canvas
213.4 x 162.6 cm (84 x 64 in.)
National Museum of American Art,
 Smithsonian Institution,
 Museum purchase

Bait Shop
1994
acrylic and oil on canvas
213.4 x 162.6 cm (84 x 64 in.)
Collection of the artist, Courtesy
 Charles Cowles Gallery, New
 York

Male Head #4
1995
painted plaster and steel
96.5 x 33 x 61 cm (38 x 13 x 24 in.)
Collection of the artist, Courtesy
 John Berggruen Gallery, San
 Francisco

Female Head #1
1995
painted plaster and steel
154.9 x 50.8 x 60.1 cm
 (61 x 20 x 24 in.)
The Barrett Collection, Dallas

Male Bust #5
1995
painted wood
188 x 121.9 x 61 cm (74 x 48
 x 24 in.)
The Barrett Collection, Dallas

Frederick Brown

Chief Seattle
1992
oil on linen
152.4 x 127 cm (60 x 50 in.)
Collection of Timothy B. Francis

Black Elk
1992
oil on linen
121.9 x 101.6 cm (48 x 40 in.)
Collection of Gerald L. Pearson

She Knows How
1992
oil on linen
152.4 x 127 (60 x 50 in.)
Courtesy Gallery 10, Inc., Scottsdale

I Thought of Crazy Horse
1992
oil on linen
121.9 x 101.6 cm (48 x 40 in.)
Collection of Sherry B. Bronfman

Kim Dingle

All works by Kim Dingle are part of
the installation *Priss' Room.*

Priss
1994
porcelain, china paint, painted steel
 wool
76.2 x 33 x 25.4 cm (30 x 13
 x 10 in.)
Collection of Clyde Beswick

nine wall panels
1995–96
wallpaper, paint stick, crayon, and
 oil paint on plywood
243.8 x 121.9 cm each (96 x 48 in.)
Collection of the artist

scatter materials
1994–96
tuna cans, crumpled paper and
 newspaper, chewed stuffed
 animals and dolls, crayons,
 power tools
dimensions variable
Collection of Clyde Beswick

Priss crib
1994–95
painted wood and fiberboard,
 synthetic mattress, newspaper,
 tuna cans
dimensions variable
Collection of the artist

Priss (2)
1994
porcelain, china paint, painted steel
 wool
76.2 x 33 x 25.4 cm each (30 x 13
 x 10 in.)
Collection of the artist

black-and-white check floor
1996
linoleum
365.8 x 365.8 cm (144 x 144 in.)
Collection of the artist

Priss
1994
porcelain, china paint, painted steel
 wool
76.2 x 33 x 25.4 cm
 (30 x 13 x 10 in.)
Collection of Sandra and Jerry
 LeWinter

Priss crib
1994
painted wood, fiberboard, synthetic
mattress, newspaper, tuna cans
dimensions variable
Collection of Sandra and Jerry
 LeWinter

Dart board
1995
oil on wood with darts
dimensions variable
Collection of Sandra and Jerry
 LeWinter

Priss
1994
porcelain, china paint, painted steel
 wool
76.2 x 33 x 25.4 cm (30 x 13
 x 10 in.)
DGM—Doll Gallery and Museum,
 Santa Monica

Gronk

Mural completed on-site
1996
acrylic and other assorted paints on
 transportable walls
243.8 x 487.7 cm (96 x 192 in.)
Collection of the artist and Daniel
 Saxon Gallery, Los Angeles

St. Rose of Lima
1991
acrylic on canvas
289.6 x 330.2 cm (114 x 130 in.)
Museum of Contemporary Art, Los
 Angeles, Gift of Nestle USA, Inc.

Sharon Kopriva

Rite of Passage
1991
papier-mâché, cloth, bone, wood,
 mixed media
152.4 x 335.3 x 182.9 cm
 (60 x 132 x 72 in.)
Collection of Nancy Reddin
 Kienholz

Hung Liu

Father's Day
1994
oil on canvas with architectural
 panel
137.2 x 182.9 cm (54 x 72 in.)
Collection of Bernice and Harold
 Steinbaum

Children of a Lesser God
1995
oil on canvas with red lacquer boxes
 and cans
182.9 x 203.2 x 7.6 cm
 (72 x 80 x 3 in.)
Collection of Esther S. Weissman

The Ocean is the Dragon's World
1995
oil on canvas, architectural panel,
 birdcage
243.8 x 208.3 x 45.7 cm
 (96 x 82 x 18 in.)
National Museum of American Art,
 Museum purchase in part
 through the William R. and
 Nora H. Lichtenberg Endowment
 Fund

Five Eunuchs
1995
oil on canvas, cigar boxes
177.8 x 243.8 x 10.2 cm
 (70 x 96 x 4 in.)
Collection of Bernice and Harold
 Steinbaum

Baby King
1995
oil on canvas
182.9 x 152.4 cm (72 x 60 in.)
Collection of Penny and
Moreton Binn, New York

Deborah Oropallo

The Wolf
1993
oil on canvas
218.4 x 162.5 cm (86 x 64 in.)
Collection of Anne Marie
 MacDonald

Pinocchio
1994
oil and paper on canvas
147.3 x 132.1 cm (58 x 52 in.)
Courtesy the artist and
 Zolla/Lieberman Gallery Inc.,
 Chicago

Snow White
1994
oil and paper on canvas
243.8 x 175.3 cm (96 x 69 in.)
Collection of William R. and Judith
 P. Timken

Pepón Osorio

Installation: *Badge of Honor*
1995
mixed media, video
overall dimensions: 309.9 x 1005.8
 x 378.5 cm
 (122 x 396 x 149 in.)
Courtesy Ronald Feldman Fine Arts,
New York

Frank Romero

The Arrest of the Paleteros
1996
oil on canvas, diptych
overall dimensions: 243.8
 x 365.8 cm
 (96 x 144 in.)
Courtesy the artist

The Death of Ruben Salazar
1986
oil on canvas
182.9 x 304.8 cm (72 x 120 in.)
National Museum of American Art, Smithsonian Institution, Museum purchase made possible in part by the Luisita L. and Franz H. Denghausen Endowment

The Closing of Whittier Boulevard
1984
oil on canvas
182.9 x 304.8 cm (72 x 120 in.)
Collection of Peter U. Schindler

Roger Shimomura

The Princess Next Door
1995
acrylic on canvas, diptych
94 x 91.4 cm (37 x 36 in.)
Courtesy Steinbaum Krauss Gallery, New York

Return of the Rice Cooker
1994
acrylic on canvas, diptych
147.3 x 137.2 cm (58 x 54 in.)
Courtesy Steinbaum Krauss Gallery, New York

Beacon Hill Boy
1994
acrylic on canvas, diptych
147.3 x 137.2 cm (58 x 54 in.)
Collection of The St. Paul Companies, Inc., Minneapolis

After the Movies, no. 2
1994
acrylic on canvas, triptych
121.9 x 142.2 cm (48 x 56 in.)
Courtesy Steinbaum Krauss Gallery, New York

Suburban Love
1995
acrylic on canvas, diptych
213.4 x 182.9 cm (84 x 72 in.)
Courtesy Steinbaum Krauss Gallery, New York

Jaune Quick-to-See Smith

Trade (gifts for trading land with white people)
1992
oil, collage, mixed media on canvas with objects, triptych
152.4 x 431.8 cm (60 x 170 in.)
Chrysler Museum, Norfolk, Virginia Museum purchase

Genesis
1993
oil, collage, mixed media on canvas, diptych
152.4 x 254 cm (60 x 100 in.)
High Museum of Art, Atlanta, Georgia, Purchase through funds provided by AT&T NEW ART/NEW VISIONS with funds from Alfred Austell Thornton in memory of Leila Austell Thornton and Albert Edward Thornton, Sr., and Sarah Miller Venable and William Hoyt Venable, 1995.54

Renée Stout

All works by Renée Stout are part of the installation *Madam Ching's Parlor*

Madam's Desk
1995
found and handmade objects
overall dimensions: 143.8 x 96.5 x 71.1 cm (56⅝ x 38 x 28 in.)

Courtesy the artist and David Adamson Gallery, Washington, D.C.

The Old Fortune Teller's Board
1993
painted wood, watercolor and ink on paper, glass, mudfish bones, and leather
10.2 x 60.6 x 59.4 cm (4 x 23⅞ x 23⅜ in.)
National Museum of American Art, Smithsonian Institution, Museum purchase made possible by Ralph Cross Johnson and Mrs. William Rhinelander Stewart

Ogun
1995
found and handmade objects
101.6 x 35.6 x 40.6 cm (40 x 14 x 16 in.)
Courtesy David Adamson Gallery, Washington, D.C., and Horwitch/LewAllen Gallery, Santa Fe

Conjuring Vest
1995
found and handmade objects, antique blouse
63.5 x 50.8 x 30.5 cm (25 x 20 x 12 in.)
Courtesy David Adamson Gallery, Washington, D.C., and Horwitch/LewAllen Gallery, Santa Fe

Ancestral Portrait No. 1
1996
acrylic on wood
69.9 x 59.7 cm (27½ x 23½ in.)
Courtesy David Adamson Gallery, Washington, D.C., and Horwitch/LewAllen Gallery, Santa Fe

Ancestral Portrait No. 2
1996
acrylic on wood
63.5 x 53.3 cm (25 x 21 in.)
Courtesy David Adamson Gallery, Washington, D.C., and Horwitch/LewAllen Gallery, Santa Fe

Doublecross
1996
wood with found and handmade objects
91.4 x 182.9 cm (36 x 72 in.)
Courtesy David Adamson Gallery, Washington, D.C., and Horwitch/LewAllen Gallery, Santa Fe

Mark Tansey

Continental Divide
1994
oil on canvas
162.6 x 217.2 cm (64 x 85½ in.)
Collection of W. Scott Hedrick

Columbus Discovers Spain
1995
oil on canvas
181 x 274.3 cm (71¼ x 108 in.)
Private collection, Houston

Landscape
1994
oil on canvas
181.6 x 365.8 cm (71½ x 144 in.)
Stefan T. Edlis Collection

Mark Tansey in collaboration with Fritz Buehner
Wheel
1990
plywood and wood veneer
96.5 x 121.9 x 121.9 cm (38 x 48 x 48 in.)
Collection of the artist. Courtesy Curt Marcus Gallery, New York